St Helens College
Library
Water Street, St. Helens, Merseyside, WA10 1PP
Tel: 01744 623 256

This book is due for return on or before the last date shown below.

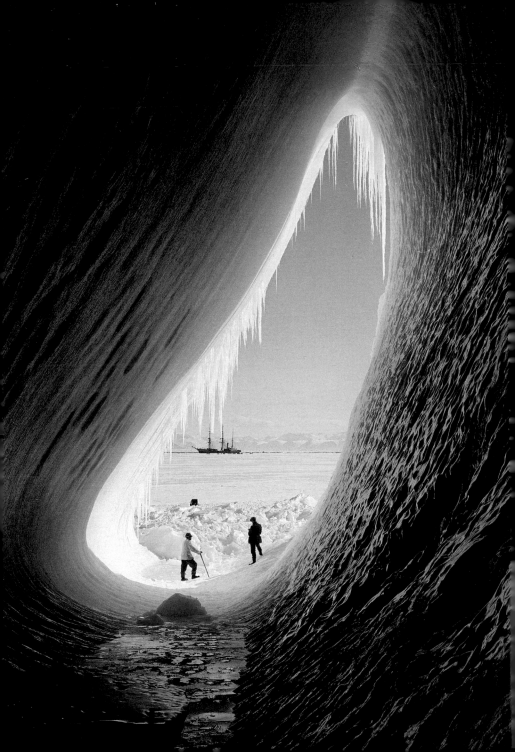

...isms

UNDERSTANDING PHOTOGRAPHY

EMMA LEWIS

Bloomsbury Visual Arts
An imprint of Bloomsbury Publishing Plc

B L O O M S B U R Y
LONDON · OXFORD · NEW YORK · NEW DELHI · SYDNEY

Contents

Photography is structured by technological innovation, artistic movements, its cultural role as a documentarian and storyteller, and its function in commercial contexts, all of which act as categories for the practice of different photographers. This book is an accessible guide to these classifications.

Since its invention in the early 19th century, photography has proved itself to be a restless medium – far more so than any other. From the foundational inventions of these early years (like William Henry Fox Talbot's method for producing prints from negatives, or Eadweard Muybridge's technique for recording motion) to the game-changing innovations of the 20th and 21st centuries (such as the launch of colour film, and digital and front-facing cameras), chemistry and technology are constantly transforming the very nature of photography – and therefore our relationship with it.

Throughout this evolution, photography has been ascribed arguably its most important, and certainly its most contested, role – as a witness to current events. It has also been relied upon to communicate political ideas, and shaped by groups of photographers with firm ideas about what their medium is or should be used for. And, just like painting, drawing or sculpture, it has been integral to some of the major movements in modern art.

The structure of the book reflects how all of these different facets have overlapped or diverged over the course of time. While there are movements, such as Surrealism, which can be pinpointed to a specific place or moment, there are also themes like Still Life that span history and geographies. These themes are explored here from the key period when they were first introduced, especially productive or influential. Other approaches that have gone through very different iterations, such as conflict photography, appear in two or three different places throughout the book to illustrate the ways in which they have shifted in accordance with culture, industry and technology. Some chapter titles are names coined by the photographers involved, some simply describe the approach, and others – Industrialism, Subjectivism, Satirism, Düsseldorf Deadpan and Fictional Narrativism – have been coined for this book to pithily sum up a style or approach.

It is important to point out that the photographers included in each chapter are necessarily representative but, like photography itself, their practices are fluid and not defined solely by the category in which they appear here. This publication is, therefore, not an exhaustive summary, but an essential guide, offering the key information necessary to understand and enjoy the medium that permeates almost every aspect of our lives.

THE FOUR TYPES OF ISM

1 MOMENTS
e.g. The First Photograph; Motionism

These chapters signpost the key events that have shaped photography's history. This includes technological developments. It also includes the types of photography that are understood here through the specific cultural and historical moment in which they existed; for example, Mexican Modernism. Key exhibitions, like 'The Family of Man', are also featured under this header to reflect how a particular assembly of photographers captured the *zeitgeist*.

2 THEMES
e.g. The Studio Portrait; Still Life

These chapters focus on photography that is understood primarily – though not exclusively – through the subject matter that it depicts. Some, like Survey, have fulfilled a specific purpose at a particular time; others, like The Nude, are ongoing subjects within fine-art photography. The photographers in these chapters are rarely associated solely with only one genre, however; many are also associated with different artistic movements, and they work in a variety of styles.

3 MOVEMENTS
e.g. Dadaism; New Formalism

These chapters encompass groups of artists who either coined a term themselves to label their practice or had the word suggested (at the time or retrospectively) by a critic; they are the 'isms' from which this book takes its name. Some are specific to photography, others are part of broader artistic movements. Often they have a manifesto or essay in which the artists' shared goals and processes are clarified. A number of the artists labelled with a particular ism by critics might have rejected the term themselves, but it has remained in common use as a description of their work.

4 APPROACHES
e.g. Photojournalism; Diarism

This is the most common type of ism in the book. Like themes, approaches necessarily do not belong to specific places or moments in time. They are broadly classified according to their treatment of a particular subject matter, as well as, or instead of, the subject matter itself. Each chapter under this header falls under one of the broader categories of reportage, documentary, commercial or conceptual photography.

TH Symbols are used to distinguish between the four different types of 'ism' outlined in this introduction: key moments **MM**; themes **TH**; movements **MV**; and approaches **AP**. Some chapters, or 'isms', could arguably be understood by more than one of these, but this book has used the most relevant header.

INTRODUCTION
Each chapter opens with a brief summary to explain the key features of the moment, theme, movement or approach.

KEY PHOTOGRAPHERS
Up to five key photographers are listed in each chapter. The list could often be extended, but exploring their work would give you a comprehensive understanding of style, approach or moment in time discussed.

KEY WORDS
These are words taken from the main definition text that relate closely to the 'ism' and are often repeatedly used in explanations of the affiliated photographers' work.

MAIN DEFINITION
This describes the key ideas, methods and photographers' practices in more depth. It gives a brief overview of the historical, cultural and technological context that relates to the moment, theme, movement or approach being explained, including key exhibitions, publications, and innovations in photographic products and processes.

Conflict & Surveillance · TH · 136 / 137

The rise of surveillance and the changed nature of conflict have prompted new photographic application. Often creating their images by hijacking the technologies they are investigating, photographers reveal what hidden systems look like and how they permeate our lives.

EDMUND CLARK (1963–); RAPHAEL DALLAPORTA (1980–); MISHKA HENNER (1976–); TREVOR PAGLEN (1974–); DONOVAN WYLIE (1971–)

data; counter-terrorism; intelligence gathering; investigation; satellite

Post 9/11, the mechanisms behind conflict and counter-terrorism activity, and concerns about how surveillance technologies are an accepted part of life, have become a major subject in photography. Some photographic series concentrate on hidden sites: Edmund Clark, for instance, has documented camp complexes, naval bases and detainees' homes in Guantanamo Bay, and terrorist control centres to which he was granted access. Others reveal what is in plain sight, but taken for granted, as in Donovan Wylie's photographs of military watchtowers in England, Ireland and the Arctic, which illustrate how structures of national defence imprint themselves upon the landscape. Both employ the deadpan style associated with the New Topographics photographers. Trevor Paglen seeks to represent the facets of mass surveillance and data collection that do not have an obvious or tangible form. In 2014, he located and photographed the buildings that housed the top-five US intelligence agencies, and made his images freely available online. The buildings may look like any other civic institutions, but by bringing the images into the public domain he seeks to create what he has called a 'visual and cultural vocabulary' around surveillance, making it seem less of an abstract concept.

Collaboration – with scientists, human rights activists or journalists, among others – is a major characteristic of this genre. So too is investigation. Paradoxically, many photographers make use of the very surveillance technology on which they are commenting in order to create their work. Paglen has used commercial satellite technology to track classified US drones, while Mishka Henner has used Google Street View to help locate the overt and covert sites that are the focus of his series *Fifty-One US Military Outposts* (2014).

These technologies can yield beautiful results. In Henner's *Dutch Landscapes* (2011) he captures the colourful shapes that the Dutch government use to censor sites on Google's satellite imagery, while Paglen's images from space possess an abstract quality sometimes referred to as an 'astronomical sublime'. For Raphaël Dallaporta, surveillance technology offered a means of making alternative representations of a country at war: in *Ruins* (2011) he used a pacifist drone to create strikingly aerial studies of landscapes in Afghanistan that represent important archaeological sites.

↑ TREVOR PAGLEN
STSS-1 and Two Unidentified Spacecraft over Carson City (Space Tracking and Surveillance Systems, USA 205), 2010, from *The Other Night Sky*, 2007–11
Smithsonian American Art Museum, Washington DC

Paglen used data produced by amateur satellite observers to map secret American satellites and space debris in the earth's orbit, which he then shot using telescopes and digital and large-format cameras.

OTHER WORKS

RAPHAËL DALLAPORTA
Ruin, Season 1, from *Ruins*, 2011
Musée Nicéphore Niépce, Chalon-sur-Saône, France

MISHKA HENNER
Nato Storage Annex, Coevorden, Drenthe, from *Dutch Landscapes*, 2011
Centre Pompidou, Paris

DONOVAN WYLIE
OP 1a, Forward Operating Base, Masum Ghar, Kandahar Province, Afghanistan, 2010, printed 2015, from *Outposts*, 2010
National Gallery of Canada

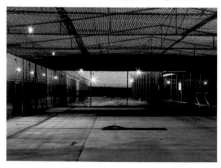

↑ EDMUND CLARK
Camp One: Exercise Cage from Guantanamo: If the Light Goes Out, 2009
Imperial War Museum, London

Shot straight-on, and devoid of people or action, Clark's image concentrates attention on the structure of one of the places that detainees must spend countless hours of their time. The mesh ceiling that takes up a third of the horizontal plane emphasises that this is a place of oppression.

Survey; War Reportage; New Topographics; Post-Internet

The Nude; Still Life; Postwar Colour; Advertising & Fashion; New Formalism

KEY WORKS

Each chapter is illustrated with one or two works by Key Photographers. These are selected from publicly accessible art collections. Individual photographs are very often made as part of a larger body of work, which might exist as a series of prints, be published as a photobook, or both. This information is noted in the caption that accompanies the image.

OTHER WORKS

This is a supplementary list of works that also relate to the chapter subject. As with the Key Works, the larger body of work – series or photobook – is noted in addition to the name of the individual photograph, if relevant (though the collection will not necessarily have all of the photographs in that series). Photographs are also by their nature reproducible, which means that the same photograph might be held in several different collections. Those listed in this book have been selected based on various factors, including which have the largest holdings of works by that photographer overall, or have the most instructive online resources on that work.

 SEE ALSO

This is a list of other chapters in the book that relate to the 'ism' under discussion and perhaps share a working process, stylistic tendency or concept.

 DON'T SEE

These 'isms' feature a key idea or process that contradicts that under discussion. Their conceptual approach or precepts might be antithetical, or aesthetically they might be very different.

Other resources included in this book

LIST OF PHOTOGRAPHERS

All of the photographers included in this book are indexed alphabetically at the back. The 'ism', or 'isms', with which they are associated in the book are noted, as well as their birth and death dates.

GLOSSARY OF USEFUL TERMS

Terms mentioned in the book that are not commonly understood are listed in a glossary at the back, including brief explanations of some of the main photographic processes discussed.

LIST OF COLLECTIONS

A list of the major museums, galleries and other collections mentioned in the Key Works and Other Works sections of each chapter, organised by country. Many of these list their collections online, with images and other resources for further exploration and research.

CHRONOLOGY OF ISMS

This is a timeline of all of the different 'isms' explained in the book, from the very first permanent photograph in 1826 to the burgeoning movements of New Formalism and Post-Internet photography. The start and endpoints of 'isms' can often be debated: even movements that declared an official ending often had a legacy beyond this, while approaches like photojournalism began in different places at different times. The timeline here marks the widely accepted moment when an 'ism' was established and when it declined. For thematic categories that have no set endpoint, such as The Nude, the timeline marks the core period on which the chapter focuses.

Dictyota dichotoma
in the young state, &
in fruit.

I

THE
INVENTION OF
PHOTOGRAPHY
AND THE
RECORDING OF
THE WORLD
1826–1910s

◔ Photography is the result of three processes announced in the 1820s and 1830s that made it possible to record, fix and reproduce an image. The first in-camera photograph was a unique, permanent image made with a camera obscura.

◑ ANNA ATKINS (1799–1871); LOUIS-JACQUES-MANDÉ DAGUERRE (1787–1851); HUMPHRY DAVY (1778–1829); JOSEPH NICÉPHORE NIÉPCE (1765–1833); WILLIAM HENRY FOX TALBOT (1800–77); THOMAS WEDGWOOD (1777–1805)

◕ camera obscura; heliography; photogenic drawing; positive; unique

● First steps towards the photographic image were made by Thomas Wedgwood and Humphry Davy, who in 1802 published accounts of their experiments with recording light. The findings that launched photography came later, beginning with the work of inventor Joseph Nicéphore Niépce.

Interested in lithography, Niépce sought a technique to supplement his professed lack of skill as an engraver. In 1816 he experimented with placing sensitised paper into the back of a camera obscura, an optical device that projects images. He found that where light hit the paper it would darken, creating a negative impression. But the results were only temporary: the paper turned completely black in daylight.

Six years later, Niépce discovered that putting a solution of bitumen and Judea, a mineral spirit, onto the paper would permanently fix the image. The spirit hardened on contact with the light, and was commonly used in lithography. He called this invention heliography, meaning 'light drawing', after helios, the Greek word for sun. His reproduction made by placing an engraving of Pope Pius VII in direct contact with sensitised paper is considered to be the first made from a photographic process.

In 1826 or 1827, Niépce created the world's first in-camera photograph by placing a pewter plate coated with the bitumen preparation inside a camera obscura. After leaving the camera in a window for at least eight hours, he rinsed the plate with a lavender oil solution to reveal a direct positive (and therefore unique) permanent image of the outdoor scene. Niépce's partnership with expert in the camera obscura Louis-Jacques-Mandé Daguerre, from 1829, contributed to the first commercially viable photographic process. He died in 1833 before it was fully refined, though, and it was announced to the world in 1839 as the daguerreotype.

News of Daguerreotypy spurred William Henry Fox Talbot to announce the findings of his own experiments. His hopes to fix the image projected by a camera obscura led to the 1833 discovery of what he called the 'photogenic drawing' (a photogram): an image made without a camera by placing objects directly onto paper coated with a light-sensitive silver chloride solution that darkens on exposure to sunlight. John Hershel's 1842 invention of the cyanotype followed the same basic principle, but he used a solution that turned bright Prussian blue upon exposure. Botanist Anna Atkins was the first to realise the potential of this for recording plant specimens; her volume Photographs of British Algae: Cyanotype Impressions was published serially between 1843 and 1853. By that point, Talbot had already announced his next discovery, the calotype – the first negative-positive process.

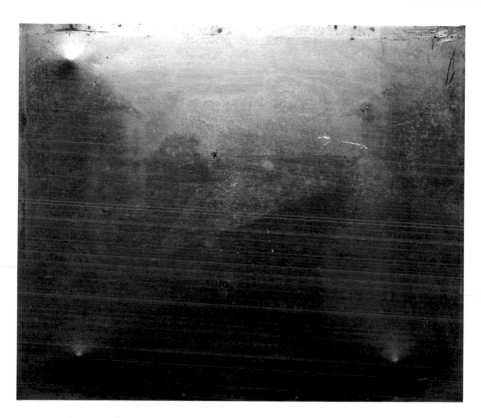

↑ **JOSEPH NICÉPHORE NIÉPCE**

View from the Window at Le Gras
(Point de vue du Gras), c 1826–27
Harry Ransom Center, University of Texas at Austin

This is the earliest surviving photograph made in a camera. Despite the blurriness of the pewter plate, it is just possible to see the rooftops of the outbuildings of Niépce's family estate in Le Gras, France. After decades in obscurity, it was eventually located by photo-historians Alison and Helmut Gernsheim in 1952.

ANNA ATKINS (see p10)

Dictyota dichotoma in the Young State and in Fruit, from *Photographs of British Algae: Cyanotype Impressions,* 1843–53
J. Paul Getty Museum, Los Angeles

Atkins had experimented with various methods before trying the cyanotype process. Because this could enable multiple prints, she was able to make more than a dozen copies of her volume on British algae, considered to be the first book illustrated with photographs.

OTHER WORKS

ANNA ATKINS
Ceylon, British Ferns, from *Cyanotypes of British and Foreign Ferns,* c 1853
J. Paul Getty Museum, Los Angeles

ANONYMOUS
Shark Egg Case, c 1840–45
The Metropolitan Museum of Art, New York

JOHN HERSCHEL
Still in my Teens, 1838
Harry Ransom Center, University of Texas at Austin

WILLIAM HENRY FOX TALBOT
Leaves on a Stem, c 1838
Victoria and Albert Museum, London

 Daguerreotypy;
Negative-Positivism

 Motionism; Early Street; Futurism;
Photojournalism; Conceptualism

A daguerreotype is a unique, highly detailed, positive image on a silvered copper plate, made by a chemical and technical process perfected by Louis-Jacques-Mandé Daguerre. It was the first commercially successful means of producing photographs and the main process in use throughout the 1840s and early 1850s.

ANTOINE CLAUDET (1797–1867); ROBERT CORNELIUS (1809–93); LOUIS-JACQUES-MANDÉ DAGUERRE (1787–1851); JOSEPH NICÉPHORE NIÉPCE (1765–1833); JOHN ADAMS WHIPPLE (1822–91)

commercial; detail; fragile; portrait; unique

In 1829, artist and theatre set designer Louis Daguerre and inventor Joseph Nicéphore Niépce formed a working partnership to bring together Niépce's pioneering methods of recording light and fixing a permanent image, known as 'heliography', with Daguerre's expertise with the camera obscura that he developed as inventor of the diorama – an illusionary three-dimensional stage device. Following Niépce's death in 1833, Daguerre continued alone, arriving four years later at a successful method of making a permanent recording. One of his most important findings was the 'latent image': exposing

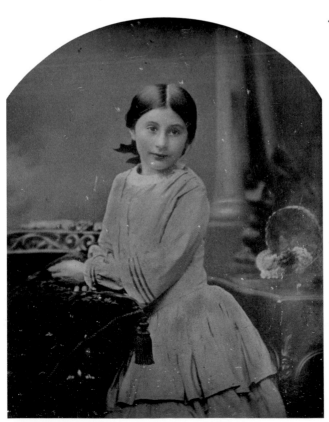

← **ANTOINE CLAUDET**
Portrait of Girl in a Blue Dress, c 1854
J. Paul Getty Museum, Los Angeles

Claudet hired portrait miniature painters to add jewel-like tones and decorative backdrops to his photographs. Here, the tones complement the young sitter's features, while sensitive application means that colour does not obscure the plate's lustre.

⇶ **LOUIS-JACQUES-MANDÉ DAGUERRE** *(overleaf)*
Boulevard du Temple, 1838
Bayerisches Nationalmueum, Munich

The daguerreotype's ability to reproduce fine detail is evident here in the texture of the cobbled streets and in the crisp lines of rooftops and edges of buildings. This plate took more than 10 minutes to expose: too long to register the traffic and bustling crowds, though the blurry figure of a shoe-shiner can just be made out.

an image that was then 'developed out' (made visible) using mercury vapour. This reduced exposure times from hours to minutes, and formed the basis of processes still in use today.

The announcement of the daguerreotype process in August 1839 at a meeting of the French Académie des sciences and the Académie des Beaux-Arts in Paris was received with great enthusiasm. Demand for the daguerreotype camera was instantaneous and so-called 'daguerreomania' quickly took hold. Views of Paris were made within days; soon after, scenes from Africa, Asia, the Middle East, as well as Europe and North America had been rendered in the daguerreotype's impressive detail. Print engravings made from daguerreotypes of landscapes and monuments became immensely popular, reflecting the burgeoning public appetite for travel.

This rapid spread of Daguerreotypy can be credited to the fact that (except in Britain and the Commonwealth) it was not under patent. Shrewdly, the French government had acquired the process and presented it to the world as a 'gift from the nation'. Numerous individuals were thus able to improve upon Daguerre's technique: Antoine Claudet, Robert Cornelius and John Frederick Goddard reduced the original 20-minute-plus exposure times, making the process better suited for portraiture and cityscapes; Hippolyte Fizeau introduced the use of gold toning to strengthen the surface; and Johann Baptist Isenring pioneered techniques for colouring the daguerreotype with gum and pigment, later patented by Richard Beard.

Into the 1840s, the daguerreotype portrait – housed in an ornate case to protect its fragile surface and often hand-coloured – became a fashionable staple of bourgeoisie life, and hundreds of studios opened across Europe and the US. The process was also adopted in the fields of geology, medicine, anthropology, archaeology and even astronomy: in 1851 John Adams Whipple made the first daguerreotypes of the moon and Jupiter.

Daguerrotypy was not without its drawbacks. Crucially, it yielded only a unique image that could be reproduced only as a lithograph print or engraving, or by making a daguerreotype of a daguerreotype – a much lesser quality object. From the 1850s the process was largely superseded by the introduction of negative-positive processes and the commercialisation of reproducible photography.

OTHER WORKS

ROBERT CORNELIUS
Self-Portrait; Believed to be the Earliest Extant American Portrait Photo (The First Light Picture Ever Taken), 1839
Library of Congress, Washington DC

LOUIS-JACQUES-MANDÉ DAGUERRE
The Artist's Studio (L'Atelier d'Artiste), 1837
Société Française de Photographie, Paris

JABEZ HOGG (attributed)
An Operator for Richard Beard, c 1843
Victoria and Albert Museum, London

GEORGE PHILLIPS BOND AND JOHN ADAMS WHIPPLE
Moon, c 1851
Harvard College Observatory, Cambridge, Massachusetts

 The First Photograph; Negative-Positivism; The Studio Portrait; Travel, Expedition & Tourism; Still Life

 Motionism; Subjectivism; Conceptualism; Diarism; Satirism

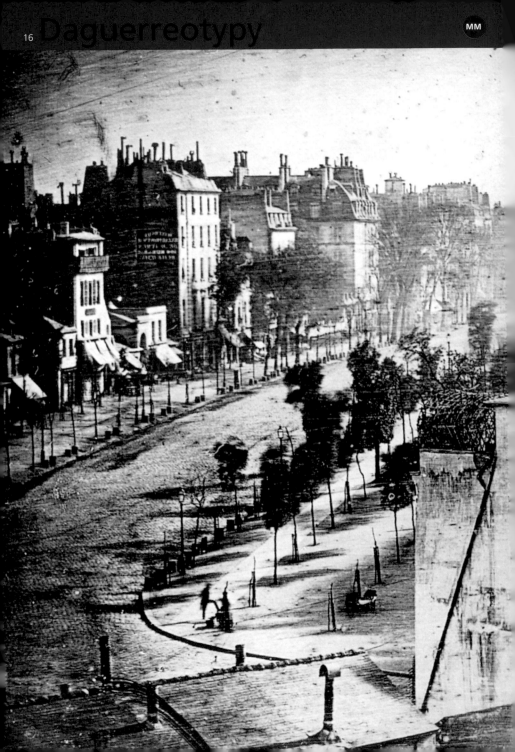

 The invention of the calotype negative in the 1840s introduced a means of reproducing images multiple times, which provided the basis for the negative-to-positive processes still in use.

FREDERICK SCOTT ARCHER (1813–57); HIPPOLYTE BAYARD (1801–87); LOUIS-DÉSIRÉ BLANQUART-EVRARD (1802–75); GUSTAVE LE GRAY (1820–84); WILLIAM HENRY FOX TALBOT (1800–77)

calotype; glass plate; photogenic drawing; waxed paper; wet collodion

Photography resulted from an intense period of experiment by numerous scientists and inventors during the early 19th century. The cornerstones of this were Joseph Nicéphore Niépce's methods for fixing a permanent image, discovered in 1826; Daguerreotypy, announced in 1839; and William Henry Fox Talbot's pioneering technique for creating multiple positive images from a single negative, which he arrived at in what he described as 'the brilliant summer of 1835'.

Talbot's investigations with photography began in 1833, when his desire to record the Lake Como landscape prompted him to explore ways to fix the image projected by a camera obscura. His major breakthrough came when he found that an impression of an object could be made by placing it directly onto a sheet of paper coated with a light-sensitive solution of sodium chloride (table salt) and silver nitrate. Where sunlight fell onto the paper it would darken; where protected, it would remain light. He called this 'photogenic drawing'.

Talbot then experimented with placing the sensitised paper into a camera. He found that the resultant 'drawing' could be placed in contact with another piece of sensitised paper to create the same image with reversed tones: a 'positive' from a 'negative'. These terms, like the word

→ **WILLIAM HENRY FOX TALBOT**
The Open Door, before May 1844
The Metropolitan Museum of Art, New York

Talbot made many versions of this while experimenting with his newly invented calotype process. Influenced by Dutch still-life painters, his apparently straightforward arrangement is in fact loaded with symbolic meaning, as doors represented the threshold between life and death.

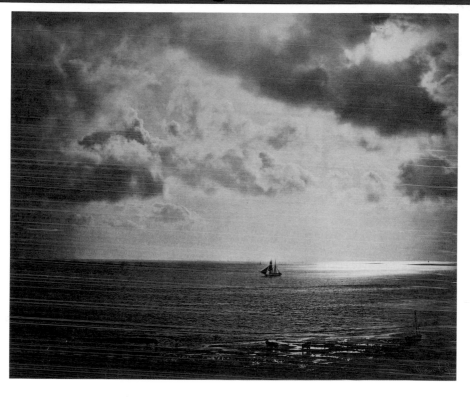

'photography' itself, were coined by his
friend John Herschel, who also introduced
the use of a photographic fixing agent that
is still in use today.

Talbot had done little work on his
method when Louis Daguerre announced
his own photographic process in Paris in
1839. The daguerreotype was an immediate
success. But the fact it was a unique object,
and on a metal plate, was a major practical
hindrance. Talbot rightly believed that
the future lay in the reproducible paper
image, and this led him to begin his
experiments again in earnest.

His discovery of the latent image in
1840 (something that Daguerre had also
arrived at independently) was pivotal. This
meant that the photographer did not have
to wait for long periods of time for an

image to develop in the camera. Instead,
they could allow it to register invisibly on
light-sensitised paper, then use a chemical
solution to reveal it at a later stage, thus
reducing exposure times from hours or
minutes to mere seconds. Talbot called this
the calotype process – from the Greek
words for 'beautiful' ('*kalos*') and
'impression' ('*tupos*'). He showcased his
invention in *The Pencil of Nature* (1844–64),
a volume of salted paper prints made using
calotype negatives.

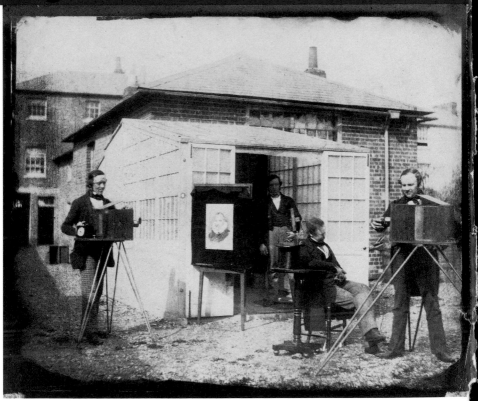

↑ **BENJAMIN COWDEROY**
The Reading Establishment, c 1845
The Metropolitan Museum of Art, New York

This tableau vivant was staged at the studio of Nicolaas
Henneman, Talbot's former assistant, and depicts his
hopes for the industrialisation of the process. Men are
using the camera to make studies of artworks, while an
assistant exposes a large batch of prints in sunlight.

OTHER WORKS

HIPPOLYTE BAYARD
Self Portrait as a Drowned Man, 1840
Société Française de Photographie, Paris

WILLIAM HENRY FOX TALBOT
Nelson's Column under Construction, Trafalgar Square,
1844
The Metropolitan Museum of Art, New York

In the end, the softness of the image on
paper and the fact that the prints were
liable to fade curtailed the calotype's
success. Both of these drawbacks were
surmountable, were it not for Talbot's
decision, in 1841, to patent his process,
which limited its uptake and therefore its
opportunity for improvement by others.
Such complications were characteristic of
photography's early years, which were mired
in politics of intellectual credit and financial
gain.

Subsequent developments in negative-
positive processes thus came from
individuals whose inventions fell beyond
the remit of Talbot's patent. Louis-Désiré
Blanquart-Evrard created a similar process
using albumen-coated paper, and

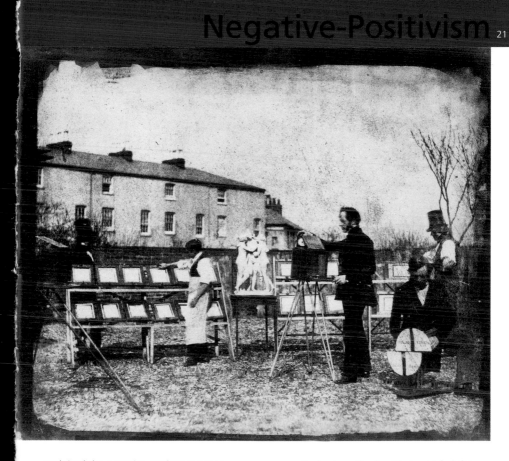

exploited the negative-positive process to print photographs on an industrial scale for the first time. Gustave Le Gray found that adding wax to the paper negative created a sharper image with a far better tonal range, which he demonstrated in seascapes.

The next great achievement in Negative-Positivism came in 1851 with Frederick Scott Archer's publication of the wet collodion process. He used a glass plate as a negative, which yielded far greater detail than paper, and the collodion greatly accelerated exposure. This represented everything photographers had been working towards: an image on paper that showed great tonal range and definition, did not fade and could be reproduced.

Archer's method vastly expanded the possibilities for photography's applications in the sciences, in commercial endeavours – particularly the portrait studio – and in early reportage photography. It remained the main photographic process in use until the 1880s, when it was gradually superseded by the gelatin silver print and the introduction of negative film.

 The First Photograph; Daguerreotypy; Travel, Expedition & Tourism; Early Conflict

 Motionism; Futurism; Dadaism; Surrealism; Art Documentary

 Immediately upon the announcement of the daguerreotype, photography was commercialised in the form of portrait studios that opened up across the globe. Later, the reproducible nature of portraits on paper, particularly in the form of cartes de visite, cemented the use of the portrait to denote social status.

ROBERT CORNELIUS (1809–93); **LALA (RAJA) DEEN DAYAL** (1844–1905); **GEORGE LUTTERODT** (ACTIVE FROM 1876); **NADAR (GASPARD-FÉLIX TOURNACHON)** (1820–1910)

celebrity; choreographed; collecting; commercialism; mass distribution

With the spread of Daguerreotypy during the 1840s came a demand for the creation of photographic 'likenesses' from the middle and upper classes. Commercial portrait studios opened across Europe and the US, with successful practitioners such as Antoine Claudet, Robert Cornelius and Josiah Johnson Hawes attracting well-to-do customers and charging high prices.

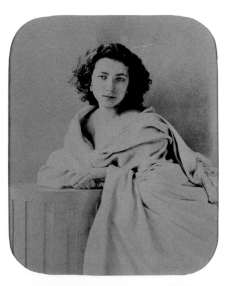

In the 1850s, paper prints made through the collodion process began to supplant the daguerreotype, particularly in the form of cartes de visite – the 'calling card'. In 1854 André-Adolphe-Eugène Disdéri patented a four-lensed camera that could register up to eight different images on one plate. Photographers experimented with presenting their sitters in different poses and with various accoutrements, and the small images – around 4 x 2.5 inches (10 x 6 cm) – were pasted onto slightly larger pieces of card. Ownership of a carte de visite and its bigger version, the cabinet card, suggested a personal relationship with the subject. Individual touches in posture and dress were added to standard poses and backdrops, all the while conforming to social, class and gender norms.

The craze for cartes de visite also reflected a new appetite for images of celebrities. Figures from politics, the arts, entertainment and fashion had portraits made and duplicated for mass distribution. Studios grew in size and the sets and props they provided became increasingly elaborate. Disdéri and Pierre-Louis Pierson photographed French royalty, while in England Queen Victoria commissioned cartes de visite of the royal family from John J E Mayall in 1860.

The desire to collect portraits of celebrities and aristocracy also gave rise to albums of 'contemporary figures' produced by successful studio owners such as Étienne Carjat, Franz Hanfstaengl, Nadar, Camille Silvy and Emile Tourtin (active 1873–99). Lala (Raja) Deen Dayal's studios across India met demand for portraiture from the British and Indian ruling classes.

The introduction of Kodak's 'You Press the Button, We Do the Rest' system in 1888 lessened the need for the general public to have themselves photographed formally.

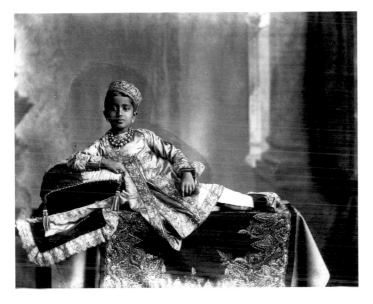

The desire for the portrait made in the carefully choreographed studio environment endured, however, transformed in subsequent decades in the fields of fashion and advertising, and with the advent of artificial lighting.

← **LALA (RAJA) DEEN DAYAL**
Fateh Singhrao Gaekwad of Baroda, 1891
Indira Gandhi National Centre for the Arts, New Delhi

Dayal was India's most prolific and commercially successful photographer of the 19th century. He produced many thousands of portraits of British and Indian nobility, such as this image of a young member of the Gaekwad dynasty.

← **NADAR**
Sarah Bernhardt, 1859
Musée d'Orsay, Paris

Nadar's photographs of Sarah Bernhardt are considered among his most sophisticated portraits. Here, his characteristically soft, sideways lighting illuminates her décolleté and emphasises the drapuu of the velvet in which she is wrapped to create a sense of voluptuousness.

OTHER WORKS

ANDRÉ-ADOLPHE-EUGÈNE DISDÉRI
Napoléon III, Emperor of France; Napoléon Eugène Louis Jean Joseph Bonaparte, Prince Imperial; Eugénie, Empress of France, c 1858
National Portrait Gallery, London

GEORGE LUTTERODT AND SON
Untitled (Five Men), c 1880–85
The Metropolitan Museum of Art, New York

NADAR AND ADRIEN TOURNACHON
Portrait of a Mime (Paul Legrand), 1854–55
Bibliothèque Nationale de France, Paris

 Daguerreotypy; Negative-Positivism; Fashion & Society; Self-Portrait, Performance & Identity

 The First Photograph; Motionism; Early Street; Industrialism; Subjectivism

 Early photographic technology necessitated long exposure times, making landscape an ideal subject. A growing tourism industry created a demand for photography that helped to establish its place in 19th-century life.

MAXIME DU CAMP (1822–94); FRANCIS FRITH (1822–98); HERBERT PONTING (1870–1935); JOHN THOMSON (1837–1921); LINNAEUS TRIPE (1822–1902)

expedition; picturesque; plate camera; stereo card; survey

From its inception, photography fulfilled the need of governments, scientists and anthropologists for accurate visual representations of the world. Linnaeus Tripe's images of India and Burma made in the 1850s for the British East India Company are an exemplar. In the 1860s, John Thomson's travels across Siam, Cambodia and China produced one of the most extensive accounts of any region, and serve as prototypical anthropological records.

Developments in photography also coincided with the growth of the mass tourism industry. New markets formed around souvenirs for tourists, and volumes aimed at the 'armchair traveller'. In many cases the aesthetic of these images was tailored to the 19th-century affinity for the Romantic, sublime and picturesque. In Europe, the opening up of the Alps as a tourist destination saw numerous photographers set up studios to cater to the demand for views of the dramatic landscapes. Stereo cards were an immensely popular memento: Adolphe Braun and

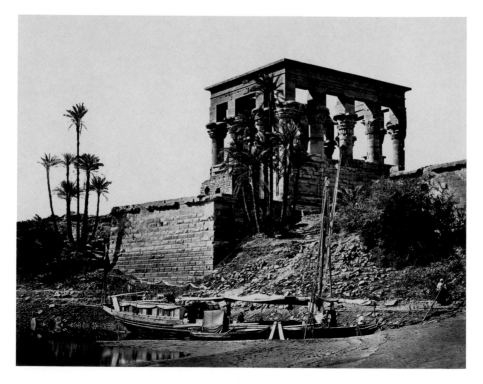

Claude-Marie Ferrier were among those working in the region who made images in this format.

The first travel albums were engravings of daguerreotypes, to which appealing scenic details were often added. Noël Marie Paymal Lerebours' *Daguerreotype Excursions* (1840–44) is the earliest example. By 1850, following the introduction of the calotype and the subsequent refinement of negative-positive processes, Louis-Désiré Blanquart-Evrard created a revolutionary method of producing albums in large editions by printing on albumen paper. He published the first volume of reproduced photographs, Maxime Du Camp's *Egypt, Nubia, Palestine and Syria*, in 1852. Views of ancient sites such as these were favoured subjects. Those made by Francis Frith in his pioneering journeys along the Nile, published in the two-volume *Egypt and Palestine Photographed and Described* (1858–60), are considered to be the most sophisticated.

Within just two decades of its inception, and despite the challenges associated with transporting huge amounts of kit and producing photographs in extreme climates, photography had been employed to capture landscapes and cultures worldwide. 50 years later, Herbert Ponting, official photographer to Captain Scott's Terra Nova Expedition to the Antarctic, would create some of the most enduring images of the polar landscape.

Daguerreotypy; Negative-Positivism; Survey; New Topographics; Environmentalism & Globalisation

Modernism; The Social Document; Bauhaus & the New Vision; Conceptualism; Satirism

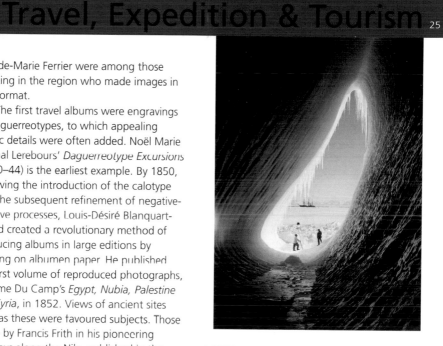

↑ HERBERT PONTING
Grotto in a Berg. Terra Nova in the Distance. Taylor and Wright (Interior), 5 January 1911
Scott Polar Research Institute Museum, University of Cambridge, UK

Ponting travelled with a vast outfit of still and movie cameras, making work that was as pictorial as it was documentary.

← FRANCIS FRITH
The Kiosk of Trajan, Philae, c 1858
J. Paul Getty Museum, Los Angeles

To take this photograph Frith set up a darkroom in a *dahabije*, or sailboat, like the one depicted here moored in front of a Roman temple.

OTHER WORKS

FELICE BEATO
Japanese Girl, c 1866–67
J. Paul Getty Museum, Los Angeles

ADOLPHE BRAUN
Upper Glacier, Grindelwald, c 1865
J. Paul Getty Museum, Los Angeles

JOHN THOMSON
A Knife Grinder, c 1871–72
Wellcome Library, London

LINNAEUS TRIPE
Madura, Trimul Naik's Choultry, 1858
Peabody Essex Museum, Salem, Massachusetts

The landscape surveys undertaken in the US from the 1860s had a cultural, environmental and ideological impact that far exceeded their intended documentary purpose. They shaped the 'pioneer spirit' and helped create the mythic and enduring vision of the 'American West'.

EO BEAMAN (1837–76); JOHN K HILLERS (1843–1925); WILLIAM HENRY JACKSON (1843–1942); TIMOTHY H O'SULLIVAN (1840–82); CARLETON E WATKINS (1829–1916)

expansion; frontier; mythic; sublime; wilderness

Exploration and photography had gone hand in hand since the medium's earliest days. The introduction of the plate camera in the 1850s, with processing and developing methods more practicable for fieldwork, and negatives that provided greater resolution and yielded multiple prints, transformed the scale and scope of these projects.

One of the greatest examples of this kind took place in the US in the surveys undertaken as part of the population's westward expansion; in particular, the four 'great surveys' of 1867–79 that followed the American Civil War (1861–65). Under the auspices of either the War Department or the Department of the Interior, large expedition groups were assembled to survey and map natural resources or assess development opportunities, mostly working along the terrain newly opened up by the transcontinental railroads, and they commissioned photographers to record their activities.

Timothy H O'Sullivan, a leading photographer during the Civil War, took part in two of the four major expeditions: George Wheeler's 100th Meridian Survey, and Clarence King's Fortieth Parallel Survey, which Carleton E Watkins also accompanied in 1867. EO Beaman and John K Hillers both took part in John Wesley Powell's Survey of the Rocky Mountain Region; and William Henry Jackson was appointed as official photographer of Ferdinand Hayden's US Survey of the Territories.

The images produced by these photographers, and the many others who worked outside of the official survey capacity, functioned as far more than visual descriptions. By carefully selecting vantage points, and often placing people within the frame to provide a sense of scale, they created scenes that were dramatic and awe inspiring; charming and picturesque. The wider public who encountered these images in the press or in guidebooks, or purchased them as prints and stereo cards, were well versed in Romantic notions of the sublime, which associated sites of natural grandeur with the divine and spiritual. To them, these magnificent and yet accessible landscapes held great appeal. So too did the pioneer spirit and the mythic American frontier that these images helped to convey.

Most important of all was the role of the survey photographs in environmentalism. President Lincoln's 1864 bill to protect the Yosemite Valley, the first of its kind, was directly influenced by Watkins's majestic 18 x 22 inch (46 x 56 cm) studies of the region made three years earlier. Jackson's 1871 views of Yellowstone saw the region established as the first US National Park in 1872, paving the way for the launch, in 1916, of the National Park System that would preserve the unspoiled wilderness to which these surveys of the American West had attested.

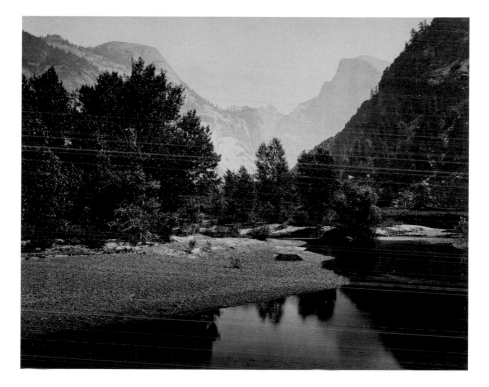

OTHER WORKS

EO BEAMAN
Lodore Canyon, Colorado River/The Heart of Lodore,
1871
J. Paul Getty Museum, Los Angeles

JOHN K HILLERS
Cliff Dwellings, c 1875
George Eastman Museum, Rochester, New York

WILLIAM HENRY JACKSON
Grand Canyon of the Colorado River, c 1883
J. Paul Getty Museum, Los Angeles

TIMOTHY H O'SULLIVAN
*Ancient Ruins in the Canon de Chelle [sic], N.M. In a
Niche 50 Feet Above Present Canon Bed,* 1873
George Eastman Museum, Rochester, New York

↑ **CARLETON E WATKINS**
*Distant View of the Domes, Yosemite Valley,
California,* c 1861–66, printed 1986
Minneapolis Institute of the Arts, Minnesota

Watkins's oversized glass-plate negatives allowed him to
capture the grandeur of the Yosemite Valley at an
unprecedented scale. This view conjures what has
become known as a 'domesticated sublime': certainly
awe-inspiring, but also picturesque, unthreatening, and
so of great appeal to potential tourists.

 Negative-Positivism; Travel, Expedition
& Tourism; Group f.64; New
Topographics

 Bauhaus & the New Vision,
Industrialism; Social Realism;
Photojournalism; Satirism

 From the 1850s, photographers were regularly sent to cover conflict. Their role was aided by the introduction of faster processes that could yield multiple prints.

FELICE BEATO (1832–1909); **MATHEW BRADY** (1822–96); **ROGER FENTON** (1819–69); **TIMOTHY H O'SULLIVAN** (1840–82); **JAMES ROBERTSON** (1813–88)

aftermath; commercial; evidence; propaganda; systematic

The invention of the wet-collodion process enabled photographers to document the many conflicts that took place in the decades following European colonial expansion. Though still cumbersome, the equipment required could be transported by photographers in wagons that also acted as portable darkrooms.

Photography began to be employed for propagandistic, commercial and military purposes: governments commissioned images that told specific stories about action overseas, while engravings, photographs, stereographs and cartes de visite were made to supply increasing demand.

Although daguerreotypes of the Mexican-American War (1846–48) are regarded as the earliest conflict photographs, the Crimean War (1853–56) saw the first major proliferation of such imagery, including the work of Jean-Charles Langlois, Roger Fenton, James Robertson and Carol Szathmari. The technological limitations on capturing action meant that images mainly documented preparations for battle, its aftermath and army life rather than the drama of conflict.

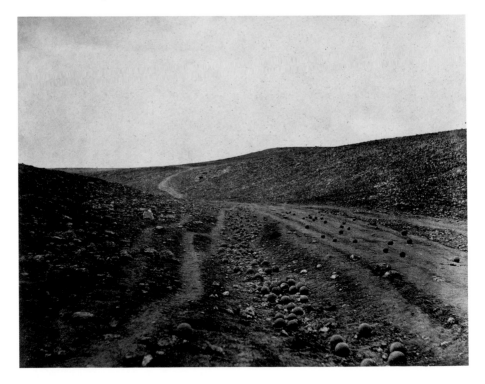

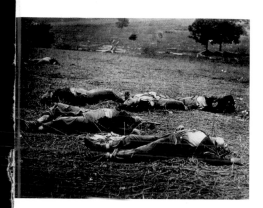

← TIMOTHY H O'SULLIVAN AND
ALEXANDER GARDNER
Gettysburg 1st Day, 1863
Victoria and Albert Museum, London

O'Sullivan captured the aftermath of the American Civil
War's bloodiest battle in graphic detail while working for
Alexander Gardner, who published this in his
Photographic Sketchbook of the War (1865–66).

← ROGER FENTON
Valley of the Shadow of Death, 23 April 1855
J. Paul Getty Museum, Los Angeles

There are two versions of this image; the other shows
the cannonballs cleared into the ravine. The question of
whether this might have been staged for dramatic effect
has remained the subject of intense, and as yet
unresolved, debate.

OTHER WORKS

FELICE BEATO
*Interior of the Angle North Fort Immediately after its
Capture,* 1860
Victoria and Albert Museum, London

MATHEW BRADY
*Scene Showing Deserted Camp and Wounded Soldier
(Zouave),* c 1865
Library of Congress, Washington DC

ROGER FENTON
Roger Fenton's Photographic Van, 1855
National Army Museum, London

TIMOTHY H O'SULLIVAN
A Harvest of Death, Gettysburg, Pennsylvania, 1863
George Eastman Museum, Rochester, New York

JAMES ROBERTSON
*General View of Balaklava with the Huts of the Guards
in the Foreground and Shipping at Anchor,* 1855
Imperial War Museum, London

A similarly formal style appeared in the
many photographs of the American Civil
War (1861–65) by George Barnard, Mathew
Brady, George S Cook, Alexander Gardner
and Timothy H O'Sullivan. The conflict was
documented with the intention of both
recording a historical event and of
commercialising the resulting images. Brady
trained photographers, assigned them army
units, and equipped them with darkrooms
in horse-drawn wagons. More than 7,000
photographs were produced showing
battlefields, army encampments and ruins.

The period from the late 1850s to the
1880s saw photographers including Felice
Beato, John Burke, Gustave Le Gray and
John McCosh travelling to capture conflicts
in Asia, Africa and the Middle East. Such
imagery came to be regarded as objective
documents. Yet photographers like Gardner
and Beato admitted to moving corpses and
providing props to enhance the drama of
their scenes. Images of the Paris Commune
of 1871 taken by Jules Andrieu, Eugène
Appert and Bruno Braquehais provided a
similar threat to photography's reliability.
Appert was commissioned by the French
government to falsify images that could act
as evidence for the Communards' crimes.

 Daguerreotypy; The Studio Portrait;
War Reportage; Conflict &
Surveillance

 Motionism; Pictorialism, Futurism,
Bauhaus & the New Vision;
Subjectivism

◖ From the 1870s, innovations with multiple cameras and improved shutter speeds made it possible to create accurate studies of movement. This was revolutionary for the sciences, influenced modern art, and the sequencing of stills provided the basis for cinematography.

◓ **THOMAS EAKINS** (1844–1916); **HAROLD EDGERTON** (1903–90); **ÉTIENNE-JULES MAREY** (1830–1904); **EADWEARD MUYBRIDGE** (1830–1904); **ARTHUR MASON WORTHINGTON** (1852–1916)

◕ cinematography; high-speed; instantaneous; scientific; sequential

● From photography's earliest days attempts were made to produce 'instantaneous' images of moving entities to make visible what was ordinarily imperceptible to the human eye. By the early 1870s, shutter speeds of one-thousandth of a second had been introduced, and gelatin dry-plate negatives, with their increased light sensitivity, allowed for faster exposures. As a consequence, 'chronophotography' – the capturing of several images in quick succession that could be layered in one frame or presented sequentially – was developed and used to explore the mechanics of motion.

Physiologist Étienne-Jules Marey employed photography to examine muscular and skeletal movement. He isolated his subjects against black backgrounds and photographed them using a specially developed *fusil photographique* (photographic gun), which contained a swiftly rotating film cassette that could shoot 12 frames per second. At a similar time, Eadweard Muybridge made the first sequential photographs of horses in motion and discovered that contrary to popular understanding, all four of a horse's hooves left the ground at points during the running cycle. In his method, a row of 12 cameras were triggered one by one by the movement of the horse as it ran across a sheet rigged with threads connected to the cameras' shutters.

Following the success of his horse photographs, Muybridge made a further 100,000 experimental images of human and animal movement. He worked alongside the realist painter Thomas Eakins, who also produced his own chronophotographs with a *fusil photographique* similar to that used by Marey. Physicist Arthur Mason Worthington made use of high-speed photography to study fluid mechanics, while Ottomar Anschütz photographed animals in zoos and army manoeuvres for use in military training, both using a multiple-camera method.

Developments in motion photography had a profound effect on the scientific and artistic communities in the decades that followed. Marey and Muybridge published their images in academic journals and the popular press, and exhibited and lectured on their work. Both had invented machines for reanimating and projecting sequential images, leading to innovations in cinematography in the 1890s by Thomas Edison and Auguste and Louis Lumière. In 1911, brothers Anton Giulio and Arturo Bragaglia developed photodynamism, which proposed the creative use of photography to represent the trajectory of an action, and Marcel Duchamp's groundbreaking Modernist painting *Nude Descending a Staircase (No.2)* (1912) was inspired by studies of perpetual motion. During the 1930s, Harold Edgerton and Gjon Mili introduced the strobe light to photography to record movement at speeds of one-millionth of a second, leading to pioneering research into fluid dynamics, frequency and human action.

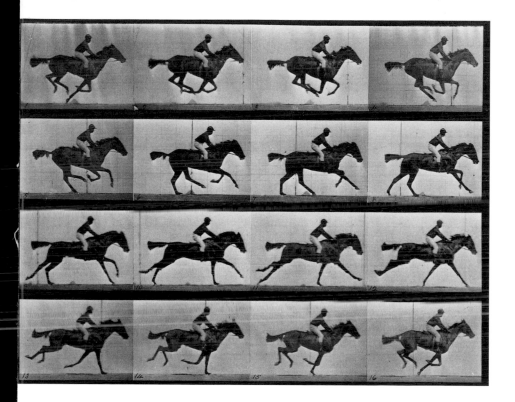

OTHER WORKS

THOMAS EAKINS
History of a Jump, c 1884–85
The Library Company of Philadelphia

HAROLD EDGERTON
Milk Drop in Milk (Sequence), c 1935
Massachusetts Institute of Technology, Cambridge

ÉTIENNE-JULES MAREY
Chronophotographic Study of Man Pole Vaulting,
c 1890–91
George Eastman Museum, Rochester, New York

EADWEARD MUYBRIDGE
*Plate 164 of volume 1 ('Pole Vaulting'), from Animal
Locomotion,* 1887
Boston Public Library, Massachusetts

ARTHUR MASON WORTHINGTON
*Instantaneous Photography of Splashes: Series C, D, E
and F,* c 1900
Victoria and Albert Museum, London

↑ EADWEARD MUYBRIDGE
*Plate 626 of volume 9 ('Annie G Galloping'), from
Animal Locomotion,* 1887
Boston Public Library, Massachusetts

Muybridge's trigger system for recording split-second
movement revealed, for the first time, that there is a
point when a galloping horse lifts all four hooves from
the ground. *Animal Locomotion* also included studies of
humans in action, which proved invaluable for the fields
of medicine, anthropology and physiology.

 Futurism; Bauhaus & the New Vision;
War Reportage; The Family of Man

 Still Life; New Objectivity;
Industrialism; Subjectivism;
Düsseldorf Deadpan

From the mid-1800s, photographers began to record human experience, anticipating what would in later decades become known as 'social documentary'. Then, as now, this type of photography often focused on the disadvantaged.

ROBERT ADAMSON (1821–48) AND DAVID OCTAVIUS HILL (1802–70); LEWIS HINE (1874–1940); OSCAR G REJLANDER (1813–75); JACOB RIIS (1849–1914); JOHN THOMSON (1837–1921)

archetypes; concerned; empathy; injustice; reform

Photography's ability to quickly produce a clear, accurate image meant that it was embraced by the sciences, including the social sciences. Among its many applications was the recording of human beings and foreign cultures for the purpose of anthropological and medical studies.

The 19th-century preoccupation with classification extended to depictions of a more sociological nature, too. In 1844, portrait photographers Robert Adamson and David Octavius Hill included societal archetypes in *The Fishermen and Women of the Firth of Forth*. Like August Sander's typological survey *People of the Twentieth Century* (1892–1954) they function as historical evidence while providing

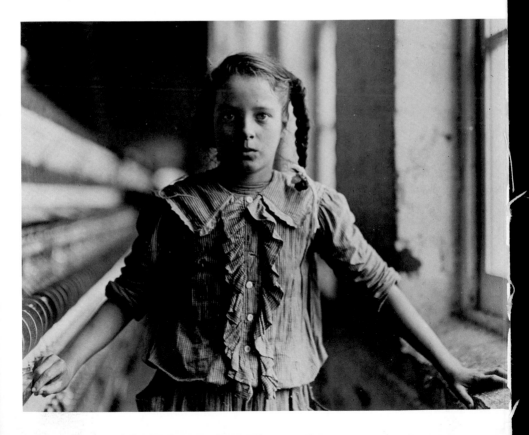

insight into the social hierarchies of the time.

By mid-century, portrayals of human experience were popular. Street photography of the urban working classes, homeless and unemployed was a growing trope. Oscar G Rejlander's *Night in Town* (c 1860) has become emblematic of the sentimentalised approach to this subject.

In *London Labour and the London Poor* (1851), social reformer Henry Mayhew illustrated interviews with street traders with engravings based on Richard Beard's daguerreotypes. The invention of the photomechanical Woodburytype process in 1866, however, introduced a successful method of reproducing photographs for publication at a quality and detail close to the original. This fidelity benefited politically motivated projects such as *Street Life in London* (1877) by Adolphe Smith and photographer John Thomson, where realism and accuracy were vital in drawing attention to the social injustices they described.

In the US, Jacob Riis and Lewis Hine produced the most extensive bodies of 'concerned photography'. Riis, a social reformer and police reporter for the *New York Tribune*, made thousands of images of the city's slums, eventually published accompanied by descriptive text in *How the Other Half Lives* (1890). He adopted a no-holds-barred approach to elicit an empathetic response from the middle and upper classes, galvanising their charity and support for his campaigns to improve housing, parks and sanitation.

As a staff photographer for the National Child Labor Committee, Hine recorded instances of children working in factories, mills and mines. His captioned images successfully supported campaigns to eradicate child labour. In contrast, in his 'worker portraits' produced throughout the 1920s he presented the relationship between man and machine in a positive light, imbuing his subjects with dignity and pride. This was a marked change from the pitying tone that characterised earlier works in this trope and a major influence for subsequent generations who would fully cohere the documentary style in the 1930s.

← **LEWIS HINE**
Adolescent Girl, a Spinner, In a Carolina Cotton Mill, 1908
Princeton University Art Museum, New Jersey

The industrial boom following the American Civil War was accompanied by a surge in child labour. Hine's photographs, accompanied by detailed, factual descriptions, helped bring about reform. The girl's direct gaze conveys a sense of agency characteristic of his tendency to emphasise the individual behind the story.

OTHER WORKS

ROBERT ADAMSON AND DAVID OCTAVIUS HILL
Two Newhaven Fishwives, Perhaps Mrs Elizabeth (Johnstone) Hall on the Right, from *The Fishermen and Women of the Firth of Forth*, c 1843–47
National Galleries of Scotland, Edinburgh

LEWIS HINE
Steamfitter, 1920, from *Men at Work*, 1932
Museum of Modern Art, New York

OSCAR G REJLANDER
Night in Town, c 1860
George Eastman Museum, Rochester, New York

JACOB RIIS
Lodgers in Bayard Street Tenement, Five Cents a Spot, 1889, from *How the Other Half Lives*, 1890
Museum of Modern Art, New York;

JOHN THOMSON
The Crawlers, from *Street Life in London* (photobook), 1877
Victoria and Albert Museum, London

 Travel, Expedition & Tourism; Early Street; Social Realism; Street & Society

 The Nude; Still Life; Futurism; Dadaism; Surrealism; Subjectivism

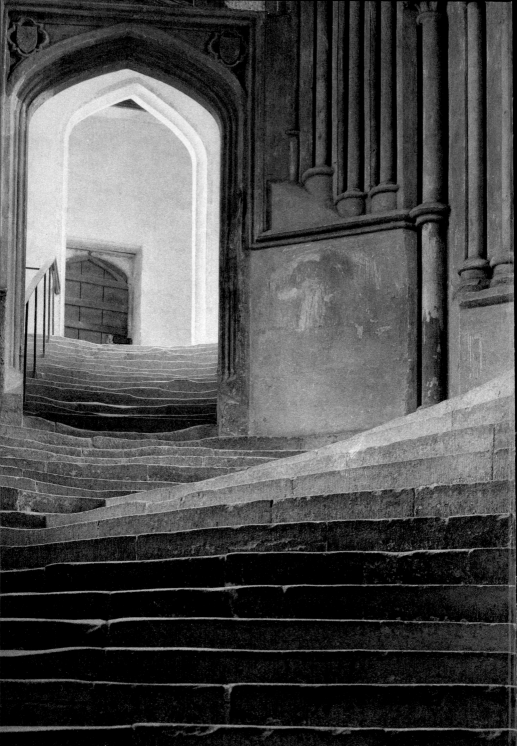

2

INTO THE MODERN
1850s–1930s

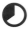 With the advent of photographic processes that made it more feasible for the photographer to work outside the studio, the camera soon played a significant role in documenting, and reflecting upon, street life.

EUGÈNE ATGET (1857–1927); **BILL BRANDT** (1904–83); **BRASSAÏ (GYULA HALÁSZ)** (1899–1984); **HENRI CARTIER-BRESSON** (1908–2004); **ANDRÉ KERTÉSZ** (1894–1985)

archetypes; ephemeral; formalism; urban; voyeuristic

While photographers had made cityscapes since the medium's very earliest days, it was in the late-19th century – with the introduction of smaller cameras, lenses with shorter focal lengths, and film sensitive enough to record in low or fleeting light – that they first began to capture the activity that took place there. Scenes of street life became a major subject.

Some of the earliest street photography, made in the 1850s by Charles Marville and Charles Nègre, featured scenes of Parisian architecture and local characters. Later, street archetypes such as beggars, organ-grinders and shoeshiners also became key subjects for photographers including Alice Austen and Paul Strand in New York, Paul Martin in London, and Eugène Atget in Paris. Their images were often unsentimental, and did not offer socio-

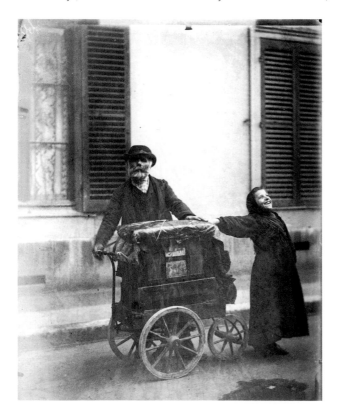

← **EUGENE ATGET**
Organ Grinder, 1898
The Metropolitan Museum of Art, New York

Among the 8,000 negatives that comprised the vast archive of images that Atget called his 'documents for artists' were studies of street traders. In most he depicted them as anonymous 'types', but in this image he allows their characters to shine.

↘ **BRASSAÏ**
Pont Louise-Philippe Seen through the Pont Marie (Le Pont Louis-Philippe vu à travers le Pont Marie), c 1935
Victoria and Albert Museum, London

Brassaïs view is a study in texture, form and composition, but loaded with atmospheric intensity. Here he used a flashbulb to accentuate the light reflected from the water, creating this gloomy and ominous effect.

advocated artistic expression over documentary photography and the amateur snapshot; and craftsmanship over photography's increasing industrialisation. The most active were the Camera Club of Vienna, the Photo-Club de Paris and the UK's Brotherhood of the Linked Ring, which admitted foreign members, including US photographers Alfred Stieglitz, Clarence H White and F Holland Day. With this level of activity came the shift from 'pictorial photography' (a style) to 'Pictorialism' (a movement), which gathered momentum internationally. In Japan and Australia, the exhibition of works by British and Viennese Pictorialists in the late 1890s helped cohere the inclination towards artistic photography there, and the movement flourished in these countries, as elsewhere, through official societies, amateur camera clubs, journals and annual salons.

In the US, the movement was spearheaded by Stieglitz and likeminded peers including White, Gertrude Käsebier, Edward Steichen and Alvin Langdon Coburn, who broke away from the Camera Club of New York in 1902 to form the Photo-Secession. Stieglitz promoted their vision in his luxurious, subscription-only quarterly *Camera Work*, and showcased members' work at his Manhattan exhibition space Little Galleries of the Photo-Secession (later known as 291).

The prominence of Käsebier, Eva Watson-Schütze and Anne Brigman within the Photo-Secession reflects the significant role that Pictorialism played in establishing a platform for the female artist-photographer. The movement was deemed appropriate for women because of its soft aesthetic and emphasis on beauty, and the belief that women possessed greater emotional insight than men and were therefore better portraitists. This idea was evinced in the reverence in which the expressive portraits by British photographer Julia Margaret Cameron were held.

Though Pictorialism's practitioners were united in their desire to elevate photography to the status of fine art, they did not have a shared aesthetic. This was due in part to the fact that the new photographic processes,

↖ **HENRY PEACH ROBINSON**
Fading Away, 1858
The Metropolitan Museum of Art, New York

Robinson made this tableau of a consumptive girl from five separate negatives. The constructed nature of the image and the evocative subject matter – Victorians attached a great deal of romanticism to tuberculosis, especially afflicted women – helped introduce the idea of artistic photography, paving the way for Pictorialism.

→ **EVA WATSON-SCHÜTZE**
Woman with Lily, 1905
George Eastman Museum, Rochester, New York

Watson-Schütze trained as a painter, but it was in photography that she found an outlet for creative expression. She was held in high regard for prints such as this, where gentle subject matter is matched by the softness of light and tone that result from her mastery of the platinum print process.

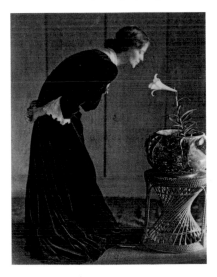

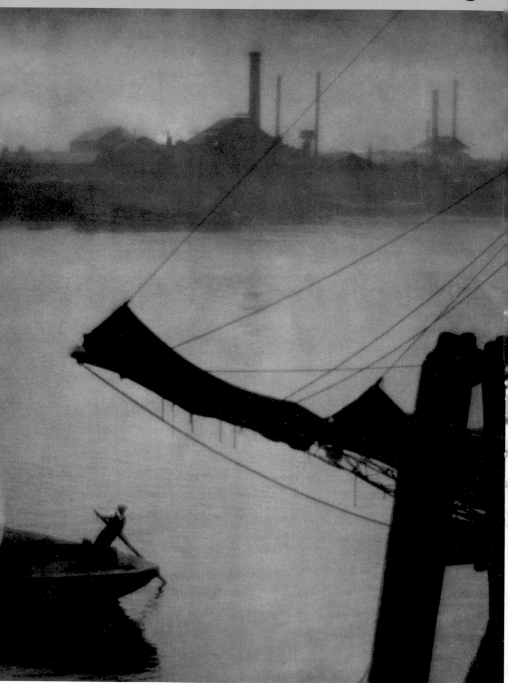

which its practitioners prided themselves in refining, created very different effects. Many embraced oil, bromoil and gum-bichromate processes that allowed for manipulation on the negative or print to create painterly effects, with visible brushstrokes where emulsions or inks had been applied. Robert Demachy, for instance, mastered the soft, pastel-like look of the gum-bichromate process. Detractors called the images 'fuzzygraphs'. Heinrich Kühn achieved success with Autochrome, creating colour images that bore the ebullient look of Impressionist paintings. While many embraced processes that mimicked paintings or drawings, however, others like Frederick H Evans were against manipulation. He preferred to take advantage of the delicate tones of the platinum process to emphasise the aesthetic quality of light.

Subject matter also varied greatly. Members of the Linked Ring like co-founder George Davison tended to favour gentle and often bucolic scenes; stylised nudes and portraits by Anton Josef Trcka and František Drtikol reflected the influences of Symbolism and Art Nouveau on Czech Pictorialist photographers; while the subject matter that US Photo-Secessionists explored could be as diverse as brooding nocturnal scenes (by Steichen), experimental staged portraits (by Holland Day), or painterly landscapes (by Coburn, among others). In Japan, Suizan Kurokawa sought to preserve the compositional style of Japanese painting, while some of his peers adopted Western aesthetics.

By the end of the 1910s and into the 1920s this lack of consensus about style and subject matter, together with the impact of the First World War, saw the leading Pictorialist groups disband, and many of the existing practitioners in Europe and the US gravitated towards the sharper aesthetic of

Modernist photography. This transition was not clear-cut, however, and in many countries including Czechoslovakia, Japan and Australia the two approaches coexisted, or appeared in a hybrid form, as late as the 1940s.

← **ALVIN LANGDON COBURN**
Wapping, 1904
George Eastman Museum, Rochester, New York

The diverse influences of Japanese woodblock printing and the painter James Abbott McNeill Whistler can both be seen in this view of the Thames, an example of the numerous dockland scenes Langdon Coburn made while living in England.

FREDERICK H EVANS (see p34)
A Sea of Steps, Wells Cathedral, 1903
Los Angeles County Museum of Art

Evans made many studies of cathedrals, often spending long periods of a time familiarising himself with the buildings to understand how sunlight illuminated the interiors at different hours. This was not intended as straightforward architectural study, but a poetic meditation on the beauty of the space.

OTHER WORKS

JULIA MARGARET CAMERON
Beatrice, 1866
Victoria and Albert Museum, London

HEINRICH KÜHN
Mary Warner and Lotte in the Meadow, c 1908
The Metropolitan Museum of Art, New York

GERTRUDE KÄSEBIER
The Manger (Ideal Motherhood), 1899
J. Paul Getty Museum, Los Angeles

EDWARD STEICHEN
The Pond – Moonrise, 1904
The Metropolitan Museum of Art, New York

CLARENCE H WHITE AND ALFRED STIEGLITZ
Torso, 1907, printed 1907–9
The Metropolitan Museum of Art, New York

 Negative-Positivism; The Studio Portrait; The Nude; Still Life; Subjectivism

 Futurism; Constructivism; New Objectivity; Industrialism; Group f.64

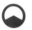

Between the 1880s and 1930s, photographic approaches to the nude shifted from studies that mimicked painting, to explorations with uniquely photographic ways to represent the body.

ANNE BRIGMAN (1869–1950); RUDOLF KOPPITZ (1884–1936); GEORGE PLATT LYNES (1907–55); OSCAR G REJLANDER (1813–1875); EDWARD WESTON (1886–1958)

académie; censorship; classicism; distortion; figuration

In photography's earliest years, the only form in which the nude was permitted was the *'études d'après nature'*, or 'study after nature'. Any other forms were deemed obscene. Photographers such as Félix-Jacques Moulins and Eugène Durieu posed their models in accordance with classical style to create images for use by academically trained artists. Often it was difficult for censors to distinguish between these *académies* and pornographic imagery.

Those who first explored photography as an art form, such as Oscar G Rejlander, approached the nude by adhering to the figurative tradition of Renaissance and Baroque painting. But by the end of the 19th century, the Pictorialist movement had opened up distinct new ways of picturing

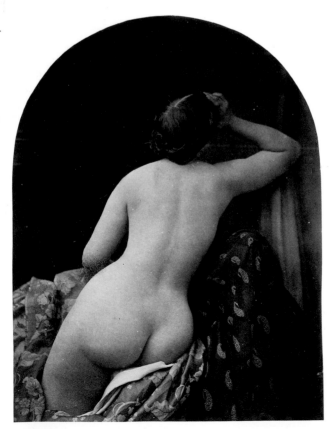

← **OSCAR REJLANDER**
Ariadne, 1857
National Gallery of Art, Washington DC

Rejlander created a series of nude studies based on paintings by Titian, Rembrandt and Rubens, among others, here replicating Titian's study of Venus in his *Venus and Adonis* (c 1555–60).

↗ **ANDRÉ KERTÉSZ**
Untitled (Distortion #40), 1933
J. Paul Getty Museum

Kertész used three parabolic mirrors and fitted his camera with an early zoom lens to flatten, twist and stretch the image of the female form.

the nude. Alice Boughton, for example, created picturesque compositions of women and children that appealed to the Victorian affinity for narrative. Anne Brigman spent days camping out in the Sierra Nevada as preparation for her dramatic, pagan-inspired compositions of women in nature. Robert Demachy isolated the body from the composition

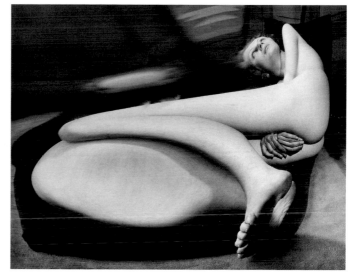

to focus solely on the figure, which he aestheticised by using print processes that created gestural brushstroke-like effects.

Into the 20th century, Western photographic approaches to the nude evolved against a backdrop of social and cultural change that included women's emancipation and changes in censorship laws. Isadora Duncan's pioneering modern dance also stimulated new attitudes to the body and comportment, embracing a more instinctive mode of expression. Some of the strongest articulations of the 'modern body' were made by František Drtikol and Rudolf Koppitz during the early 1920s. They arranged their dancer-models into dynamic poses that emphasised their muscular definition and suggested strength and energy; controversially, Drtikol did not retouch his negatives to remove signs of pubic hair. Around the same time, Germaine Krull made female nudes and mises en scène inspired by cabaret culture, which suggested changing attitudes to notions of women's sexuality.

A very different approach to picturing the nude prevailed within so-called 'straight photography'. Photographers associated with this style, like Edward Weston and Imogen Cunningham, were interested in the camera's ability to capture subjects with graphic detail and precision. Approaching the body as they did any other subject, they celebrated the camera's ability to render the flesh 'as hard as steel', as Weston described it, and often used tight crops to concentrate on particular curves and folds. That Cunningham titled a close-up study of breasts Triangles (1928), reflects how it was shape and form that were of primary interest.

One of the most significant moments in the evolution of the photographic nude during the 20th century was the Surrealists' departure from realistic depictions of the body. The group was stimulated by psychological theories that proposed new ways of thinking about the self and the unconscious mind. They were also interested in how African and Oceanic cultures

represented the body. Photographers including Man Ray and Maurice Tabard used darkroom techniques including solarisation, *brûlage* and double exposure to manipulate physical form and sometimes posed models so as to hide limbs, suggesting dismemberment. In some instances these distortions appeared macabre, even sinister; in others, as in Man Ray's famous *Ingres's Violin* (1924), where he painted the shape of violin F-holes onto his photograph of a woman's back, they read as playful subversions of the classical nude.

Surrealist approaches to the human figure endured long after the movement officially dissolved. Some of the most significant photographic studies of the male nude were the Surrealist-inflected works made by Herbert List, George Hoyningen-Huene and George Platt Lynes during the 1930s. They staged otherworldly, dreamlike scenes with men arranged in classical poses or among Greco-Roman style sculpture.

The legacy of the 'Surrealist body' also continued in the work of those who experimented with darkroom or in-camera techniques to depict the body in unconventional ways. Heinz Hajek-Halke, a leading figure in Subjectivism, featured the nude in highly stylised, enigmatic scenes made using combination and negative printing. André Kertész and Bill Brandt, a former assistant of Man Ray, both made Surrealist-inspired distorted female nudes. Kertész first made his on commission for satirical magazine *Le Sourire* (1899–1940) in 1933 using zoom lenses and mirrors to twist, magnify and compress the image of the female form. Brandt's, made between 1945 and 1978, were less uncanny and more mysterious, created with an antique camera that produced curious perspectives.

While the nude endured as one of the most important subjects in photography, it was the experiments with figuration and abstraction that took place in the early and modern period that established what it meant to make a purely 'photographic nude' and so laid the foundations upon which subsequent generations would work.

→ **RUDOLF KOPPITZ**
Movement Study (Bewegungsstudie), 1925
Victoria and Albert Museum, London

Koppitz made several nude studies with dancers from the Vienna State Opera. The fluid pose, enigmatic cloaked figures and tight, decorative composition were redolent of the decadence and drama of Art Nouveau and Symbolism.

OTHER WORKS

BILL BRANDT
Nude; Campden Hill, London, 1956, printed 1976
Victoria and Albert Museum, London

ANNE BRIGMAN
The Storm Tree, 1911
Museum of Fine Arts, Houston

ANDRÉ KERTÉSZ
Untitled (Distortion #48), c 1932–33
Art Institute of Chicago

GERMAINE KRULL
Standing Female Nude (Nu Féminin Debout), 1929
Centre Pompidou, Paris

GEORGE PLATT LYNES
The Sleepwalker, 1935
The Metropolitan Museum of Art, New York

EDWARD WESTON
Nude, 1936
Center for Creative Photography, Tucson, Arizona

◉ Pictorialism; Still Life; Surrealism; Group f.64; Postwar Fashion

◒ New Objectivity; Industrialism; Satirism; New Formalism

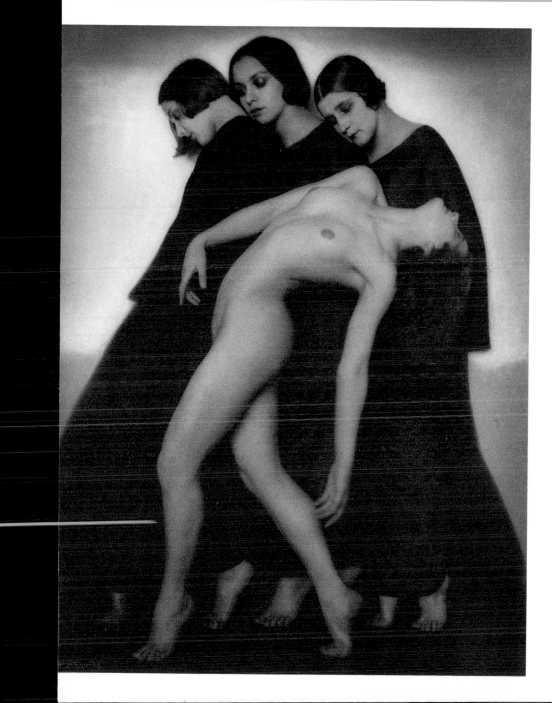

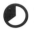

Fashion photography established itself with the birth of high-end society magazines in the 1910s. By the 1930s, the genre was transformed by colour photography and outdoors shoots.

CECIL BEATON (1904–80); LOUISE DAHL-WOLFE (1895–1989); HORST P HORST (1906–99); ADOLPH DE MEYER (1868–1946); EDWARD STEICHEN (1879–1973)

aristocracy; artificial lighting; outdoors; Surrealism; theatrical

The introduction of half-tone printing processes in the early 1890s made it possible to reproduce photographs in print. The fashion press flourished in the 1910s as Condé Nast relaunched *Vogue* (1892–) and *Vanity Fair* (1913–36; 1983–) as high-end fashion monthlies, and Hearst did the same with *Harper's Bazaar* (1867–).

Vogue's first staff photographer was Adolph de Meyer. Appointed in 1914, his images of actresses, dancers and aristocrats characterised 'a new social movement': the cosmopolitan coming-together of members of fashionable society with figures from literature, theatre and the visual arts. His work influenced another photographer celebrated for his portraits of society's elite, Cecil Beaton, who became renowned for his glittering portraits of debutantes and Hollywood stars posed in fantastical costumes and elaborate sets.

De Meyer's aesthetic was distinctly Pictorialist, flattering his sitters in a romantic haze created by his mastery of artificial lighting. When Edward Steichen was made Condé Nast's chief photographer in 1923 – a year after De Meyer decamped to *Harper's Bazaar* – he introduced a bold new look that reflected the glamour of Art Deco style.

One of the most exciting aspects of fashion photography in the late 1920s and 1930s was its crossover with the artistic avant-garde. Some of the most important images made by Surrealist photographer Man Ray, like *Black and White* (1926), were made on assignment for French *Vogue*. Erwin Blumenfeld adapted his Dada-influenced use of distortion and manipulation to a commercial context. Horst P Horst made fetishistic portraits, photographed stage costumes by Salvador Dalí and used studio sets and model poses that echoed the Surrealist affinity for classical themes.

The creative reign these photographers had was made possible only by the editors and art directors who employed them. Alexey Brodovitch was one of the most visionary art directors of his generation. He used unconventional layout and crops, and worked with the most innovative photographers. These included Martin Munkácsi, who took advantage of new point-and-shoot technology to photograph outdoors, and Louise Dahl-Wolfe, whose embrace of Kodachrome film and location shoots helped pioneer the use of colour while conveying the idea of the independent, worldly woman.

OTHER WORKS

HORST P HORST
Mainbocher Corset, 1939
Victoria and Albert Museum, London

ADOLPH DE MEYER
Dolores Modeling, 1921
International Center of Photography, New York

MARTIN MUNKÁCSI
The First Fashion Photo for Harper's Bazaar (Lucile Brokaw), 1933
Hungarian Museum of Photography, Kecskemét

EDWARD STEICHEN
Gloria Swanson, 1924
The Metropolitan Museum of Art, New York

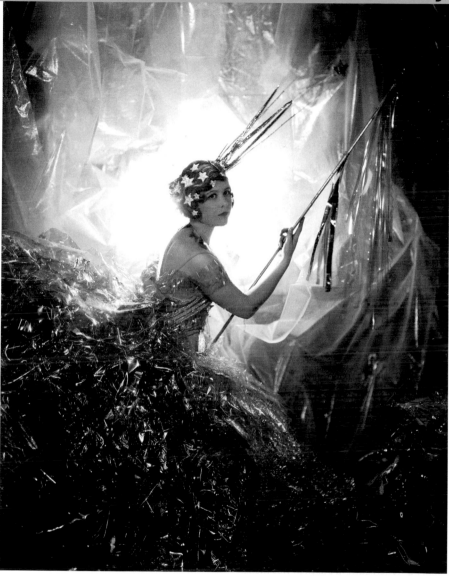

CECIL BEATON
Miss Nancy Beaton as a Shooting Star, 1928
Victoria and Albert Museum, London

Early in his career, Beaton often used his sisters
Nancy and Baba in place of models and actresses.
Here, Nancy is wrapped in cellophane and illuminated
by a 1,000-watt bulb behind her head, to dazzling and
theatrical effect.

The Studio Portrait; Surrealism;
Postwar Fashion; Advertising
& Fashion

Daguerreotypy; Futurism;
Constructivism; The Social Document;
Industrialism

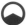 The arrangement of inanimate objects enabled photographers to experiment with composition, lighting, and reproduction of texture and form. In the modern period it was used to demonstrate photography's inherent qualities and transformed advertising.

 ROGER FENTON (1819–69); FLORENCE HENRI (1893–1982); PAUL OUTERBRIDGE (1896–1958); PAUL STRAND (1890–1976); THOMAS RICHARD WILLIAMS (1824–71)

advertising; communication; object study; spatial composition; vanitas

The long exposure times of 19th-century camera technology made the still life a practical choice for photographers of the period. Among the earliest ever made is *Set Table* (1827) by Joseph Nicéphore Niépce. When the daguerreotype and calotype processes were introduced just over a decade later, their respective inventors used the still life to demonstrate their efficacy.

During the 1850s the still life was used primarily as a documentary resource. Roger Fenton spent around five years cataloguing objects in the British Museum's collection, which informed the highly popular compositions of antiques and fruit that he made in an independent capacity. The use of the still life in this regard was also seen in studies that were created for art and design, like Adolphe Braun's *Photograph of Flowers* (1855), a catalogue of 300 still lifes made for textile manufacturers.

Many early photographers who used the still life as a means of artistic expression did so by borrowing from the traditions of painting. Flora, fauna, fruit, musical instruments and objets d'art all featured in compositions that recalled still-life paintings made in Northern Europe between the 16th and 18th centuries. Thomas Richard Williams's daguerreotype *The Sands of Time* (c 1850–55), which included an hourglass, book, compass and skull, is an exemplar of how photographers interpreted vanitas paintings, where objects were arranged to symbolise the futility of life's pleasures against the certainty of death.

From the 1880s photographers became less inclined to replicate history painting. Instead they made scenes in a style akin to

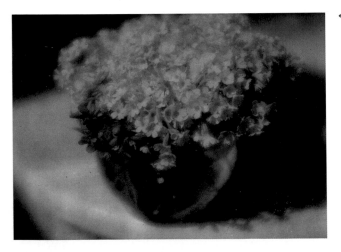

← HEINRICH KÜHN
Flowers in a Bowl,
c 1908–10
The Metropolitan Museum of Art, New York

The still life is well-suited to experiment with new processes and techniques. The floral arrangement lent itself to the saturated palette and soft effect created by the early colour process Autochrome.

→ **FLORENCE HENRI**
Jeanne Lanvin, 1929
Victoria and Albert Museum, London

Henri placed the Lanvin perfume bottle on its side between two mirrors to create an intriguing, but confusing, multiplied effect. Henri was influenced by movements such as Cubism and Constructivism, and translated their concern with perspective into experimental still lifes.

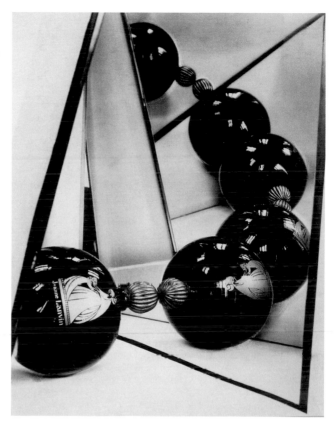

the Impressionist movement of the time. Edward Steichen and Adolph de Meyer were among those who focused on subject matter such as bowls of fruit or floral arrangements. These subjects were also seen in the first examples of colour still lifes: vibrant Autochrome studies by Frederick S Dellenbaugh and Heinrich Kühn.

Into the 20th century, some artists associated with movements such as Dada and Surrealism utilised the photographic still life as a site for communicating artistic agenda. But for many others, like Paul Strand, the still life was purely a means of exploring style, process and technique. Alfred Stieglitz, who

was responsible for introducing European avant-garde art stateside via his gallery, 291, and journal, *Camera Work*, regarded Strand's work as the epitome of modern photography.

At the Bauhaus school of design in Germany object studies were used as an important exercise in understanding the rudiments of spatial composition, lighting and form. Photographs by Walter Peterhans (a Bauhaus director), Iwao Yamawaki and Horacio Coppola, for example, reveal how objects were selected simply for their shape or texture. Florence Henri's use of mirrors and prisms represented how avant-garde photographers interpreted the interest in

perspective and perception that was being explored elsewhere in modern art.

Also in Germany, manufacturers embraced the precise aesthetic of the New Objectivity movement. This emphasis on clarity and precision was echoed in the US, where industrial still lifes by practitioners such as Ralph Steiner imbued metal, steel and plastic with a hard-edged glamour communicating the spirit of the Machine Age. Like many of the photographers who shot product advertisements at that time, such as Paul Outerbridge and Margaret Watkins, Steiner was an alumnus of the Clarence H White School of Photography, whose curriculum was transformative in applying artistic principles to commercial training.

Demand for advertising photography was booming in the 1920s thanks to the rise of the illustrated press and mail-order catalogues, and White's school, like the Bauhaus, fostered a generation of photographers who worked in both artistic and commercial capacities. Meanwhile, organisations such as the New York-based Art Directors Club promoted 'artistic excellence' in advertising, helping to establish photography as the first truly modern art form. It was also through the pages of magazines like *House Beautiful* (1896–) and *McCall's* (1872–2002) that colour photography first reached a wide audience, in the synthetic palette of images made by the few photographers, including Outerbridge and Nickolas Muray, who had mastered the complex and labour-intensive tricolour carbro process.

Outside of commerce, the still life endured as a means of expressing artistic conceits. In the 1930s, Edward Weston made luminous studies of natural objects that demonstrated his belief that all forms were equal. In the 1940s and 1950s,

photographers associated with Subjectivism in the US, like Frederick Sommer and Minor White, used the still life to explore darker, psychological subject matter: White through close-up and high contrast; Sommer through graphic and visceral depictions of animal and human artefacts that he referred to as 'biological still lifes'.

↔ **PAUL STRAND**
Abstraction, Porch Shadows, Connecticut, 1916
Museum of Modern Art, New York

Strand used a tight crop and oblique angle to transform this image of a porch table into a study of light and form. His peers regarded this as one of the first truly modern photographs.

OTHER WORKS

ADOLPHE BRAUN
Wreath: Apple Blossom, Rhododendron, Lilies of the Valley, c 1855
Victoria and Albert Museum, London

HORACIO COPPOLA
Still Life with Egg and Twine, 1932
Museum of Modern Art, New York

ROGER FENTON
Still Life with Fruit and Decanter, 1860
J. Paul Getty Museum, Los Angeles

PAUL OUTERBRIDGE
Ide Collar, 1922
Museum of Modern Art, New York

THOMAS RICHARD WILLIAMS
The Sands of Time, c 1850–55
J. Paul Getty Museum, Los Angeles

 Pictorialism; Bauhaus & the New Vision; New Objectivity; Industrialism; New Formalism

 Survey; Motionism; Early Street; Street & Society

Futurism

Futurism's early leaders were hostile towards photography, which they saw as a static medium. Despite this, by the 1930s the movement's second generation had heralded new waves of experimental practices that connected Italy with an international avant-garde.

ANTON GIULIO AND **ARTURO BRAGAGLIA** (1890–1960/1893–1962); **FORTUNATO DEPERO** (1892–1960); **TATO (GUGLIELMO SANSONI)** (1896–1974); **WANDA WULZ** (1903–84)

motion; photodynamism; photomontage; speed

Futurism was launched in 1909 with the publication of poet Filippo Tomaso Marinetti's *The Founding and Manifesto of Futurism*. In impassioned rhetoric, he proposed a cultural revolution in which he espoused the glory of war, beauty of speed and love of danger. Futurism's central tenet was 'universal dynamism': the idea that the world is in constant motion.

Futurists expressed their ideas across art and design, poetry and performance. But for many, the idea of Futurist photography was anathema: how could a medium that froze a moment in time be assimilated into a style based upon perpetual movement?

This challenge was taken up by brothers Anton Giulio and Arturo Bragaglia, who invented 'photodynamism': the use of a flash gun and long exposure to trace an object's movement through space. In three treatises published between 1911 and 1913, they explained that photodynamism set out to represent synthesis. Form was dissolved into a blurred and voluminous mass of motion that suggested the psychological imperative behind the action.

Marinetti's revival of Futurism after the First World War saw the movement affiliated with fascism. While photography was not used as a revolutionary tool per se, artists such as Mario Castagneri and Marcello Nizzoli used montage, multiple exposure and graphics to depict the regime's ideals of speed, efficacy and strength. Beyond collusion with political parties, the movement's 'second generation' established a viable place for photography, bolstered in 1930 by Marinetti and Tato's *Manifesto of Futurist Photography*. Tato, Vinicio Paladini, Ivo Pannaggi, Bruno Munari and Wanda Wulz created photo-collages and photomontages that variously foreground machinery, technology, sport and the expression of the inner self. Filippo Masoero's *aerodinamisimo* involved him leaning out of a propellor plane to dynamise city views.

→ **ANTON GIULIO BRAGAGLIA**
The Bow, 1911
The Metropolitan Museum of Art, New York

This photodynamic study of a bow uses long exposure with flash to trace the full trajectory of the gesture to dematerialise the body. Revealing movement in continuum, as opposed to a sequence of discrete actions, expressed the Futurist interest in the world in perpetual motion.

OTHER WORKS

FORTUNATO DEPERO
Self Portrait with Fist (Autoritratto con Pugno), 1915
Museo di Arte Moderna e Contemporanea di Trento e Roverto, Italy

TATO
Central Weights and Measures, 1932
Museo di Arte Moderna e Contemporanea di Trento e Roverto, Italy

WANDA WULZ
Cat + I (Lo + Gatto), 1932
Museo Nazionale Alinari Della Fotografia, Florence

Motionism; Constructivism; Dadaism; Bauhaus & the New Vision; Surrealism

Pictorialism; Group f.64; Postwar Fashion; Conceptualism; New Topographics

Constructivism

After the 1917 Russian Revolution, a distinctive style of photography emerged to use the medium to convey socialist ideology. The avant-garde believed that photography was better suited to proletariat society than traditional art forms.

BORIS IGNATOVICH (1899–1976); **GUSTAV KLUTSIS** (1895–1938); **EL LISSITZKY** (1890–1941); **ALEXANDER RODCHENKO** (1891–1956); **GYORGY ZELMA** (1906–84)

avant-garde; dynamic; ideology; photomontage; revolutionary

Revolutionary photography in the Soviet Union was propelled by Constructivism. Guided by the idea of *faktura* – looking to a material's inherent properties to exploit its fullest potential – artists and designers developed new approaches to photography to convey

socialist ideology. Gustav Klutsis, El Lissitzky and Alexander Rodchenko were among the key proponents.

Like the Dadaists, these artists embraced photomontage to express political messages to a wide audience. Klutsis made the first Soviet montage in 1918 and collaborated often with his wife, designer Valentina Kulagina, to make propaganda posters using this technique, such as *Electrification of the Entire Country* (1920), made in support of Lenin.

Lissitzky, too, was known for photomontage, as well as photograms that he made by layering negatives to superimpose images. His technique was informed by his time in Berlin as a cultural attaché. There, his association with the circles around László Moholy-Nagy helped define the Modernist New Vision. It also propagated international Constructivism, seen for instance in the work of the Polish group Blok.

Kazimir Malevich's Suprematism had been a formative influence on many associated with Russian Constructivism, though they later rejected its 'art's for art's sake' ethos. It was on these grounds that Rodchenko renounced painting for photography in 1921. Those involved with the *Left Front of the Arts (Lef)* magazine (1923–25), whose covers Rodchenko designed, and the photographic section of the October group that he founded with Boris Ignatovich in 1930, represented the vanguard of Soviet Art and Design.

Inspired by film, typical techniques were the use of dynamic angles and foreshortening to transform how viewers 'read' everyday scenes. These were adopted to some extent by the other main photography group at that time, the Russian Association of Proletarian Photographers (ROPF).

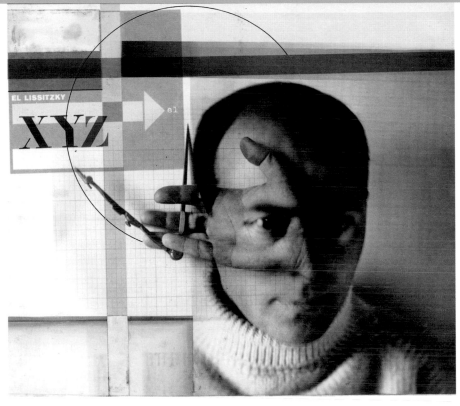

EL LISSITZKY
Self-Portrait (The Constructor), 1924
State Tretyakov Gallery, Moscow

Lissitzky photographed himself and his hand, layered the negatives, and exposed them at the same time. He combined this with a photogram reproduction of his letterhead, and then glued on rectangular shapes.

ALEXANDER RODCHENKO
Fire Escape, from *Building on Miasnitskaia Street,* 1925
San Francisco Museum of Modern Art

Rodchenko advocated the use of dynamic 'worm's-eye' and 'bird's-eye' viewpoints to distort scale and perspective. Here, this transforms a depiction of a fire escape into a graphic study of line and form.

OTHER WORKS

BORIS IGNATOVICH
Dynamo, 1930
Spencer Museum of Art, Lawrence, Kansas

EL LISSITZKY
Runner in the City, c 1926
The Metropolitan Museum of Art, New York

ALEXANDER RODCHENKO
Osip Brik, 192,
Pushkin State Museum of Fine Arts, Moscow

GYORGY ZELMA
Gorky Park, 1931
Spencer Museum of Art, Lawrence, Kansas

 Futurism; Dadaism; Bauhaus & the New Vision; Social Realism

 Pictorialism; Fashion & Society; Celebrity & Paparazzism; Diarism

Dadaism

An artistic standpoint adopted across Europe and in New York during the First World War as those who were disillusioned by the values of modern society sought to attack them through provocative acts and cultural propaganda.

 RAOUL HAUSMANN (1886–1971); JOHN HEARTFIELD (1891–1968); HANNAH HÖCH (1889–1978); MAN RAY (1890–1976); CHRISTIAN SCHAD (1894–1982)

 anti-art; disorder; photogram; photomontage; political

In 1916, writers Hugo Ball and Emmy Hennings formed the Cabaret Voltaire nightclub in Zurich. Away from the activity of the war, writers and artists including Tristan Tzara, Richard Hülsenbeck and Sophie Taeuber (later Taeuber-Arp) participated in exhibitions and experimental performances. The raucous gatherings embraced nonsense, noise and chance as a form of attack against modern society. At the same time, the idea of what an artwork was and could be were being overturned by Dada's New York faction: Man Ray, Marcel Duchamp and Francis Picabia. After the war, Dada cohered in groups in Paris and across Germany.

These groups reacted against 'accepted' forms of art. 'The Dadaist considers it necessary to fight against art, because he has seen through its fraud as a moral safety valve,' wrote Hülsenbeck in 1920. Photography, certainly not accepted as an art form by the bourgeoisie, was thus an apt media for the radical avant-garde.

The photogram appealed because the technique demanded that the artist embrace the accidental, and created a disordered, often dreamlike aesthetic. Key proponents were Zurich-based Christian Schad; and Man Ray, who experimented with this technique after moving to Paris in 1921. The 'schadographs' were rough-hewn objects made by arranging scraps of found materials on light-sensitive paper left to expose on a windowsill. The 'rayographs' were more polished, made by carefully controlling exposure to light to achieve the desired level of abstraction.

As with all the art forms they used, the Dadaists' approach to photography ranged in tone from the irreverent – as exemplified in the photogram – to the anarchic. In Berlin, the most political of the Dada groups – John Heartfield, Hannah Höch and Raoul Hausmann – extended the Cubist collage to pioneer photomontage. They used it as a dissident tool, splicing images from newspapers and magazines to make satirical statements about Weimar culture. Later, Heartfield's radically anti-fascist works put him on the Gestapo's 'most wanted' list.

The beginning of the 1920s marked the decline of Dada as many members turned to André Breton's Surrealism. By 1924, the Dadaists had in effect wiped the slate clean for art, and laid the foundations for cultural provocation that would emerge again in earnest in the postmodern era.

OTHER WORKS

JOHN HEARTFIELD
Adolf, the Superman, Swallows Gold and Spouts Tin, 1932
The Metropolitan Museum of Art, New York

HANNAH HÖCH
Untitled, 1929, from *An Ethnographic Museum*, 1925–30,
Museum für Kunst und Gewerbe, Hamburg

MAN RAY
Rayograph, 1922
Museum of Modern Art, New York

CHRISTIAN SCHAD
Schadograph, 1918
Museum of Modern Art, New York

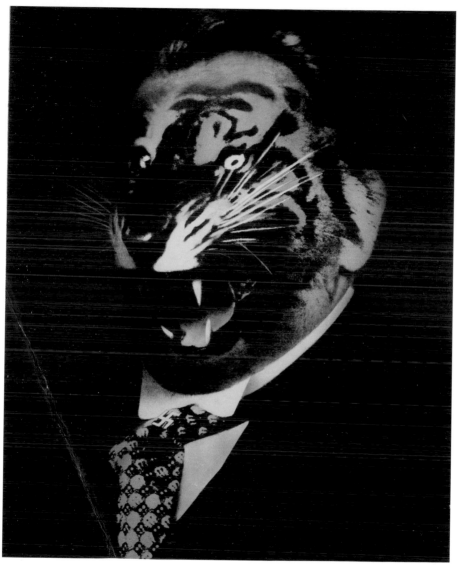

↑ **JOHN HEARTFIELD**
On the Crisis Party Congress of the SPD, 1931
Akademie der Künste, Berlin

Heartfield's collaging of a growling tiger's head with a portrait of a man who represents a Social Democratic Party politician was intended as an attack on the SPD's capitalist allegiance.

 Futurism; Constructivism; Bauhaus & the New Vision; Surrealism; Postmodernism

 The Studio Portrait; Survey; Pictorialism; Group f.64; Social Realism

Bauhaus & the New Vision ⬤MV

← LÁSZLÓ **MOHOLY-NAGY**
Berlin, Radio Tower, 1928
Museum of Modern Art, New York

The revolutionary effects of technology on one's perception and experience of the world were at the heart of Moholy-Nagy's New Vision.

→ **GYÖRGY KEPES**
R with Compass, c 1939–40
Tate, UK

Kepes was renowned for his integrative approach to art, science and technology. He experimented widely with the effects created by exposing objects with different material properties directly onto photographic paper. Here, the prism creates a soft translucent effect; the compass a hard graphic outline that is echoed in the painted-on letter 'R'.

⬤ Characterised by dynamic perspectives and experimental techniques, the New Vision, coined by László Moholy-Nagy, utilised various avant-garde 'isms' to shape a new visual language that reflected modern society.

⬤ GYÖRGY KEPES (1906–2001); LUCIA MOHOLY (1894–1989); LÁSZLÓ MOHOLY-NAGY (1895–1946); FRANZ ROH (1890–1965); IWAO YAMAWAKI (1898–1987)

⬤ avant-garde; experimentation; modernism; perspective; technology

⬤ In the years following the First World War, a new avant-garde emerged that sought to represent the energy and dynamism of the increasingly technological, mechanical and commercial world. The picture press, film industry and industrialised mass-printing methods created a newly photo-rich culture: fertile ground for photographers, artists and designers to innovate new forms and techniques.

The heart of this shift was Berlin, where the revolutionary zeal of Constructivism coalesced within a group of progressive

émigré artists. Among them were husband and wife Hungarian artist-writers László Moholy-Nagy and Lucia Moholy, who directed this spirit towards promoting a new photographic mode. Inspired by the radical re-presentations of reality offered by advances in scientific photography like X-ray and microphotography, their New Vision advocated the use of forms and techniques that would offer a different perspective on the world. This included the playful juxtaposing of 'straight' documentary images, dynamic worm's-eye and bird's-eye views, photomontage, and photograms – made without a camera by placing objects directly onto photographic paper and exposing it to light.

László Moholy-Nagy's teaching post as co-head of the preliminary course at the Bauhaus, Dessau, from 1923 located the art and design school as the epicentre of the photographic avant-garde despite the fact that photography was not taught as a dedicated course. His influence, coupled

with the school's integrated approach to art and industry, galvanised likeminded peers across different disciplines, such as graphic designers Franz Roh and Jan Tschichold. Their photobook *Photo-Eye* and Werner Gräff's *Here Comes the New Photographer!* (both 1929) were published around the landmark 'Film und Foto' touring exhibition that brought over a thousand international examples of New Vision (Modernist) photography to interntional audiences.

While the rise of fascism all but suppressed the activities of the New Vision in Europe, its momentum continued elsewhere. Former Bauhaus student Iwao Yamawaki was instrumental in promoting Modernist photography in Japan. In the US, where the New Bauhaus was founded in Chicago in 1937 (later the Institute of Design), director Moholy-Nagy and teacher György Kepes extended the influence of the early 20th-century avant-garde into a new technological era.

OTHER WORKS

GYÖRGY KEPES
Propeller, c 1939–40
Tate, UK

LÁSZLÓ MOHOLY-NAGY
Fotogramm, 1926
The Metropolitan Museum of Art, New York

FRANZ ROH
Lightbulb (Photogram) (Glühbirne [Fotogram]), 1928–33
Museum of Modern Art, New York

IWAO YAMAWAKI
Untitled (Modernist Architecture), 1932
Tate, UK

 Futurism; Constructivism; Dadaism; New Objectivity; Surrealism

Daguerreotypy; Travel, Expedition & Tourism; Survey; Pictorialism

New Obectivity (Neue Sachlichkeit) was an approach by artists and writers in Germany characterised by the impulse to depict the modern world as it is, without romanticism or artistic effect. In photography, this meant harnessing the camera's ability to capture the subject with absolute precision.

AENNE BIERMANN (1898–1933); KARL BLOSSFELDT (1865–1932); IMRE KINSZKI (1901–45); ALBERT RENGER-PATZSCH (1897–1966); AUGUST SANDER (1876–1964)

detachment; modernity; order; precision; typology; uniformity

Expressionism, the dominant artistic movement in Germany of the early 20th century, was firmly anti-realistic. New Objectivity reacted against this; instead, practitioners took a rigorous approach to light, shadow and perspective to focus attention on structure and form. Their response to the modern world supported new ideologies of the period that were based on order, industry and progress.

Albert Renger-Patzsch was one of the key photographers associated with New Objectivity. His 1928 book *The World is Beautiful* is considered to be the defining statement of the movement. Featuring singular images of plants, animals, historic and contemporary architecture, commercial still lifes and studies of craftsmen at work, it illustrated how the traditional sat alongside the modern, and nature alongside the industrial and man-made.

Key to this meticulous treatment of detail was the close-up perspective, as seen in the work of Aenne Biermann and Karl Blossfeldt. Biermann progressed from family portraits to objective still lifes after being commissioned by geologist Rudolf Hundt to make detailed photographs of minerals. In 1930, her book *60 Photos* was published.

Featuring Franz Roh's seminal essay 'The Literary Dispute about Photography', it positioned her in the photographic avant-garde.

Blossfeldt is known for his magnified studies of botanical specimens. He made cameras that enabled him to photograph in minute detail, usually working with large-format negatives because they retained greater definition when the image was enlarged, and often retouching the negative and print to achieve the desired uniformity. His work was championed by the Surrealists, who found a sense of the uncanny in the extreme close-up forms.

August Sander applied this emphasis on order to document German society. Between 1925 and 1927 he devised the concept for *People of the Twentieth Century,* a 'cultural work in photographs' that would eventually comprise thousands of portraits made between 1892 and 1954. He divided these into seven archetypes: The Farmer; The Skilled Tradesman; The Woman; Classes and Professions; The Artists; The City; and The Last People. This concept of cataloguing and classifying in a uniform manner came to be a defining characteristic of the New Objectivity movement, and Sander's typologies have influenced subsequent generations of photographers.

The fall of the Weimar Republic brought New Objectivity to an end, but not before its influence had reached beyond Germany as part of the international spread of the New Vision. Photographers associated with Hungarian and Czech avant-garde photo-clubs, such as Imre Kinszki and Jaromír Funke respectively, were among the many who experimented with its principles as part of the shift away from Pictorialism towards Modernism's cleaner aesthetic.

→ **ALBERT RENGER-PATZSCH**

Flat Irons for Shoe Manufacture, 1928

J. Paul Getty Museum, Los Angeles

Renger-Patzsch did not attempt to pictorialise the flat irons, but used the camera to intensify their material qualities – just as he did with natural forms. This study is a celebration of the uniformity and elegance of the man-made. It was taken the year he moved to Essen, where he earned his living from industrial commissions such as this.

OTHER WORKS

JAROMÍR FUNKE
Plates (Tálire), 1923–24
Museum of Modern Art, New York

KARL BLOSSFELDT
Equisetum hyemale, Rough Horsetail, Top of Shoot, before 1926
Universität der Künste, Berlin

AUGUST SANDER
Pastrycook (Konditor), 1928, from *People of the Twentieth Century,* 1892–1954
SK Stiftung Kultur, Cologne

 Still Life; Bauhaus & the New Vision; Surrealism, Group f.64; Düsseldorf Deadpan

 Pictorialism; Diarism; Satirism; Activism; Fictional Narrativism

Surrealism

Launched in Paris in 1924, Surrealism was influenced by new Freudian theory and centred on the desire to explore the unconscious mind. Photography's importance lay in its relationship to reality and ability to depict the dreamlike and the uncanny.

JACQUES-ANDRÉ BOIFFARD (1902–61); DORA MAAR (1907–97); MAN RAY (1890–1976); MAURICE TABARD (1897–1984); RAOUL UBAC (1910–85)

anthropology; appropriation; chance; darkroom experimentation; subconscious

Unlike Dadaism, Surrealism represented an intellectual rather than a social revolution. Led by André Breton, who published the *First Manifesto of Surrealism* in 1924, and influenced by Freud's theories of the unconscious, artists and writers seized upon techniques of automatism – the artistic equivalent of Freud's free association – as part of a liberation of the unconscious mind they believed was necessary to help revivify society after the First World War.

The belief that photography was an expression of the subconscious granted it an important place within the Surrealist movement. Much of the photography Surrealism claimed for itself included experimentation, the celebration of chance, odd juxtapositions and the found object, and the infusion of reality with the dreamlike and the uncanny. Images and text were disseminated in publications including Breton's *The Surrealist Revolution* (1924–29), *Minotaure* (1933–39), and Georges Bataille's *Documents* (1929–30).

Man Ray was one of the most prominent photographers associated with the movement. His use of innovative darkroom techniques, including combination printing, photograms (which he called 'rayographs') and solarisation – a technique he perfected with his studio assistant Lee Miller – all appealed to the Surrealist desire to move beyond reality. They were adopted by practitioners including Maurice Tabard and Raoul Ubac, the latter of whom is known for his use of *brûlage* (burning of the negative) to create violently distorted figures.

Explorations of the psychological led Surrealists to unearth the monstrous side of human existence. Dora Maar created disturbing scenes through unexpected combinations of everyday objects, oddly positioned figures and strange animals; Hans Bellmer made and photographed dolls twisted into nightmarish forms; while Grete Stern and Kati Horna's work included absurdist photomontages.

The darker side of human existence was also suggested through techniques of appropriation and defamiliarisation. Surrealist interest in the anthropological and scientific was evinced in various publications that recontextualised police and medical imagery, everyday snapshots, film stills and close-ups of biological matter in an uncanny and often uncomfortable light. For Hungarian photographer Brassaï, the human psyche revealed itself in discarded scraps of paper he called 'involuntary sculptures' and in graffiti found around the city.

This new emphasis on the psychological, the random, the spontaneous and the illogical had an immediate impact on approaches to the growing fields of advertising, fashion and street photography that endured long after the onset of the Second World War marked the official dissolution of the movement.

→ **DORA MAAR**
*The Simulator
(Le Simulateur)*, 1936
San Francisco Museum of Modern Art

Maar collaged a photograph of a boy onto an upside-down image of a corridor, then photographed the result. The confused orientation and the boy's contortion and scratched-out eyes create a nightmarish effect that is characteristic of her use of experimental techniques to provoke a sense of mental unease.

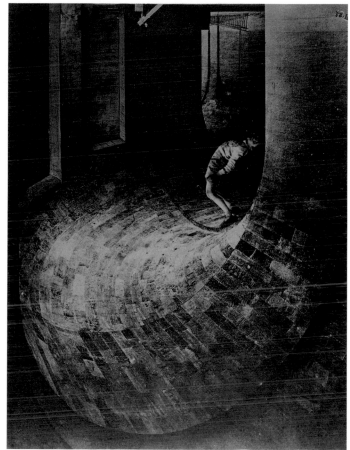

OTHER WORKS

JACQUES-ANDRÉ BOIFFARD
*Big Toe [Male Subject, 30 Years Old]
(Gros Orteil [Sujet Masculin, 30 Ans])*, 1929
Centre Pompidou, Paris

MAN RAY
Ingres's Violin (Le Violon d'Ingres), 1924
Centre Pompidou, Paris

MAURICE TABARD
Am I Beautiful?, 1929
Museum of Modern Art, New York

RAOUL UBAC
Le Conciliabule, 1938
Centre Pompidou, Paris

 The Nude; Fashion & Society; Dadaism; Bauhaus & the New Vision; Mexican Modernism

 New Objectivity; Social Realism; Photojournalism; The Family of Man; New Topographics

→ **MAN RAY**
Solarization, 1931

George Eastman Museum, Rochester,
New York

After accidentally discovering
solarisation with his assistant
Lee Miller, Man Ray pioneered
its artistic use by deliberately
overexposing film in the
darkroom, giving silvery
reversed tones and a halo-like
outline around the subject.
Applying this technique to
nudes and portraits, he
invested otherwise
straightforward images with
psychological charge.

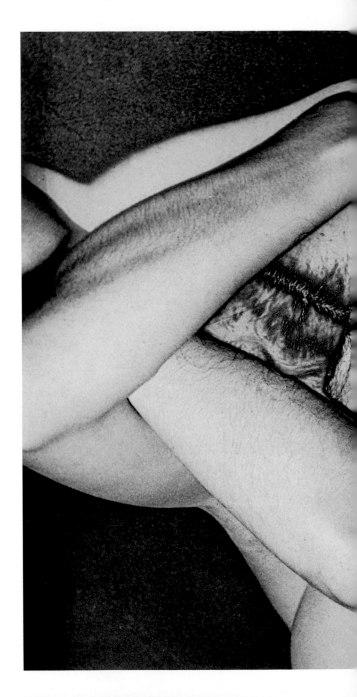

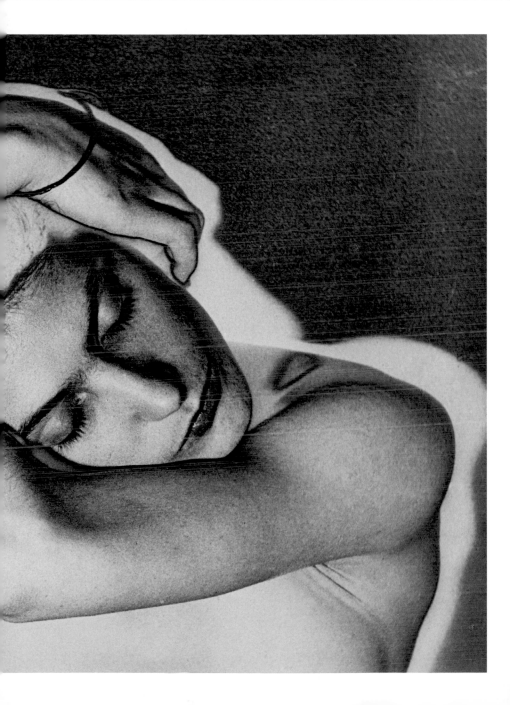

Following the Mexican Revolution, native and immigrant photographers documented the socialist plight, visualised a new Mexican identity, or conveyed their personal experiences, establishing the country as a key site for the progression of Modernist photography.

LOLA ÁLVAREZ BRAVO (1907–93); MANUEL ÁLVAREZ BRAVO (1902–2002); HENRI CARTIER-BRESSON (1908–2004); KATI HORNA (1912–2000); TINA MODOTTI (1896–1942)

cultural renaissance; identity; revolution; socialist; Surrealism

The years of social and political upheaval following the Mexican Revolution (1910–17) ignited a cultural renaissance. As the government commissioned Diego Rivera, José Clemente Orozco and David Alfaro Siqueiros, among others, to paint political murals to educate the masses, other artists and writers harnessed their medium to support the socialist cause and assert a new, uniquely Mexican, identity.

The fervour of this moment attracted many creatives and intellectuals from abroad, among them photographers Tina Modotti and Edward Weston, who settled there in 1923. Unlike her partner, Modotti used her camera to further the socialist cause, documenting proletariat demonstrations and indigenous communities and creating still lifes such as *Bandolier, Sickle, Corn* (1927) that symbolised the life of Mexican workers, some of which were published in communist journals including *El Machete* (1924–38).

Modotti's less political images also found an outlet in the cultural journal *Mexican Folkways* (1924–29). When she was deported in 1930, she handed over her role there to Manuel Álvarez Bravo, whose work became instrumental in visualising Mexican identity. While he occasionally chronicled political action – as in his famous *Striking Worker Assassinated* (1934) – Álvarez Bravo concentrated on everyday scenes; sometimes honing in on formal details, at other times foregrounding traditional themes and motifs. The Surrealists lauded his eye for the uncanny, but it was his skill as a documentarian that brought his work to an international audience. In 1934 and 1935 he showed in Mexico and New York alongside Henri Cartier-Bresson, who brought his own understanding of light, shadow and composition to street photographs of Zapotec culture.

Experimentation also formed an important strand of Mexican Modernism. Lola Álvarez Bravo pioneered photomontage in the country. Just as photographers had done in post-revolutionary Russia, she found that recombining images could communicate new social ideals. In dense collages – an aesthetic that echoed the style of Rivera et al's murals – she imagined the bustling modern metropolis and the future of the emancipated woman. Kati Horna's approach was similarly subversive. Hungarian-born, she moved in Surrealist circles in Paris and was a reportage photographer in the Spanish Civil War before being exiled to Mexico in 1939. She brought her experience of persecution and conflict to bear in theatrical staged portraits, as well as symbolic images that involved montage, negative reversal and combination printing, to reflect on the experience of political turmoil in a subjective, non-representational manner. Published in the Mexican press, they disseminated avant-garde photography to a broad audience.

→ **MANUEL ÁLVAREZ BRAVO**
Daughter of the Dancers / Muchachita!, 1933
J. Paul Getty Museum, Los Angeles

Bravo's composition leaves us to guess whether the *muchachita*, or young girl, is simply peering in through the wall of a colonial mansion, or engaged in conversation. The graphic shapes of the window, tiles and sombrero contrast with the drapery of her clothing and lilting pose, to poetic effect.

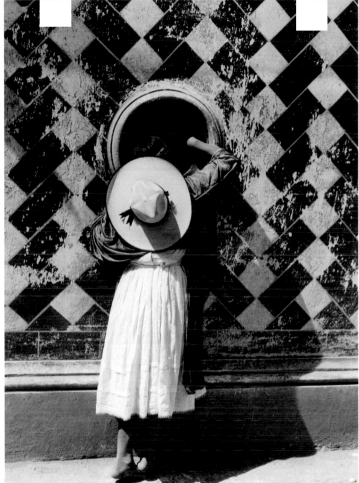

OTHER WORKS

LOLA ÁLVAREZ BRAVO
Architectural Anarchy in Mexico City, c 1954
Center for Creative Photography, Tucson, Arizona

HENRI CARTIER-BRESSON
Santa Clara, Mexico, c 1934–35
Museum of Modern Art, New York

KATI HORNA
Remedios Varo in a Mask by Leonora Carrington, 1957
Museum of Fine Arts, Boston

TINA MODOTTI
Woman with Flag, 1928
Museum of Modern Art, New York

Early Street; Constructivism; Surrealism; Social Realism; Street & Society

Fashion & Society; Postmodernism; Staged Tableaux; New Formalism; Post-Internet

 A dominant style of photographic Modernism in the 1920s and 1930s in which photographers used dynamic angles and close-ups to convey the experience of the Machine Age.

BERENICE ABBOTT (1898–1991); **GERMAINE KRULL** (1897–1985); **EDWARD QUIGLEY** (1898–1977); **CHARLES SHEELER** (1883–1965); **RALPH STEINER** (1899–1986)

advertising; geometric; landscape; machine; precision

By the mid-1920s, advances in technology had revolutionised society; dams, skyscrapers and suspension bridges were transforming the landscape; and aeroplanes, automobiles and new streamlined trains forever changed how people and products were transported. The Machine Age, as it came to be known, was in full force, and it was the camera – faster, sharper and more mobile than ever before – that captured it.

In 1927, artists' preoccupation with these new mechanical forms was revealed in the 'Machine-Age Exposition' at the Brooklyn Museum, New York, which showed photographic documentation of architecture and engineering alongside modern art. That year, Charles Lindbergh flew the Atlantic, construction of the George Washington Bridge began, and Ford launched its first car designed for mass consumption, the Model A. To promote it, Charles Sheeler was commissioned to document the company's landmark River Rouge plant. As well as a commercial photographer, Sheeler was a key proponent of Precisionism (Cubist Realism). Influenced by the crisp, angular city views made by photographers such as Paul Strand, Precisionist painters used clear outlines and simple geometric shapes to monumentalise modern architecture. They, in turn, helped cohere this particularly hard-edged branch of photographic Modernism.

Margaret Bourke-White's statement that 'any important art coming out of the industrial age will draw inspiration from industry, because industry is alive and vital' typified the new reverence for the man-made. As well as her architectural studies, she captured the factory environment, with smoke, steam and fire illuminated to take on a near-divine quality. Her peer Berenice Abbott completed a five-year Federal Art Project, *Changing New York* (1939), in which she documented the urban environment. Germaine Krull's *Métal* (1928) paid homage to the geometric lines of industrial structures in Paris, Marseille and Amsterdam. The dynamic angles these photographers used were integral to Industrialism and connected them to the New Vision in Europe, where László Moholy-Nagy and Alexander Rodchenko advocated use of the Constructivist 'worm's-eye' and 'bird's-eye' views to convey the psychological experience of being in the metropolis.

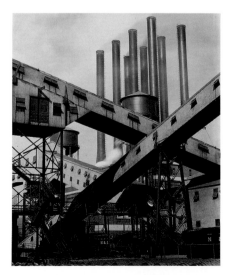

→ **GERMAINE KRULL**
Eiffel Tower, 1927, from
Métal (photobook), 1928
J. Paul Getty Museum, Los Angeles

Krull saw the industrial view as
representing a modern kind of
romanticism. This study of
France's great symbol of
modern engineering, featured
in her celebrated photobook
Métal, secured her a steady
stream of commercial work.

↙ **CHARLES SHEELER**
*Criss-Crossed Conveyors –
Ford Plant,* 1927
Museum of Fine Arts, Boston

Sheeler employed a low
perspective to create a
dynamic effect that emphasises
the monumentality of the
structure, while his vantage
point accentuated the
geometric lines and forms
found within the composition.

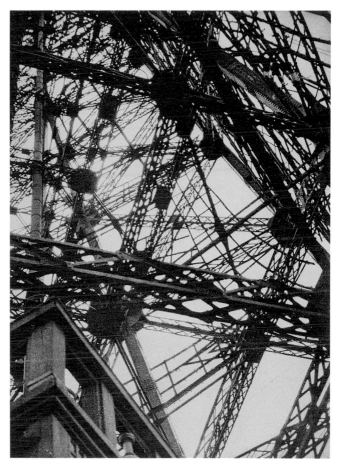

Much of Industrialism resulted from
commissions from publishers, but
advertising agencies also fuelled the
aesthetic. Close-up studies of machinery,
and product still lifes that glamorised
man-made materials – by photographers
such as Ralph Steiner, Edward Quigley and
Albert Renger-Patzsch – were as vital to
picturing industry as those that registered its
colossal scale. By the end of the 1930s, loss
of confidence in the machine and cynicism
about the utopia it had promised brought
this style into rapid decline.

OTHER WORKS

BERENICE ABBOTT
Night Aerial View, Midtown Manhattan, 1933
National Museum of American History, Washington DC

RALPH STEINER
Electrical Switches, 1930
Center for Creative Photography, Tucson, Arizona

 Still Life; Futurism; Constructivism;
Bauhaus & the New Vision

 Pictorialism; The Nude; Surrealism;
Subjectivism

This California-based collective was the nucleus of the 'straight photography' movement that became the defining aesthetic of American Modernism, relinquishing Pictorialism in favour of precise reproductions of natural forms.

ANSEL ADAMS (1902–84); **IMOGEN CUNNINGHAM** (1883–1976); **EDWARD WESTON** (1886–1958); **WILLARD VAN DYKE** (1906–86)

form; nature; precision; sharpness

In a 1917 edition of Alfred Stieglitz's journal *Camera Work,* his protégé Paul Strand advocated 'purity of use' in photography, explaining that 'hand work and manipulation is merely the expression of an impotent desire to paint'. This position was finally codified in 1932 by a group of San Francisco-based photographers named Group f.64. Their objective was to present the best examples that upheld their standards of 'pure photography', 'possessing no qualities of technic [sic],

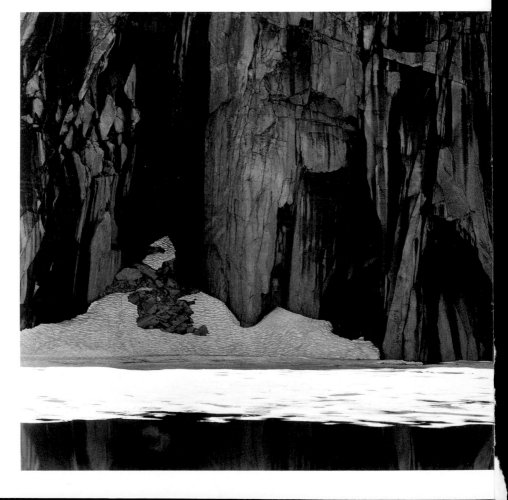

composition or idea derivative of any other art form'.

Group f.64 named themselves after what was then the smallest aperture of a lens of a large-format camera that achieved the greatest depth of field, meaning that both near and far distance are rendered in sharp focus. They favoured contact prints made from 8 x 10 inch (20 x 25 cm) negatives, which retained great detail, and gradually replaced the softer effect of processes such as bromoil with gelatin silver prints that achieved a harder, higher-contrast image with a glossier finish.

In addition to leader Edward Weston, Group f.64's founder members were Ansel Adams, Imogen Cunningham, John Paul Edwards, Sonya Noskowiak, Henry Swift and Willard Van Dyke. From their first exhibition in November 1932, however, the group evolved as they invited photographers including Consuelo Kanaga, Preston Holder, Dorothea Lange, Alma Lavenson, Peter Stackpole and Weston's son Brett to exhibit alongside them as honorary members.

These photographers were aware of the experimental Modernism taking place in Europe, and their values were aligned to the New Objectivity movement. Through organs such as *Camera Work* and regular visits to New York they were also alert to the activities of like-minded peers working across the country such as Strand, Berenice Abbott and Charles Sheeler.

The Group f.64 circle refined a distinctive aesthetic based on their own surroundings; subjects that projected beauty and timelessness, such as the Sierra Nevada region, nude studies and natural still lifes, as well as occasional industrial forms. Though geographic dispersal and a general inclination towards documentary photography all but ceased their activities as a collective by the end of the 1930s, the legacy of straight photography endured into the 1950s as the predominant aesthetic of Modernism in the US.

← **ANSEL ADAMS**
Frozen Lake and Cliffs, Sierra Nevada, Sequoia National Park, California, 1932
Center for Creative Photography, Tucson, Arizona

Adams shot this view with a large 8 x 10 inch negative and sharp lens to render the landscape in high definition: accentuating the contrast between the craggy rock face, the lines smoothed by snow, and the glossy, reflective surface of the frozen lake.

OTHER WORKS

IMOGEN CUNNINGHAM
Magnolia Blossom, 1925
San Francisco Museum of Modern Art

CONSUELO KANAGA
Hands, 1930
Brooklyn Museum, New York

ALMA LAVENSON
Indian Ovens, Taos, 1941
Center for Creative Photography, Tucson, Arizona

WILLARD VAN DYKE
Fence Post and Barbed Wire, c 1930
San Francisco Museum of Modern Art

EDWARD WESTON
Pepper No. 30, 1930
Center for Creative Photography, Tucson, Arizona

 Survey; New Objectivity; Industrialism; The Family of Man; New Topographics

 Daguerrotypy; Pictorialism; Futurism; Constructivism; Dadaism

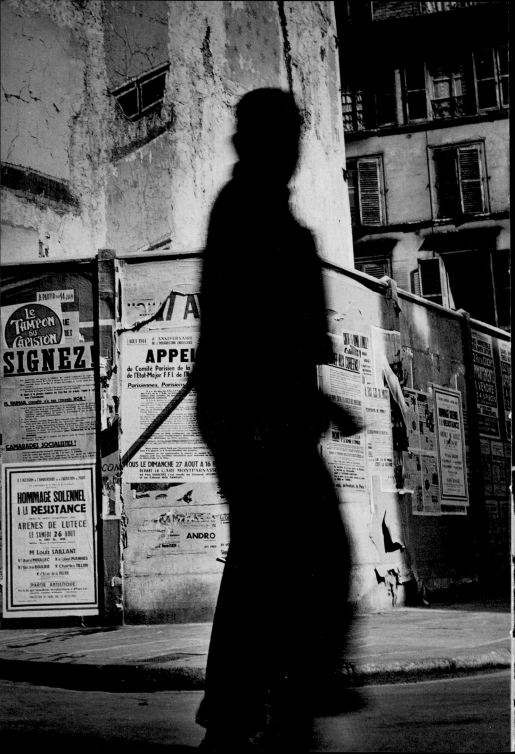

3

SOCIETY &
HUMANITY
1930s–70s

Social Realism

This movement across the arts aimed to convey the conditions experienced by the working classes and poor. Among its most powerful iterations were the images produced by US photographers employed to document the Farm Security Administration programme during the Great Depression of the 1930s, which shaped the social documentary genre.

WALKER EVANS (1903–75); DOROTHEA LANGE (1895–1965); GORDON PARKS (1912–2006); ARTHUR ROTHSTEIN (1915–85); MARION POST WOLCOTT (1910–90)

documentary; evidence; Great Depression; persuasion; propaganda

During the 1930s, the documentary – a record of people, places or events for those who were not able to bear witness – became a primary mode of communication across literature and the arts. In photography, this approach had its roots in the work of individuals such as Jacob Riis and Lewis Hine, who used the camera to drive social reform. It was in the years of the US Great Depression (1929–39), however, that photographers refined a potent combination of realistic subject matter and emotional persuasiveness. Their collective efforts were part of the broader imperative of artists to portray the living conditions endured by the poorest segments of society in this period, a movement known as Social Realism.

Active from 1935–43, the Farm Security Administration (FSA), until 1937 named the Resettlement Administration, was a relief programme for farmers under US President Roosevelt's New Deal initiative to combat the Depression. Its Information Division – essentially its public relations arm – included a photography department that was headed by photo editor Roy Stryker. Under his charge, a core group of 10–20 itinerant photographers travelled through rural and small-town communities recording migrant life. While they followed their own eye, they also worked to 'shooting scripts', lists of suggested subject matter. These were intended to shape an overarching visual narrative and achieve the division's ultimate goal of 'introducing America to Americans'. Stryker then supplied these to the press to communicate the work of the FSA to the general public.

Photo-essays produced by FSA photographers outside of their official capacity, including *An American Exodus* (1939) by Dorothea Lange and her husband, economist Paul Taylor; and *Let Us Now Praise Famous Men* (1941) by Walker Evans and writer James Agee, also proved instrumental in codifying social documentary during this period.

While the 175,000 negatives and 1,600 transparencies generated by the FSA programme created an enduring image of the Depression, it is the dialogue sparked by the multiple and conflicting roles of the photographs as propaganda (their intended function), historical evidence and works of art that has proved an equally significant part of their legacy. Details of photographers engineering shots to create the kind of impactful image that would awaken sympathy from the viewer elicited questions as to the veracity of photographs as historical evidence, for example, and the ethics of such images entering the art market remains a contentious topic.

The Social Document; Photojournalism; The Family of Man; Art Documentary

Pictorialism; Futurism; Surrealism; New Topographics

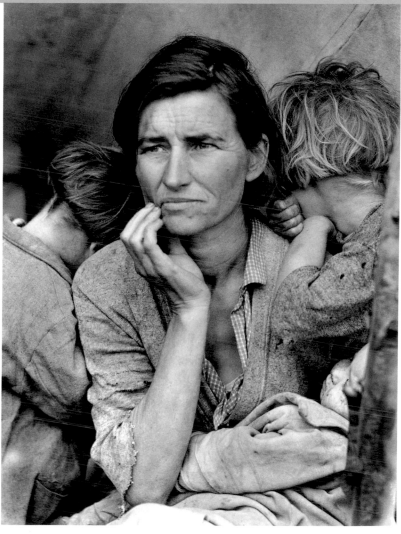

DOROTHEA LANGE
Migrant Mother, Nipomo, California, 1936
Museum of Modern Art, New York

Published in the *San Francisco News* in 1936, Lange's
original caption was 'Destitute peapickers in California;
a 32 year old mother of seven children'. She took many
photographs of the family's camp, but it is this version,
close up enough to create a Madonna-like composition
and reveal the mother's careworn expression, that
became the iconic image of the Great Depression.

OTHER WORKS

GORDON PARKS
American Gothic, Washington, 1942
National Gallery of Art, Washington DC

ARTHUR ROTHSTEIN
Landscape with House, 1936
J. Paul Getty Museum, Los Angeles

MARION POST WOLCOTT
Workers and Truck, c 1938, printed later
Smithsonian American Art Museum, Washington DC

War Reportage

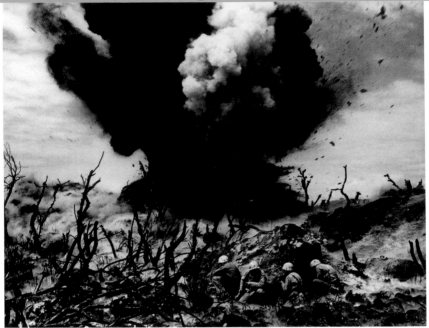

By the 1930s, improved camera technology enabled photographers to capture motion and work faster and closer to the action, transforming depictions of armed conflict. Press circulation of these images formed a new visual language for the horror – and humanity – of war.

DMITRI BALTERMANTS (1912–90); ROBERT CAPA (1913–54); DON MCCULLIN (1935–); LEE MILLER (1907–77); W EUGENE SMITH (1918–78)

 action; documentary; humanism; motion; press

The introduction of small, handheld cameras from 1925 marked a new era of photojournalism. From the late 1920s, the flourishing of reportage was represented in the launch of illustrated weeklies such as *Life* (1936–2000) and *Look* (1937–71) in the US, and *Vu* (1928–40), *Picture Post* (1938–57) and *Paris Match* (1947–) in Europe. Their photo-essays profiled the many instances of conflict across the world, and subsequent demand saw the founding of picture agencies, such as Magnum Photos in 1947.

Photographers including Robert Capa, David 'Chim' Seymour and Gerda Taro were now able to capture the motion and chaos of events such as the Spanish Civil War (1936–39). Capa's images of the 1944 Normandy landings, published in *Life*, showed blurred action that demonstrated how close photographers could now come to their subjects. They had greater access to the horrors of war, as seen in Dmitri Baltermants's and Galina Sanko's images of corpses and suffering civilians on the Eastern Front during the Second World War. W Eugene Smith's scenes of Japan during the conflict were representative of the new, humanist approach that reflected the experiences of soldiers, local people and the photographer himself. Such unflinching realism was often mediated through

censorship, and contrasted with state-sanctioned views.

The dangerous and inaccessible nature of some conflicts or military regimes meant that only their aftermaths could be photographed. The devastating atomic bombs dropped on Hiroshima and Nagasaki by the US were captured by Japanese serviceman Yosuke Yamahata and press photographer Eiichi Matsumoto. In the same year, the liberation of Nazi concentration camps in Germany and Poland was swiftly followed by photographic excursions there by George Rodger, Margaret Bourke-White and Lee Miller, whose work revealed the extent of the camps' atrocities.

The rapid circulation of imagery was such that many depictions of war quickly came to serve as iconic representations of specific conflicts, such as Joe Rosenthal's 1945 photograph of the victorious raising of the American flag in Japan, as well as scenes from the Vietnam War shot by Eddie Adams, Huýnh Công (known as Nick) Út and Don McCullin. The chaos and futility of the Vietnam conflict and its coincidence with Postmodernist thought on the reliability of documentary imagery also resulted in new forms of reportage: McCullin, Larry Burrows, David Douglas Duncan and Philip Jones Griffiths were among those who demonstrated a new awareness of the influence of composition, text and context on photographic narratives.

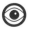 Early Conflict; Photojournalism; Conflict & Surveillance

 Still Life; Celebrity & Paparazzism; Staged Tableaux; Advertising & Fashion

← **W EUGENE SMITH**
Marine Demolition Team Blasting out a Cave on Hill 832, Iwo Jima, 1945
International Center of Photography, New York

Smith's image of US destruction of a block house in which Japanese were hiding shows the grim devastation wrought during the Pacific War with the grandeur of a history painting. *Life* reproduced this as the cover of its 9 April 1945 issue without any written description.

» **ROBERT CAPA** *(overleaf)*
Death of a Loyalist Militiaman, Cordoba Front, early September 1936
International Centre of Photography, New York

First published in *Vu* in 1936, Capa's tragic depiction of a loyalist soldier captioned as shot in the back of the head became an icon of both personal and Republican defeat. Since the 1970s, research into the location of the image and the subject's identity has fuelled speculation that 'The Falling Soldier' was staged, adding to its mythological status.

OTHER WORKS

EDDIE ADAMS
Moment of Execution, 1 February 1968
Museum of Modern Art, New York

DMITRI BALTERMANTS
Grief, 1942, printed c 1960s /0s
Museum of Modern Art, New York

ROBERT CAPA
American Troops Landing on Omaha Beach, D-Day, Normandy, France, 6 June 1944
International Center of Photography, New York

DON MCCULLIN
Shell-Shocked US Marine, the Battle of Hue, 1968, printed 2013
Tate, UK

LEE MILLER
The Bürgermeister's Daughter, Town Hall, Leipzig, Germany, 1945
Victoria and Albert Museum, London

W EUGENE SMITH
Wounded, Dying Infant Found by American Soldier in Saipan Mountains, June 1944
International Center of Photography, New York

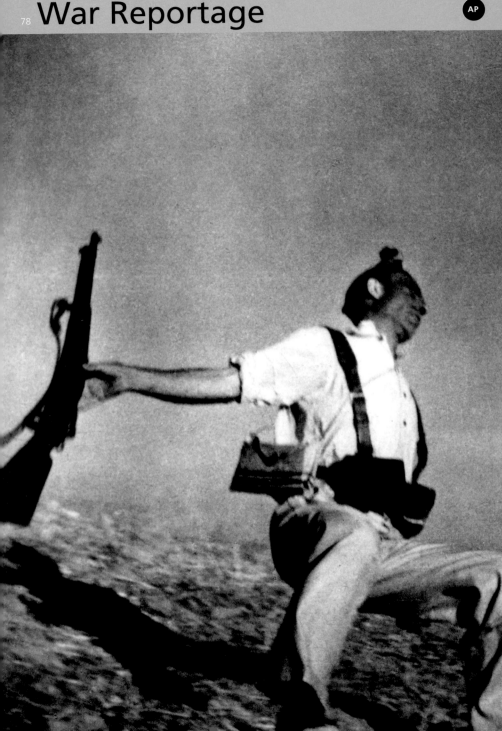

Photojournalism

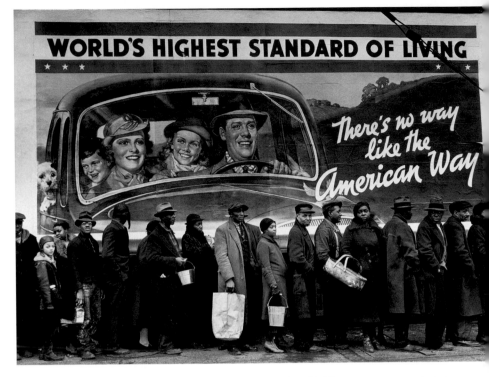

 The combination of journalism and photography came into its own from the late 1920s. With improved camera technologies came more dynamic images, ushering in a 'golden age' of photojournalism that endured well into the 1960s.

EVE ARNOLD (1912–2012); MARGARET BOURKE-WHITE (1904–71); ERNEST COLE (1940–90); SUNIL JANAH (1918–2012); GEORGE RODGER (1908–95)

global crises; handheld; spontaneity; photo-essay; Wirephoto

Technological development of cameras during the 1920s and 1930s accelerated image making and dissemination. Beginning with the Leica (in 1925) and the Contax (in 1932), smaller, lighter handheld cameras were marketed that used the recently introduced 35 mm film roll, and improved lenses and faster shutter speeds allowed for closer, sharper and more dynamic shots. The launch of illustrated publications such as *Vu* (1928–40), *Life* (1936–2000) and *Berliner Illustrirte Zeitung* (1892–1945) popularised the image-led, captioned photo-essay. Newly labelled 'photojournalists' were sent on assignments across the globe. The Associated Press's phototelegraphy network, Wirephoto, meant that contact sheets could be transmitted to a picture editor thousands of miles away.

Popular modern photojournalism included portraiture of famous figures. Erich Salomon's images of Berlin politicians and socialites spurred a taste for 'candid'

portraiture, while Eve Arnold showed celebrities such as Marilyn Monroe behind the scenes. A more choreographed style was represented in Alfred Eisenstaedt and Philippe Halsman's portraits, many of which appeared as *Life* covers.

Photojournalists often had to condense a whole story into one representative frame. Bill Brandt, George Rodger, Werner Bischof and Marc Riboud's images of social and political events involved a spontaneity defined by Henri Cartier-Bresson as the 'decisive moment' – the coming together of the situation and the photographic eye in a way that registered significance.

'Concerned' photojournalists often devoted themselves to exposing ongoing global crises. South African magazine *Drum* (1951–) published work by Ernest Cole and Peter Magubane that provided unflinching accounts of apartheid oppression. Sunil Janah and Homai Vyarawalla recorded key moments in the struggle for Indian independence in the 1940s, including Gandhi's assassination in 1948. Margaret Bourke-White's 1947 photo-essay on Indian independence typified her coverage of milestone events for *Life* magazine, which also included features on industrial growth in North America, life in the Soviet Union and Korea, and harsh conditions endured by black miners in South Africa.

The 'golden age' of print Photojournalism began its decline in the 1960s: many photographers became frustrated by editors' increasing control over their work, choosing instead to exhibit their images or publish them in books. The rise of television news was another major factor, a medium itself now under threat from the rise of citizen journalism.

← **MARGARET BOURKE-WHITE**
At the Time of the Louisville Flood, 1937
Museum of Modern Art, New York

An example of how effective photojournalistic imagery conveys a whole story in one discrete shot, Bourke-White captured the glaring disjuncture between the ideology portrayed in the billboard advertisement, and reality of life for the citizens queuing for provisions at an Ohio relief station.

OTHER WORKS

EVE ARNOLD
Photograph of Marilyn Monroe and Arthur Miller Dancing on Location for The Misfits, 1961
Yale University Library, New Haven, Connecticut

MARGARET BOURKE WHITE
Fort Peck Dam, Montana, 1936
The Metropolitan Museum of Art, New York

ERNEST COLE
Police and Passes, from *House of Bondage,* c 1960–66
Moderna Museet, Stockholm

SUNIL JANAH
Demonstrators Burning their Relief Vehicles in a Street in Calcutta, 1942
Victoria and Albert Museum, London

GEORGE RODGER
The Wrestlers, Kordofan, Sudan, 1949
National Galleries of Scotland, Edinburgh

 Early Conflict; War Reportage; The Family of Man; Celebrity & Paparazzism

 Futurism; Conceptualism; Self Portrait, Performance & Identity; Diarism; Fictional Narrativism

Subjectivism

 An international tendency towards individual expression that was promoted and organised by Otto Steinert in the 1950s. He and fellow members of the Fotoform group outlined the creative decisions that set artistic photographs apart from those that were purely functional.

PETER KEETMAN (1916–2005); TAKEJI IWAMIYA (1920–89); BRONISŁAW SCHLABS (1920–2009); OTTO STEINERT (1915–78); MINOR WHITE (1908–76)

abstraction; expression; experimentation; individual; psyche

During the Second World War, photography in Germany had largely been deployed to help illustrate nationalist ideology. Reacting against this, Otto Steinert, Peter Keetman, Siegfried Lauterwasser, Wolfgang Reisewitz, Toni Schneiders and Ludwig Windstosser established the Fotoform group in 1949 to advance artistic photography. They sought to rehabilitate the experimentation of the prewar period and invest it with a more personal expression, a tendency they called 'Subjective Photography'.

Led by Steinert, Fotoform promoted Subjective Photography in three large group exhibitions in 1951, 1954 and 1958, shown variously in Central Europe, New York and Japan, and two accompanying publications. Writing in *Subjective Photography 2* (1955), Steinert differentiated between photography that was 'mere reproduction' and that which resulted from artistic or stylistic feeling. He explained that 'creativeness in photography is expressed by an act of choice. In some cases that may be choice of subject matter, in other cases it may be methods of treatment, and in yet other cases it may be

the isolation of a purely accidentally produced picture'.

Fotoform's thesis was not entirely new: Pictorialism, the New Vision, and the 'straight' photography of the interwar period had begun to establish the medium as an autonomous art form. What was different, however, was the desire to synthesise and promote the global efforts of photographers who were resuscitating experimental and individualistic approaches.

In featuring photographers from around the world, Subjective Photography created connections between seemingly disparate international groups. Alfredo Camisa, Thomaz Farkas, Takeji Iwamiya and Aaron Siskind alone, for example, represented the activities, respectively, of Italy's Neorealism, Brazil's Foto Cine Club Bardeirante, Japan's Graphics Group (Graphic Shudan), and New Bauhaus in the US. Steinert found commonalities in the use of abstraction (the isolation of particular forms, patterns or textures), high tonal contrast, naturalistic, lyrical subject matter, and experimental camera-less techniques.

Together, the exhibited photographs conveyed a new way of experiencing the world that connected with US photographer and educator Minor White's influential theories of mystical and spiritual expression in photography. This allusion to the psyche is now often interpreted in relation to the postwar context within which the movement crystallised.

BRONISŁAW SCHLABS
Fotogram ii/14, c 1960s
Museum of Modern Art, Warsaw

The way in which the photogram technique can emphasise texture and form to the point of abstraction made it a popular technique for proponents of Subjective Photography such as Schlabs. He experimented with layering, cutting, heating and gluing negatives before exposing them, to create visceral images that have no obvious connection to reality.

OTTO STEINERT (see p72)
Call, 1950
The Metropolitan Museum of Art, New York

The metallic tones and skewed perspectives, combined with the silhouette of a man who, disconcertingly, appears to be turned directly towards the viewer, renders the French street as a dreamlike landscape. Steinert often experimented with contrast to transform a landscape or object study into an evocation of subjectivity and the subconscious mind.

OTHER WORKS

TAKEJI IWAMIYA
Sandhill, 1949
Tokyo Photographic Art Museum

PETER KEETMAN
Oil Drops, 1950
Museum Folkwang, Essen

BRONISŁAW SCHLABS
Untitled, 1958
Museum of Modern Art, New York

OTTO STEINERT
A Dancer's Mask, 1952
Museum Folkwang, Essen

MINOR WHITE
The Sound of One Hand Clapping, Pultneyville, New York, October 10, 1957
Princeton University Art Museum, New Jersey

 Bauhaus & the New Vision; New Objectivity; Surrealism; Group f.64

Fashion & Society; Constructivism; Social Realism; Staged Tableaux

The Family of Man

 The most visited photography exhibition of all time brought together photographs from around the world that represented the universality of life's experiences. First shown in 1955, in the midst of the Cold War, it was intended as a positive statement about humanity, but was later heavily criticised.

ROY DECARAVA (1919–2009); **ALFRED EISENSTADT** (1898–1995); **ELLIOTT ERWITT** (1928–); **DOROTHEA LANGE** (1895–1965); **YOSUKE YAMAHATA** (1917–66)

Cold War; criticism; curating; humanist; universality

In organising 'The Family of Man', curator Edward Steichen set out to show the universality of human experience and make a positive statement that would defy Cold War-era political tensions. First shown in 1955 at the Museum of Modern Art, New York, it then travelled to nearly 40 different countries, including Japan and Russia, and reached over 9 million viewers. The accompanying book has never been out of print.

In 503 photographs, by 273 photographers, from 68 different countries, selected from 2 million entries, the exhibition presented what Steichen called 'the gamut of life': pictures of birth and death, work and celebration, laughter and tears. Some of the exhibited photographers like Dorothea Lange, Henri Cartier-Bresson, Elliott Erwitt and Roy DeCarava were familiar names, especially to US audiences; others were more obscure.

Much of 'The Family of Man's' impact was thanks to Steichen's curating. Rather than hanging the photographs at eye level, one after another, his exhibition took influence from Bauhaus design. Unframed photographs of many different sizes were hung at various heights, some on the wall, others on the ceiling, on the floor, or suspended from wire. The effect was dynamic, integrating different subject matter and inviting audiences to immerse themselves in images of people who were 'just like them'.

Under the threat of atomic war, this humanist statement was incredibly powerful. But into the postmodern period, from the late 1960s on, 'The Family of Man' came under fire from critics who took issue with the idea of 'sameness' and the perceived US-centric view: over half of the exhibited photographs were by Americans. Steichen was accused of racism, imperialism and promoting a colonialist perspective.

woman, beggar and street peddler among them – extremely close-up. Walker Evans later employed a similar strategy for documenting a cross-section of society's archetypes in his *Subway Portraits* (1938–41), which he made by hiding a small 35 mm camera inside his coat.

The unposed and unvarnished nature of the Candid Portrait means that it was often – and continues to be – lauded for its perceived 'authenticity'. Historically, its creators have also been accused of being voyeuristic or judgmental. Such charges were frequently levelled against Lisette Model, who began her acerbic photographic social commentary in the 1930s with portraits of strangers that revealed the European bourgeoisie at their most unappealing. While she typically honed in on individuals, her contemporary 'Weegee' tended to focus on crowds; whether at crime scenes in New York or movie theatres in Los Angeles, one of his favourite techniques was to point his camera in the opposite direction to the action, to register the onlooker's expressions.

The Candid Portrait was at the heart of the new documentary photography that flourished from the 1950s, one of the key proponents of which was Diane Arbus. Inspired by Weegee and her tutor Model, Arbus's candour lay in her exceptionally forthright style, but unlike them she always gained her subjects' permission. Intrigued by people who possessed distinctive physical characteristics, or whose lifestyles positioned them outside the mainstream, twins, transvestites, nudists, dwarfs and giants were among those she photographed in her characteristic style: square-format, straight-on and close-up, their appearance rendered surreal by her use of strong flash. Mary Ellen Mark likewise devoted her career to honest portrayals of under-represented individuals

and communities, though hers was a less sensationalist view that often resulted from long-term relationships with her subjects.

The Candid Portrait remains one of the most fertile categories of photography today, an ever-evolving form of anthropological study that reflects society's changing attitudes towards documenting itself. Bruce Gilden has been known since the 1960s for his disarmingly close-up street photography, and in 2013 began making unrelentingly harsh colour street portraits whose grotesqueness is a response to social media posturing.

← **LISETTE MODEL**
Woman with Veil, San Francisco, 1949, printed 1976
Tate, UK

Model's photograph invites us to scrutinise the way this woman has chosen to present herself. To some it is an attack on the glamour and excess of upper-class life, to others a reminder of how vulnerable we all are in front of the camera.

OTHER WORKS

DIANE ARBUS
Identical Twins, Roselle, N.J., 1966
The Metropolitan Museum of Art, New York

BRUCE GILDEN
Haiti, Port-au-Prince, Cemetery, 1988, from *Haiti,* 1984–
Museum of Modern Art, New York

MARY ELLEN MARK
Tiny in Halloween Costume Blowing Bubble, Seattle, from *Streetlife,* 1983
J. Paul Getty Museum, Los Angeles

WEEGEE
The Critic, 1943
International Center of Photography, New York

Early Street; Social Realism; Celebrity & Paparazzism; Art Documentary

The Studio Portrait; Still Life; Conceptualism; Staged Tableaux; Fictional Narrativism

Street photography became a fully established category from the 1950s on. While some found in public space the subject matter for rigorous, classical compositions, others embraced a more raw and spontaneous approach that reflected the energy of the city.

PIERGIORGIO BRANZI (1928–); ROBERT FRANK (1924–); MIYAKO ISHIUCHI (1947–); WILLIAM KLEIN (1928–); GARRY WINOGRAND (1928–84)

city; encounter; social landscape; spectacle; vernacular

During the 1930s, photographers André Kertész and Henri Cartier-Bresson refined a modern approach to street photography. Their images represented a harmonious balance of geometry and form, and the concept that would be precisely articulated by the now-infamous title of Bresson's 1952 book, *The Decisive Moment*. This term, he explained, described the split second in which all of the necessary elements of the frame cohere to give the event 'its proper expression'. It was not, as it often came to be interpreted, a reference to photographers being in the right place at the right time, but to their judicious use of angle, orientation and perspective in order to achieve the perfectly balanced composition.

Into the 1940s and 1950s, this approach – deeply formal and often described in terms of its 'timelessness' – was embraced by European photographers who wanted to immortalise a rapidly changing society. Robert Doisneau and Willy Ronis were among those to pay homage to Paris in this way, while some of its most poetic iterations came from photographers associated with Italian Neorealism, like Piergiorgio Branzi and Alfredo Camisa. They used strong tonal contrast to draw attention to the texture,

line and detail found in crumbling but picturesque city streets, and to bring emotional poignancy to quiet, quotidian scenes. Increasingly in the postwar years, this classical style was invested with a more social and political thrust.

At the same time, a very different approach to picturing society emerged among photographers who found their subject matter in the public space. For them, the city was a spectacle where life's humour and tragedies were played out.

→ **PIERGIORGIO BRANZI**
Burano, Piazza Grande,
1954
Museo Nazionale Alinari Della Fotografia, Florence

The cartwheel, a classic motif of childhood free-spiritedness, and the peeling facades of the buildings on this Venetian square, are both reminders of the brevity of life and passing of time, imbuing this image with a romantic appeal.

To photograph it was not about immaculate composition, but about capturing the perfect combination of action and expression.

In the US, the foundations for this realist approach had been laid by the new modes of documentary and reportage photography that had flourished in the 1930s and 1940s. Walker Evans, an errant Farm Security Administration photographer, and Helen Levitt, who had been assigned to the Photo League, had established how cleverly-observed vernacular details such as shop signage (in Evans's case) or children's chalk-drawings (in Levitt's) could tell a larger story about a given community. Meanwhile, photojournalist Weegee's flashbulb camera had illuminated innumerable New York tenements and crime scenes to reveal the city at its most squalid and sordid.

Working in this legacy, Robert Frank's photobook *The Americans* (1958) was inspired by Evans's *American Photographs* (1938). Depicting racial divide, consumerism

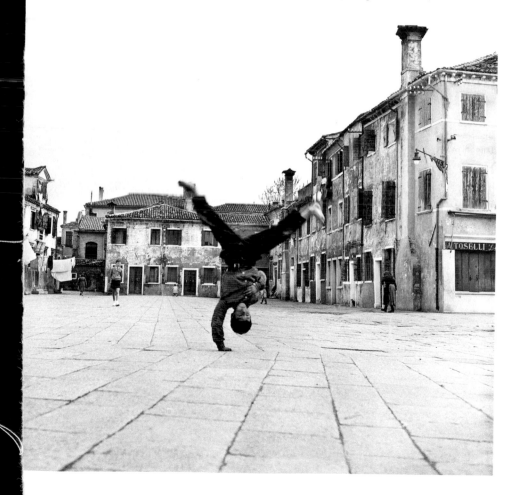

and civil disobedience, and shot variously from the pavement or car window, Frank's images provided a loaded critique of a country now in the grip of Cold War. William Klein's raw and grainy accounts of New York likewise conjured a sense of confrontation, alienation and freneticism that was a world away from the scenes portrayed by Cartier-Bresson and his peers.

In the exhibition 'Towards a Social Landscape' (1966) at the George Eastman Museum in Rochester, New York, curator Nathan Lyons proposed that the 'human environment' – what people do and how they spend their time – carried as much aesthetic import as images of nature. Bruce Davidson, Garry Winogrand, Lee Friedlander, Duane Michals and Danny Lyon represented American society through snapshot-style images of scenes on streets or in bars, at parties and at funerals. Winogrand in particular embodied the new idea of the roving street photographer. Close-up, off-kilter, and honed in on human encounter, his shots conveyed the dynamism of the city. A prolific photographer who shot millions of frames in his lifetime, his work demonstrates how selecting the right image from the contact sheet can be as vital to representing that moment as the act of clicking the shutter.

The grit and urgency that these photographers brought to depicting society was paralleled by their contemporaries across the globe. In Japan, for example, six photographers – among them Eikoh Hosoe, Kikuji Kawada and Shomei Tomatsu – had formed the Vivo collective (1959–61) to formulate a style that could adequately convey the turbulence of a country finding an identity in the midst of economic boom. Their enterprise was continued later in the 1960s and 1970s by Miyako Ishiuchi and photographers associated with the

short-lived experimental magazine *Provoke* (1968–69) like Yutaka Takanashi and Daido Moriyama, whose self-described 'rough, blurry, and out of focus' aesthetic offered a fragmented and heady interpretation of surviving in the city.

→ **WILLIAM KLEIN**
Gun 1, New York, 1954, printed 1986, from *Life is Good and Good for You in New York,* 1954–55
The Metropolitan Museum of Art, New York

Klein's gritty and confrontational style is epitomised in this photograph that forces the viewer to stare down the barrel of a gun – albeit a toy one.

OTHER WORKS

ROBERT FRANK
Parade – Hoboken, New Jersey, 1955, from *The Americans,* 1955–57
National Gallery of Art, Washington DC

MIYAKO ISHIUCHI
Yokosuka Story #73, from *Yokosuka Story,* 1977
J. Paul Getty Museum, Los Angeles

HELEN LEVITT
New York, c 1940
Museum of Modern Art, New York

YUTAKA TAKANASHI
Towards the City (Toshi-e), 1974, printed 2012
Tate, UK

GARY WINOGRAND
Central Park Zoo, New York City (Couple with Chimps), 1967
Center for Creative Photography, Tucson, Arizona

Early Street; Social Realism; The Candid Portrait; Art Documentary

Dadaism; New Objectivity; Postwar Fashion; Post-Internet

Celebrity & Paparazzism

Paparazzi photography emerged in Rome during the 1950s, offering a candid view of stars. This helped foster a celebrity culture that would become the subject of critique for artists in the postmodern period.

RON GALELLA (1931–); MARCELLO GEPPETTI (1933–98); PHILIPPE HALSMAN (1906–79); ARNOLD NEWMAN (1918–2006); TAZIO SECCHIAROLI (1925–98)

candid; Hollywood; intrusive; persona; tabloid

In the 1940s and 1950s, when photojournalism was at the peak of what would later become known as its 'golden age', and Hollywood cinema was likewise enjoying its heyday, magazines such as *Life* (1936–2000), *Look* (1937–71) and *Harper's Bazaar* (1867–) commissioned leading photographers such as Arnold Newman, Philippe Halsman and Eve Arnold to photograph stars of the day. Likewise, the studios commissioned carefully choreographed photo-stories to craft their talents' public persona.

From the 1950s a different form of photojournalistic photography emerged in the form of the paparazzo. The term was taken from the name of the main character in Federico Fellini's film *La Dolce Vita* (1960), who was based on a number of photographers in Rome at that time such as Marcello Geppetti, Tazio Secchiaroli and Elio Sorci. While Hollywood stars were in the Italian capital making movies at studios such as Cinecittà, these photographers made a living taking candid shots of them on set, going about their day-to-day business, or caught in compromising situations.

Appetite for voyeuristic images of known figures was not new. As early as the 1910s, *Penny Pictorial* (1899–1922) ran a regular feature called 'Taken Unawares: Snap Shots of Famous People'. More latterly, Weegee published *Naked Hollywood* (1953), a satire on the movie industry that included one section introduced with the statement 'A star's private life is a matter of public concern'. But the paparazzo – a name that Fellini said suggested a 'buzzing insect' – represented a different style of photography altogether.

An intrusive and pervasive presence in the lives of their famous subjects, the paparazzi used press cameras like Rolliflex to enable them to take one frame after another in quick succession, and flashbulbs

to ensure that nothing was lost in the shadows. They went to great lengths to get the most lucrative shots to sell to the tabloid press: pursuing their subjects on Vespas and on foot, bribing service staff and lurking for hours in improbable locations.

Throughout the 1960s fame and its manufacture through 'low culture' was a source of fascination for artists associated with Pop Art. Andy Warhol stated that 'a great photograph shows the famous doing something unfamous', and declared notorious New York paparazzo Ron Galella to be his favourite photographer. Warhol used celebrity portraits taken from Polaroids or magazines to create silkscreen prints that repeated their image in a grid – a prescient comment on the cult of celebrity that has continued to swell in the years since, thanks to the prevalence of paparazzi culture.

OTHER WORKS

RON GALELLA
Jackie Onassis Attempting to Distract Ron Galella from Photographing Her Daughter Caroline, Central Park, New York, 4 October 1971, printed 2007
Museum of Modern Art, New York

PHILIPPE HALSMAN
Audrey Hepburn, 1955
National Portrait Gallery, Washington DC

ARNOLD NEWMAN
Stravinsky, 1946
International Center of Photography, New York

ELIO SORCI
Walter Chiari and Tazio Secchiaroli in Via Veneto, 1958
Camera Press (online only)

↑ **TAZIO SECCHIAROLI**
Anthony Steel and Anita Ekberg, Rome 1958.
Out of Vecchia Roma Nightclub, the Actor Irritated by Photographers, 1958
San Francisco Museum of Modern Art

In something of a role reversal, the fed-up actor goes after the paparazzo. Thanks to Secchiaroli's shots this scene became infamous and was referenced in the film *La Dolce Vita* in which Ekberg starred.

 Photojournalism; The Candid Portrait; Postwar Fashion; Advertising & Fashion

 Bauhaus & the New Vision; Industrialism; Conceptualism; Diarism; Staged Tableaux

4

THE
POSTMODERN
1950s–90s

 In the postwar period, fashion photography became increasingly freer and more democratic, and colour and outdoor shoots a regular feature, creating stories that placed fashion in the 'real' world.

 RICHARD AVEDON (1923–2004); **DAVID BAILEY** (1938–); **LILLIAN BASSMAN** (1917–2012); **NORMAN PARKINSON** (1913–90); **IRVING PENN** (1917–2009)

colour; energetic; location; New Look; 'youthquake'

In the late 1940s, fashion and society magazines promoted glamour as an antidote to wartime austerity. Irving Penn and Richard Avedon, both protégés of the legendary art director Alexey Brodovitch, were the most prominent fashion photographers in their field. A master of the studio composition, Penn's fashion features were characterised by graphic silhouettes and clean, monochromatic backgrounds. Avedon shared Penn's preference for visual simplicity, but also had a distinctively energetic style.

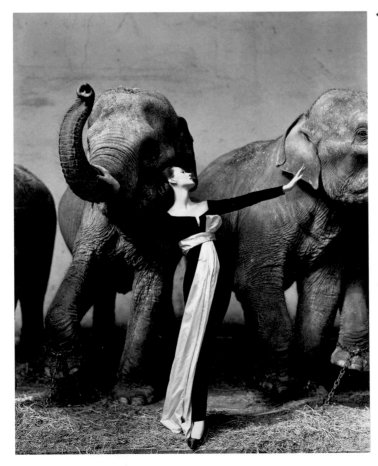

← **RICHARD AVEDON**
Dovima with Elephants, Evening Dress by Dior, Cirque d'Hiver, Paris, August 1955
Museum of Modern Art, New York

Avedon's composition contrasts the elephant's hulking frame with Dovima's grace and poise as she stands resplendent in a Christian Dior gown. The image was first published in *Harper's Bazaar* in August 1955.

↗ **RICHARD AVEDON**
Veruschka, Dress by Bill Blass, New York, January 1967
Museum of Modern Art, New York

Avedon was renowned for bringing movement to the controlled environment of the studio setting, as in this shot of model Veruschka.

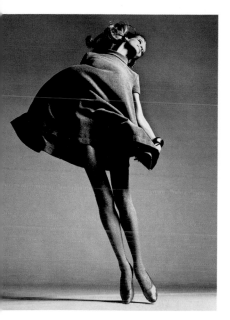

work of an ambitious new generation of photographers led by David Bailey, Terence Donovan and Brian Duffy, who brought youth-oriented fashions to life. Gone were poised debutantes and fussy studio sets: in their place waifish ingénues, and fashion stories for men and women shot in urban and industrial settings, lending the images a new grit and verve.

Into the 1970s, fashion rediscovered its taste for high-octane glamour and femininity, which was reflected in Guy Bourdin's glossy, enigmatic colour campaigns, and Helmut Newton's sexually provocative black-and-white images shot for French *Vogue*; and subverted in Deborah Turbeville's solemn, ethereal compositions.

Alongside the increased use of colour, location shots became one of the most important new shifts in mid-century fashion photography. Norman Parkinson was renowned for his images of immaculate women-about-town that helped readers to imagine bold new styles, like Christian Dior's eponymous 'New Look', in their own lives. In the 1950s, William Klein used wide-angle and telephoto lenses to make New York as much of a feature as the clothing – a precursor to 'street style' photography.

Klein's shots exemplified the continued importance of fashion photography for artistic expression and experimentation, as also seen in Lillian Bassman's distinctive use of very high contrast and bleaching techniques. The spirit and style conveyed by the photographer could be as important as capturing the garment's detail.

In the UK during the 1960s, the cultural movement *Vogue's* editor Diana Vreeland dubbed 'youthquake' was propelled by the

OTHER WORKS

DAVID BAILEY
Jean Shrimpton, from *David Bailey's Box of Pin-Ups*, 1965
Victoria and Albert Museum, London

NORMAN PARKINSON
Wenda Parkinson (née Rogerson), 1949
National Portrait Gallery, London

TERENCE DONOVAN
Thermodynamic, 1960, printed 2011
Victoria and Albert Museum, London

IRVING PENN
Harlequin Dress (Lisa Fonssagrives-Penn), New York, 1950, printed 1979
Art Institute of Chicago

 Fashion & Society; Celebrity & Paparazzism; Postmodernism; Advertising & Fashion

 Industrialism; Social Realism; The Family of Man; Conceptualism; Art Documentary

 The films, transparencies and print processes brought to the market from the 1940s opened up colour photography to creative experiment; it began to gain acceptance as a form of fine art from the mid-1970s.

 WILLIAM EGGLESTON (1939–); **ERNST HAAS** (1921–86); **SAUL LEITER** (1923–2013); **JOEL MEYEROWITZ** (1938–); **STEPHEN SHORE** (1947–)

commercial; complexity; street; chromogenic; transparency

The embrace of colour by advertising agencies and lifestyle magazines in the 1930s saw vibrant work by photographers such as Gisèle Freund, Claire Aho, Victor Keppler and Paul Outerbridge transform the face of commercial photography. The main process in use at the time was the carbro print, where a colour image was made from a black-and-white negative.

The introduction of the first colour film, Kodachrome, in 1935, and other chromogenic processes in the 1940s made colour a more practicable option. In 1941, Kodak launched Kodacolor, the first negative film that could be mailed off for development. This was followed by the Ektachrome transparency in 1942, which photographers could process in their own darkrooms.

Throughout the 1950s and 1960s, improvements to chromogenic and dye transfer processes, and the introduction of products such as Cibachrome, Polaroid and

Instamatic cameras, opened up colour photography for amateurs and specialists alike. Continued experiment and refinement by photographers such as Saul Leiter, Fred Herzog, Erwin Fieger and Ernst Haas awakened others to its artistic merits.

In the first in-depth survey of colour photography, held at the Museum of Modern Art, New York, in 1950, curator Edward Steichen included new work by established photographers such as Erwin Blumenfeld, Harry Callahan and Ruth Orkin. While he acknowledged the rich possibilities that colour offered the fields of documentary, science, fashion and advertising, Steichen declared it still 'something of a riddle' for the artist.

A major turning point was represented in William Eggleston's solo exhibition at the Museum of Modern Art in 1976. His images simply showed life as he encountered it in his hometown of Memphis, Tennessee, but the banality of the subject matter highlighted brilliant and complex tones of the dye transfer print. Together with contemporaries including Stephen Shore, Joel Meyerowitz, and Joel Sternfeld, Eggleston introduced a new school of colour photography that helped it gain acceptance on a par with black and white.

← **WILLIAM EGGLESTON**
Untitled, Memphis, 1970
San Francisco Museum of Modern Art

Eggleston's low vantage point transforms the everyday into the epic, bestowing the toy tricycle with the monumentality of a monster truck.

↖ **STEPHEN SHORE**
Beverly Boulevard and La Brea Avenue, Los Angeles, California, 21 June 1975, from *Uncommon Places,* 1973–79
San Francisco Museum of Modern Art

Shore's use of colour made the ordinary, vernacular scene compelling. The way in which his choice of perspective here organises all of the signage and architecture into a balanced composition is indicative of the formalism of his approach.

OTHER WORKS

WILLIAM EGGLESTON
Greenwood, Mississippi, 1973
Museum of Modern Art, New York

ERNST HAAS
Corner of 38th Street, 1952
Museum of Modern Art, New York

JOEL MEYEROWITZ
Porch Lighting, Provincetown 1977, printed 1985, from *Cape Light,* 1976–77
Museum of Contemporary Photography, Chicago

SAUL LEITER
Window, New York, 1957
Whitney Museum of American Art, New York

 Fashion & Society; Street & Society; New Topographics; Art Documentary; Satirism

 Daguerreotypy; Pictorialism; Futurism; Constructivism; The Family of Man

 Conceptualism's dematerialisation of the art object from the early 1960s saw artists deploy film and photography to record ephemeral artworks and use text and seriality to critique our understanding of photography as a communicator of information.

 VICTOR BURGIN (1941–); JOHN DIVOLA (1949–); JOHN HILLIARD (1945–); MIKE MANDEL AND LARRY SULTAN (1950–/1946–2009); ED RUSCHA (1937–)

anti-aesthetic; playful; critique; linguistics; seriality

Conceptual Art was the first postmodern movement in which the camera played a central role, as artists such as Bruce Nauman, Vito Acconci and Carolee Schneemann used it as part of their investigations into the body as artwork, or to record performance, while land artists such as Robert Smithson and Richard Long

used it to document ephemeral sculptures. Conceptual photography also emerged as an important category in its own right, as photographers began creating installations, series and photobooks that abandoned the Modernist championing of the art object and instead made the camera and the medium itself their subject.

A prominent facet of Conceptualism lay in the interrogation of the photograph as document or evidence. Often this was enacted in deadpan ways, as seen in the work of photographers such as John Baldessari, John Divola, John Hilliard and Ed Ruscha. Hilliard's ongoing investigation into the medium involves precise use of camera settings, film stocks, installation, cropping and captioning to underscore how photography and editing can misrepresent reality. Through interventions in the scenes that he photographs – using paint, sculptural objects or his own body – Divola investigates how photography collates, layers and presents information.

Many Conceptual photographers investigated the importance of seriality – sequencing of images from a series – to how photographs divulge facts. In Ruscha's images of gas stations, parking lots and swimming pools, he highlights the cultural codes that can be found in everyday architecture and signage. This wry take on the series as a cataloguer of information was also seen in Keith Arnatt's many identically posed photographs of social groups such as dog owners and gardeners.

Social norms and institutional critique were major subjects for the individuals who codified Conceptual photography from the mid-1960s to the mid-1970s, among them Christian Boltanski, Victor Burgin, Alexis Hunter, Mike Mandel and Larry Sultan, Martha Rosler, Ana Mendieta, Hannah Wilke and Christopher Williams. Boltanski's large-scale installations brought into question the photograph's capacity to memorialise events and people. Hunter, Mendieta, Rosler and Wilke were among the women artists who highlighted the ways in which sexual and racial identity are constructed through the photographic lens; and Mandel and Sultan used the deliberate absence of captioning for their appropriated images to interrogate the photograph's function in the age of information.

← **JOHN HILLIARD**
Camera Recording its Own Condition
(7 Apertures, 10 Speeds, 2 Mirrors), 1971
Tate, UK

Hilliard's systematic documentation of the different ways in which the camera can reproduce what is in front of it is an example of Conceptualism's approach to photography as both medium and subject. The inclusion of his fingers is a reminder that the photograph is an object of an individual's creation, not a facsimile of reality.

OTHER WORKS

VICTOR BURGIN,
25 feet two hours, 1969
Tate, UK

JOHN DIVOLA
Untitled, from *Zuma,* 1977
J. Paul Getty Museum, Los Angeles

MIKE MANDEL AND LARRY SULTAN,
Untitled, printed 2001, from *Evidence,* 1977
Tate, UK

ED RUSCHA
Standard Station, Amarillo, Texas, from *Twentysix Gasoline Stations,* 1962
Whitney Museum of American Art, New York

 New Topographics; Postmodernism; Self-Portrait, Performance & Identity; Diarism; Activism

 Pictorialism; Subjectivism; Street & Society; Postwar Fashion

The influential 'New Topographics' exhibition of 1975 brought together the work of 10 photographers who, though not a self-identified group, shared a focus on the man-made environment that heralded a new direction in landscape photography.

ROBERT ADAMS (1937–); LEWIS BALTZ (1945–2014); BERND AND HILLA BECHER (1931–2007/1934–2015); STEPHEN SHORE (1947–); HENRY WESSEL, JR (1942–)

deadpan; environmentalism; man-made; neutral; systematic

Held at the International Museum of Photography, George Eastman House, in Rochester, New York, in 1975, the 'New Topographics: Photographs of a Man-Altered Landscape' exhibition was curated by William Jenkins with Joe Deal, who was also an exhibiting photographer. It featured 168 photographs by eight Americans – Deal, Robert Adams, Lewis Baltz, Frank Gohlke, Nicholas Nixon, John Schott, Stephen Shore and Henry Wessel Jr – plus Germans Bernd and Hilla Becher, that each depicted aspects of America's vernacular and industrial landscape.

Until 'New Topographics', the landscape tradition in American photography was largely characterised by sublime views of the 'American West' associated with 19th-century surveys, and the transcendental scenes captured by Modernist photographers such as Ansel Adams, Edward Weston and Minor White. The exhibition's impact lay in its collective undoing of these mythic idylls. In place of sweeping natural vistas were images of freeways, factories, warehouses, trailer parks and rows of tract houses that characterised the economic boom and suburban sprawl of the postwar years.

The exhibited photographers did not appear to lament the changing landscapes their images described. Jenkins proposed that their use of flat, even tones (all but Shore shot in black and white), systematic approach and 'matter of fact' stance all represented absence of judgement. This style had historical precedent in Walker Evans's straightforward documentary images of rural and roadside architecture included in his book *American Photographs* (1938). The New Topographics photographers' spare and dispassionate aesthetic, use of seriality and embrace of the banal also intersected with Conceptualist and Minimalist movements. Ed Ruscha's deadpan studies of the American vernacular landscape in his influential artist's book *Twentysix Gasoline Stations* (1963), and the photographic project *Homes for America* (1966–67) by his fellow Conceptual artist Dan Graham were important precursors.

The New Topographics photographers were not a self-defined group; each had differing concerns. Adams was interested in the environmental implications of the scenes his photographs described. Yet the shared 'look' that Jenkins identified – the impassive, systematic recording of non-sentimental subject matter – has left a significant legacy. The deadpan style of the Düsseldorf School, and the focus on industrialisation and environmentalism that has emerged as an important category in contemporary landscape photography, are just two examples.

Survey; Group f.64; Conceptualism; Düsseldorf Deadpan; Environmentalism & Globalisation

Early Street; Bauhaus & the New Vision; Social Realism; Subjectivism; Diarism

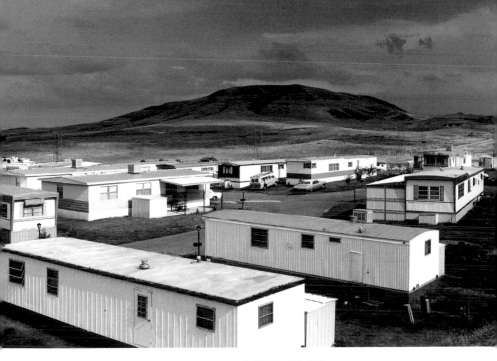

OTHER WORKS

LEWIS BALTZ
South Corner, Riccar America Company, 3184 Pullman, Costa Mesa, from *New Industrial Parks,* 1974
George Eastman Museum, Rochester, New York

BERND AND HILLA BECHER
Blast Furnaces, 1969–95
Tate, UK

JOHN SCHOTT
Untitled, from *Route 66 Motels,* 1973
George Eastman Museum, Rochester, New York

STEPHEN SHORE
Alley, Presidio, Texas, February 21, 1975, from *Uncommon Places,* 1973–79
George Eastman Museum, Rochester, New York

HENRY WESSEL, JR
Tucson, Arizona, 1974, from *California and the West,* c 1968–95
George Eastman Museum, Rochester, New York

↑ **ROBERT ADAMS**
Colorado, c 1973, from *The New West,* c 1967–73
George Eastman Museum, Rochester, New York

The ordinariness and uniformity of the sprawling tract housing, a favourite subject for Adams and Lewis Baltz, dulls any romantic notions of the American landscape. Produced within the climate of the environmentalist movement, to which he was aligned, Adams's image reads as an overt criticism of urbanisation, albeit one restrained by his characteristically cool grey tones.

 A broad term describing photographic series that chronicle real situations while making the photographer's subjective, creative agenda explicit. Art Documentary often focuses on sociopolitical themes.

CLAUDIA ANDUJAR (1931–); **GRACIELA ITURBIDE** (1942–); **CHRIS KILLIP** (1946–); **JOSEF KOUDELKA** (1938–); **TONY RAY-JONES** (1941–72)

anthropological; community; marginalised; sociopolitical

In the late-1960s, the prominence of photojournalism and increased acceptance of photography as fine art contributed to a renewed interest in the social documentary mode established in the 1930s and 1940s. Photographers began to explore how their medium could provide a faithful description of a place or community, while still allowing space for creative expression. The gradual introduction of galleries and magazines dedicated to creative photography supported a growing audience for such projects.

In the US, the controversial views of society published in Robert Frank's *The Americans* and William Klein's *Life is Good and Good for You in New York* (both 1958) were a major influence on new approaches to documentary. Danny Lyon's *The Bikeriders* (1967) offered intimate views of motorcycle club culture, while in *Tulsa* (1971) Larry Clark provided a brazen account of substance abuse among his friends. His gritty style and subject matter resonated with new, subversive documentary modes being explored elsewhere.

Bill Brandt's perceptive photographic survey of social class, *The English at Home* (1936), set the tone for Art Documentary in the UK. This was revived by later generations, beginning with Tony Ray-Jones's wry depictions of English rituals and customs shot during the 1960s. During the

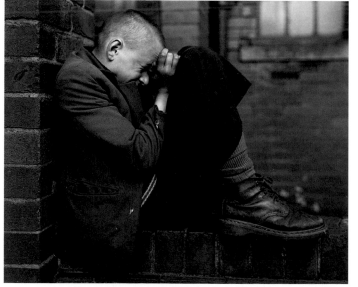

← **CHRIS KILLIP**
Youth on Wall, Jarrow, 1977, from *In Flagrante,* 1973–78
Victoria and Albert Museum, London

The boy's shaved head, bovver boots and 'Birmingham bags' trousers locate this image in 1970s working-class Britain. His pose has been interpreted as a straightforward expression of teenage frustration, and a metaphor for the despair felt by industrial communities at the time.

1970s and 1980s, *Creative Camera* magazine (1968–2001) and the Side Gallery in Newcastle upon Tyne became the nexus for a generation of photographers including Chris Killip, Graham Smith, Martin Parr and Sirkka-Liisa Konttinen, who made black-and-white photo-essays about urban and rural working-class communities where they lived or had immersed themselves.

Across the globe, many photographers exploring new approaches to documentary continued to focus on the human impact of difficult political and economic situations. For this generation working in Britain in the 1970s and 1980s, it was deindustrialisation – the closure of coal mines, steel plants and shipyards – that formed the backdrop to, and subtext of, many such images of people going about their ordinary lives. In South Africa, David Goldblatt epitomised the subjective approach by providing a visual account of apartheid through depictions of people's everyday lives in his series *The Transported of KwaNdebele* (1989).

For many, the documentary mode offered a means of providing insight into the lives of those who have historically been regarded as 'outsiders' or who represent a traditional way of life in decline. Josef Koudelka's book *Gypsies* (1975) is a seminal example. The result of a decade photographing Roma communities across eastern and central Europe, his images captured all aspects of his subjects' lives; while high tonal contrast and dynamic angles created an intense energy and impassioned tone.

Certain themes of marginalisation transcend cultures and geographies, making them a major focus of projects that fuse art and documentary. Though different in style, Paz Érrazuriz's *Adam's Apple* (1983), an intimate portrait of Santiago's transvestite community, and Ricardo Rangel's *Our Nightly Bread*, a document of Maputo's red-light district made through the 1960s and 1970s, both dealt with specific communities, but were far-reaching in terms of the issues they addressed and prejudices they sought to counter. The same is true of Mary Ellen Mark's *Streetwise* (1983) a photo-essay on homeless children and underage sex workers in Seattle that was first commissioned by *Life* magazine (1936–2000), and became a cornerstone of the new approaches to the documentary form.

→ **JOSEF KOUDELKA** *(overleaf)*
Untitled, c 1962–68, from *Gypsies*, 1962–71
Museum of Modern Art, New York

By placing the young boy at the centre of the frame, Koudelka anchors the composition and provides a striking balance to the action taking place in the background. This makes the image visually engaging while also providing descriptive details about the Roma way of life.

OTHER WORKS

CLAUDIA ANDUJAR
Untitled, 1974, from *Casa*, 1972–76
Inhotim Contemporary Art Centre, Brumadinho, Brazil

GRACIELA ITURBIDE
Our Lady of the Iguanas (*Nuestra Señora de las Iguanas*), 1979, from *Juchitán of the Women*, 1979–86
Brooklyn Museum, New York

ANDERS PETERSEN
Lily and the Rose-Cavalier, c 1967–70, printed 1986, from *Café Lehmitz*, 1967–70
Moderna Museet, Stockholm

TONY RAY-JONES
Glyndebourne, 1967
Victoria and Albert Museum, London

 The Social Document; Social Realism; Street & Society; Satirism; Expanded Documentary

 Fashion & Society; Futurism; Industrialism; Group f.64; Staged Tableaux

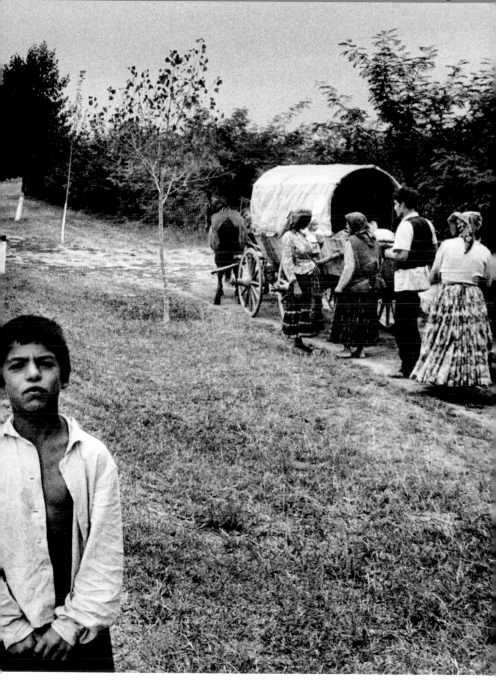

Postmodernism

◔ 'Postmodern' came into common use in the 1970s to describe the attitude that rejected the prevailing artistic ideology of universal and objective truth. Artists subverted the photographic image and its use in media culture.

◑ ROBERT HEINECKEN (1931–2006); SHERRIE LEVINE (1947–); RICHARD PRINCE (1949–); MARTHA ROSLER (1943–); CINDY SHERMAN (1954–)

◔ appropriation; critique; deconstruction; mass media; subversion

● The recognition of a gradual shift away from the attitude that characterised the Modernist period, and specifically its belief in a fundamental truth, saw the concept of the postmodern enter widespread use from the early 1970s.

Artists began to throw out conventions of style and form, and collapse distinctions between high and low culture. Cross-disciplinary artists also began to incorporate photography into their practice, prompting its gradual acceptance within the context of contemporary art.

While artists described as 'postmodern' take multiple and divergent approaches, they share scepticism towards capitalist society, and self-awareness as to how they operate within it. In the 1970s and 1980s, philosophy was crucial in establishing the 'culture of critique' that informed this standpoint. Walter Benjamin's essay 'The Work of Art in the Age of Mechanical Reproduction' (1936) gained new relevance in the context of mass media; looking to him, Martha Rosler and Allan Sekula scrutinised the role and responsibilities of documentary photography.

CINDY SHERMAN
(see p94)
Untitled Film Still #7,
1978, from *Untitled Film Stills,* 1977–80
Museum of Modern Art, New York

Sherman made 69 black-and-white images for this series in which she impersonated female archetypes found in different film tropes, from B-movies to art-house cinema, drawing attention to the reductive ways that 'femininity' is portrayed on screen.

→ **RICHARD PRINCE**
Untitled (Cowboy), 1989
The Metropolitan Museum of Art, New York

As reproductions of reproductions, Prince's photographs of the Marlboro campaign were interpreted as provocations about the perception of authenticity and authorship within media culture, and a debunking of the concept of the American dream.

Poststructuralist theory informed the new subversive tone, too, as art was used as a tool of deconstruction. An important facet was appropriation – where artists adopted the form or style of their subject in order to undermine its meaning. Synonymous with this mode were 'Pictures Generation' artists including Richard Prince, Cindy Sherman and Sherrie Levine, who borrowed, respectively, from advertising, film and social documentary photography. Sherman's own photographs were among the canonical artworks that Yasumasa Morimura restaged in the 1980s to challenge the narrative of Western art history.

The deconstruction of the ways in which women were represented in the media was one of the most important areas of Postmodernism. Feminist artists interrogated the role of television and the illustrated press in manufacturing beliefs about gender and sexuality, and used photographs as tools to enact change.

 Dadaism; Conceptualism; Self-Portrait, Performance & Identity; Diarism; Staged Tableaux

 Daguerreotypy; Travel, Expedition & Tourism; Pictorialism; Group f.64

OTHER WORKS

ROBERT HEINECKEN
Untitled, from the portfolio *Are You Rea*, 1968
San Francisco Museum of Modern Art

SHERRIE LEVINE
After Walker Evans: 4, from *After Walker Evans*, 1981
The Metropolitan Museum of Art, New York

MARTHA ROSLER
Balloons, from *Bringing the War Home: House Beautiful*, 1967–72
Art Institute of Chicago

Photographers have always made self-portraits in which they perform to the camera as an actor would perform on stage. This matured in the 1970s when props, masquerade, and play were used to react against prescribed ideas about identity.

SAMUEL FOSSO (1962–); **ROBERT MAPPLETHORPE** (1946–89); **SHIRIN NESHAT** (1957–); **GILLIAN WEARING** (1963–); **FRANCESCA WOODMAN** (1958–81)

gender; masquerade; postmodern; race; sexuality

Performative self-portraiture existed from photography's earliest days. A more politically inflected approach to this form began to take shape in the 1930s, for example in Claude Cahun's and Marcel Duchamp's radical use of make-up and costume to challenge traditional concepts of masculinity and femininity.

Since the 1970s, photographers have used the self-portrait to explore postmodern identity theories concerning gender, sexuality and race. As with much of the Conceptualist performance and video art of the period, they treated the face and body as sites on which to challenge political, social, cultural and sexual norms and ideas.

In connection with queer and feminist theory, Cindy Sherman and Adrian Piper used masquerade and staging to transgress notions of gender; while artists such as Hannah Wilke, Jo Spence and, in the 1980s, Robert Mapplethorpe used their bodies to explore physical health and political critique. Mapplethorpe's vulnerable, explicit and highly controversial works helped move gay culture into the mainstream.

From this foundation, photographers have opened up their work to questions of racial and spiritual identity. Shirin Neshat and Lalla Essaydi create psychologically charged portraits overlaid with text to explore women's roles in restrictive religious cultures. Samuel Fosso and Lyle Ashton Harris use props and staged scenarios to show how the studio portrait can both reinforce and subvert cultural identity.

Many photographers have chosen to examine the persona of the artist and the self as 'other'. Gillian Wearing has created large colour images of herself as models, artists and members of her family, while Lee Friedlander has made snapshots of himself throughout his life, often as a shadow or reflection. Others, including Boris Mikhailov, Erwin Wurm, Francesca Woodman, and Anna and Bernhard Blume have adopted surreal or burlesque poses, or contorted the body into unlikely spaces or positions.

The cultural, sociological and political role of the self-portrait continues to be important. From the 2010s, it has been reimagined by artists who explore the presence of the 'selfie' and its role in performing everyday life.

OTHER WORKS

SAMUEL FOSSO
Untitled (Nelson Mandela), 2008, printed 2009, from *African Spirits* 2008
Tate, UK

SHIRIN NESHAT
Way in Way Out, 1994, from *Women of Allah,* 1993–97
The Metropolitan Museum of Art, New York

ROBERT MAPPLETHORPE
Self Portrait, 1988
Solomon R. Guggenheim Museum, New York

BORIS MIKHAILOV
Crimean Snobbism, 1992
Tate, UK

FRANCESCA WOODMAN
Untitled, c 1975–80
Tate, UK/National Galleries of Scotland

 GILLIAN WEARING
Me as Cahun Holding a Mask of My Face, 2012
Verbund Art Collection, Vienna

Wearing references a 1927 work by Claude Cahun, the lesbian photographer renowned for staging self-portraits that subverted notions of gender and sexuality. The mask traditionally signifies the juncture between private and public-facing self.

 The Studio Portrait; Dadaism; Conceptualism; Postmodernism; Diarism

New Objectivity; Industrialism; War Reportage; New Topographics

Diarism

 The use of the camera to record life as one would use a journal. Subjective, often intimate and personally revealing, Diarism can be spontaneous, or methodical and choreographed.

NOBUYOSHI ARAKI (1940–); **RICHARD BILLINGHAM** (1970–); **LARRY CLARK** (1943–); **ED VAN DER ELSKEN** (1925–90); **NAN GOLDIN** (1953–)

autobiographical; intimate; subjective; systematic

As part of the subjective turn in documentary photography that gathered momentum in the postwar years, photographers increasingly made their personal lives their subject. Ed van der Elsken's photobook *Love on the Left Bank* (1954) is a key early example. This close-up, sexually charged photo-story, which centred on a fictional narrative enacted by his friends, offered a revealing insight into beatnik youth culture.

Elsken's gritty, black-and-white aesthetic intersected with that of his contemporaries in Japan. Eikoh Hosoe, with whom Elsken was in dialogue throughout the 1960s, foregrounded an individual and expressive style also evinced in the more stream-of-consciousness tendencies of Nobuyoshi Araki, Daido Moriyama and Takuma Nakahira, among others. Since the early 1960s, Araki has deployed the camera to record his life in obsessive detail; from chronicling the love and loss of his wife in two series compiled in the photobook *Sentimental Journey/Winter Journey* (1991) to *Pseudo Diary* (1980), where he manipulated the camera's date function to subvert the honesty often assumed of diaristic photography.

In the US during the 1970s, a postmodern inflection of the diaristic was represented in the everyday subject matter and use of colour by photographers William Eggleston and Stephen Shore. Shore's *American Surfaces* (1972) road-trip photo-diary is an exemplar of a systematic and dispassionate approach to Diarism.

During this period, a more raw and autobiographical style emerged, too. Larry Clark's two series published as *Tulsa* (1971) and *Teenage Lust* (1983), confronting portrayals of drug taking, sex and violence among his Oklahoma friends, continue to

stir controversy today. Alongside Clark, Nan Goldin is among the foremost proponents of this approach. Her series *The Ballad of Sexual Dependency* (1979–), a sequence of snapshot-style images portraying the highs and lows experienced in personal relationships, established her reputation for chronicling the intimate lives of her friends and lovers.

Into the 1990s, Goldin proved extremely influential to younger generations of

↓ **LARRY CLARK**
Jack and Lynn Johnson, Oklahoma City, 1973
Brooklyn Museum, New York

Clark's images brought the viewer into extremely close and uncomfortable proximity with his and his friends' lives. Though widely rejected at the time of publication, his convention-defying accounts of teenage life influenced generations of photographers who likewise tested how work in this trope is complicated by issues of onlooker voyeurism and subject exploitation.

photographers such as Richard Billingham, whose series *Ray's A Laugh* (1990–96), shot on the cheapest film he could find, presented a rough-and-ready account of his home life. Goldin's particular strain of Diarism – intimacy coupled with apparent indifference to the viewer's opinion – also became a favoured mode of fashion magazines during this period, led by *i-D* and *The Face* in the UK and *Index* in the US. It was also seen variously in the staged or semi-staged work of Corinne Day, Wolfgang Tillmans and, later, Ryan McGinley.

← **NAN GOLDIN**
Nan and Brian in Bed, New York City, 1983, from *The Ballad of Sexual Dependency,* 1979–
Museum of Modern Art, New York

Goldin captures herself and those closest to her with honesty and strength, but without nostalgia, to prevent others creating a revisionist account of her life. *The Ballad of Sexual Dependency* is a seminal study of male–female relationships.

OTHER WORKS

NOBUYOSHI ARAKI
Sentimental Journey, from *Sentimental Journey,* 1971
Tokyo Photographic Art Museum

RICHARD BILLINGHAM
Untitled (Puzzle), 1995, from *Ray's A Laugh,* 1990–96
San Francisco Museum of Modern Art

CORINNE DAY
Georgina, Brixton, 1995
Victoria & Albert Museum, London

ED VAN DER ELSKEN
Paris, 1951, from *Love on the Left Bank, c* 1950–54
Stedelijk Museum, Amsterdam

WOLFGANG TILLMANS
Lutz and Alex Sitting in the Trees, 1992
Tate, UK

Subjectivism; Street & Society; Satirism; Expanded Documentary

New Objectivity; Industrialism, Social Realism; Photojournalism; New Formalism

Staged Tableaux

 Staged Tableaux first emerged during the late-19th century as a popular form for Pictorialist photographers to produce images intended to be poetic and subjective. The Postmodernist utilisation of the medium from the 1980s saw photographers creating images that appeared similarly theatrical.

 GREGORY CREWDSON (1962–); **WANG QINGSONG** (1966–); **SANDY SKOGLUND** (1946–); **HANNAH STARKEY** (1971–); **JEFF WALL** (1946–)

ambiguity; art history; cinematic; detachment; narrative

Renewed emphasis on constructed tableaux that began in the 1980s has been made possible by advances in technology – in particular, the opportunity to manipulate reality convincingly using digital techniques, to present expansive scenes in an impressive amount of detail, and to print these at a very large size for display. This has allowed photographers to present Staged Tableaux on the scale of 19th-century history paintings.

While the tone of these Staged Tableaux is often surreal, enigmatic and emotionally detached, the approach to storytelling in this form is divergent in both scale and in the extent to which narrative elements are assembled, created or directed.

Since the late 1970s, Jeff Wall, a trained art historian, has been creating tableaux using styles and approaches that he has broadly classified into the 'cinematographic' (constructed, filmic scenes), the 'documentary' ('straight photography', often of unlikely subjects) and the 'near documentary' (the restaging of real events or scenes). Gregory Crewdson's similarly theatrical photographs resemble film stills in their atmospheric lighting, staging and psychological charge, all of which is the result of large-scale productions made on location or in the studio involving him directing a full cast and crew.

The melodramatic potential of the domestic setting has ensured it has remained a recurring motif across different approaches to Staged Tableaux, creating images that position the viewer as voyeur. Photographers such as Hannah Starkey, Sarah Jones or Carrie Mae Weems, for example, use actors, real subjects and self-portraiture respectively to stage everyday and naturalistic scenes within the home or similarly familiar environments. Each incorporates props and gestures that

↑ **JEFF WALL**
A Sudden Gust of Wind (After Hokusai), 1993
Tate, UK

Wall digitally combined several photographs to create his desired composition, a homage to Katsushika Hokusai's woodcut *Travellers Caught in a Sudden Breeze at Ejiri* (c 1832). Displayed as a transparency on a lightbox, and running to almost four metres in length, it shares the scale of history painting, but the spectacularised aesthetic of a cinema screen or advertising billboard.

hint at a narrative but ensure that it remains oblique or ambiguous.

Many photographers embrace the fictional in a more explicit manner, too. Wang Qingsong constructs elaborate scenes in the studio that he then digitally combines to create enormous panoramas in hyper-real tones. Since the early 1980s, Sandy Skoglund has constructed colourful sets populated with actors, props and animals to create lurid, dreamlike images. Though they are the result of physical labour, they bear the look of computer-generated or altered images that would become more commonplace by the end of the decade.

→ **SANDY SKOGLUND**
Revenge of the Goldfish,
1981
Amon Carter Museum of American Art,
Fort Worth, Texas

This image predates Photoshop;
Skoglund hand-sculpted each
of the goldfish individually. Her
work shares the postmodern
fascination with artifice, but
she deliberately leaves possible
social or political meanings
open to interpretation.

OTHER WORKS

GREGORY CREWDSON
Untitled 1999, from *Twilight,*
1998–2002
Solomon R. Guggenheim Museum,
New York

HANNAH STARKEY
Untitled, May 1997 from
Untitled, 1997–
Victoria and Albert Museum, London

WANG QINGSONG
Night Revels of Lao Li, 2000
International Center of Photography,
New York

JEFF WALL
Diagonal Composition, 1993
Tate, UK

CARRIE MAE WEEMS
Untitled, from *Kitchen Table,*
1990
Walker Art Center, Minneapolis

 Pictorialism;
Postmodernism;
Advertising &
Fashion

 The Social
Document;
New Objectivity;
Social Realism

5

CONTEMPORARY
PHOTOGRAPHY
1980s –

◐ In fashion editorial shoots or advertising campaigns, photographs are essential to communicating, promoting and selling. Commercial shoots are a collaborative process; they can also be big-budget productions, allowing for extravagant and theatrical images.

◑ NICK KNIGHT (1958–); ANNIE LEIBOVITZ (1949–); MARIO TESTINO (1954–); OLIVIERO TOSCANI (1942–); TIM WALKER (1970–)

◔ collaboration; commercial; editorial post-production; lighting

● Fashion photography is a major industry, relied upon by designers and luxury labels to showcase their creations and communicate their brand. The images might be commissioned by magazines for features, or by fashion houses for campaigns. They could be published in the pages of dedicated magazines, where they speak to a captive audience, or placed in the public space, where they vie to capture the attention – and imagination – of the casual passer-by.

Guy Bourdin's campaign for Charles Jourdan shoes (1967–81) revolutionised fashion advertising with Surrealist images that prioritised narrative and aesthetic primacy over the 'product shot'. Oliviero Toscani's collaboration with Benetton (1982–2000), which focused on global issues, took this to a new level, particularly in the highly controversial 'consciousness raising' 1992 campaign that featured subjects including a dying AIDS victim and inmates of death row.

These partnerships also reflected how a photographer can become intrinsic to the brand's signature aesthetic: as in Nick Knight for Yohji Yamamoto, Juergen Teller for Marc Jacobs, or Mario Testino for Burberry. The campaigns themselves, though, are the result of a collaborative process. Once the advertising agency and client – the designer or fashion house – agree the brief, their vision is realised not only by the photographer, but by a team of fashion directors, stylists, hair and makeup artists, retouchers and, of course, the model. The most high-production end of fashion photography is represented in the work of Annie Leibovitz, famous for her big-budget *Vanity Fair* shoots, or the fantastical, whimsical sets that are the hallmark of Tim Walker's photography.

Digital cameras have revolutionised image capture, while in the post-production stage, Adobe Photoshop, launched in 1990, is used to manipulate the photograph at pixel-level, to shift light and shadow, refine select areas, or even construct a whole image from composite elements. The Internet has also revolutionised how fashion photography is disseminated and the audiences it can reach, as well as allowing new insights into the creative process, as in the case of Knight's pioneering SHOWStudio, which broadcasts the shoot, as well as other fashion media, live.

OTHER WORKS

MARIO TESTINO
British Models Dressed by British Designers, 2001
National Portrait Gallery, London

OLVIERO TOSCANI (CONCEPT) AND **THERESE FRARE** (PHOTOGRAPHER)
Man Dying of AIDS, 1992 (poster)
Victoria and Albert Museum, London

TIM WALKER
Lily Cole & Giant Camera. Italian Vogue, 2005
Victoria and Albert Museum, London

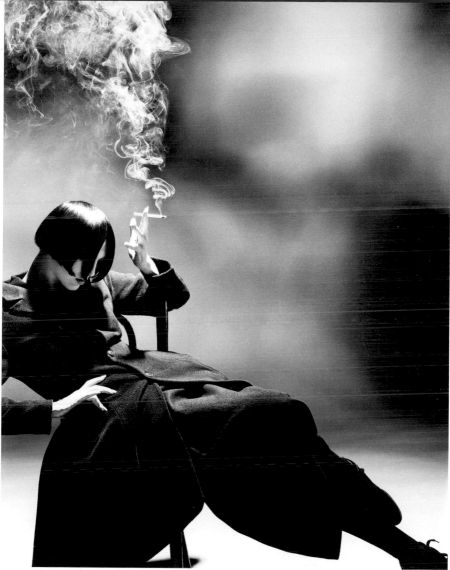

↑ **NICK KNIGHT**
Susie Smoking, for Yohji Yamamoto Autumn/ Winter, 1988–89, 1988
Kobe Fashion Museum, Japan

Knight's shot of Susie Bick smoking became iconic. Her pose is arranged into a loose triangular shape that shows off the structure of the Yamamoto designs; the plumes of smoke evoke a sense of drama and mystery.

 The Nude; Fashion & Society; Still Life; Celebrity & Paparazzism; Postwar Fashion

 Social Realism; The Family of Man; Conceptualism; New Topographics

 A type of documentary photography that emerged in Britain from the 1980s, depicting everyday subject matter and situations in a 'warts and all' style, usually in colour, in order to comment wryly on sociopolitical issues.

 ANNA FOX (1961–); **PAUL GRAHAM** (1956–); **DAVID MOORE** (1961–); **MARTIN PARR** (1952); **PAUL REAS** (1955–)

anthropological; colour; social class; humour; voyeuristic

Satirism emerged in the UK during the 1980s among a group of photographers who were influenced by two approaches to documentary that had matured in the decades before: the British documentary tradition, especially Tony Ray-Jones's affectionate depictions of the English; and the new colour images of vernacular subject matter pioneered in the US by William Eggleston, Stephen Shore and their peers in the 1970s.

These photographers – Paul Graham, Martin Parr and the generation whom some of them taught, including Anna Fox, Paul Reas and David Moore – initially focused on the climate under Margaret Thatcher's government. Pressing issues such as rising unemployment, the welfare state, and the new emphasis on social mobility, were portrayed through images of job centre queues or white-collar workers at their desks. The nuanced distinctions between different social classes were signified through images that showed how people decorate their homes, eat or spend their free time.

The distinctive aesthetic that is synonymous with this style was achieved through the use of highly saturated colour, off-kilter angles and strong flash. But the success of these images lay in the composition: the astute eye for the details that would transform apparently benign scenes into anthropological studies. Often these were accompanied by ironically deadpan titles or captions.

The photographers' position as outsiders to the scenarios they documented; the fact that the images were largely intended not for those who they depicted, but for the niche audience who bought photobooks or visited galleries; and the singularly unflattering aesthetic, meant that accusations of snobbery, voyeurism and exploitation were part of the territory for this kind of photography.

Despite these charges, Satirism's social relevance has ensured it has remained an important category of documentary practice into the 21st century. Mark Neville, for instance, actively explores the hierarchy between image and audience in this type of photography in his studies of what he terms post-industrial working-class communities. Dougie Wallace makes lurid street photographs that, like Parr, hone in on examples of modern life at its most gauche: consumerism, celebrity fandom and the lifestyles of the new 'super-rich'.

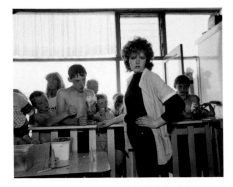

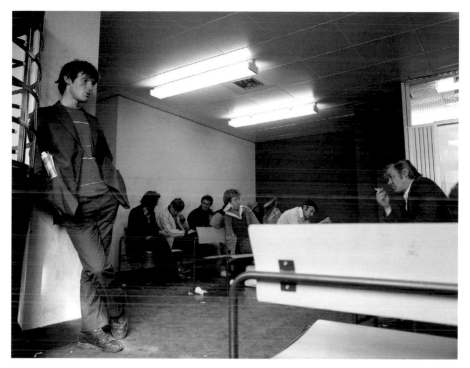

↑ PAUL GRAHAM
DHSS Emergency Centre, Elephant and Castle, South London, 1984, from *Beyond Caring,* 1984–86
Arts Council England Collection, UK

Graham shot this scene of boredom and desolation, in this drab, fluorescent-lit room, without his subjects' knowledge – hence the bench that partially obscures the view. The viewer becomes a voyeur, invited to speculate on the mood and personal circumstance of those depicted.

← MARTIN PARR
GB. England. New Brighton, from *The Last Resort,* 1983–85 *(and p 142 detail)*
British Council Collection, UK

Lurid, claustrophobic and confrontational, this image exemplifies all that is loved and loathed about Parr's work. Some perceived his photo-essay on the New Brighton seaside resort to be an unnecessarily disparaging social commentary; others saw it as a forthright view of people simply having a good time.

OTHER WORKS

ANNA FOX
Project Architect in Insurance Company, High Holborn, 1987, from *Workstations,* 1987–88
Museum of London

PAUL GRAHAM
London Executives, Bank of England, London, from *A1: The Great North Road,* 1981
Museum of Modern Art, New York

PAUL REAS
Beamish Open Air Museum 'The Northern Experience', 1992, from *Flogging a Dead Horse,* 1985–1993
British Council Collection, UK

 Social Realism; Street & Society; Postwar Colour; Expanded Documentary

 New Objectivity; Industrialism; Staged Tableaux; Conflict & Surveillance

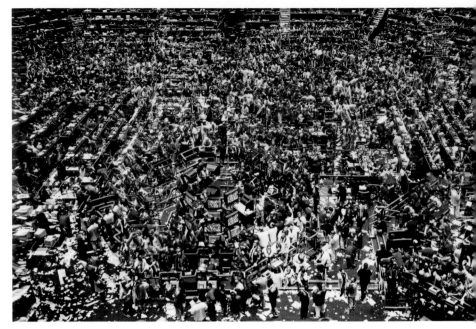

 Characterised by an 'all-over' flatness that does not emphasise any single element of the composition, the Düsseldorf Deadpan aesthetic can be traced back to the New Objectivity movement of Weimar Germany.

 ANDREAS GURSKY (1955–); CANDIDA HÖFER (1944–); AXEL HÜTTE (1951–); THOMAS RUFF (1958–); THOMAS STRUTH (1954–)

abstraction; definition; large-format; objectivity; sublime

In his tutelage at the Kunstakademie Düsseldorf in the 1970s and 1980s, Bernd Becher emphasised the objective, systematic approach that he and his wife Hilla adopted in their own practice. The term 'Düsseldorf School' is commonly used to describe five of Becher's earliest students: Andreas Gursky, Candida Höfer, Axel Hütte, Thomas Ruff and Thomas Struth. Although their approaches differ, they each adopted the Bechers' dispassionate aesthetic while applying it to contemporary subject matter. This was the beginning of the Deadpan style that dominated much of international photography during the 1990s and early 2000s.

Deadpan photographers show their subjects starkly, in high definition, with even lighting, from a substantial distance (if exterior), and without obvious narrative or personal cues. Individual experience and interaction is absent, removing subjectivity and sentimentality.

Technological advancement in the form of digital manipulation and the ability to produce large-scale, highly detailed prints allowed Deadpan photographers to render apparent objectivity on a monumental scale in a way that has come to be associated with the 'contemporary sublime'. Gursky's scenes of huge crowds of people seen from

◀ **ANDREAS GURSKY**
Chicago, Board of Trade II,
1999
Tate, UK

Dense masses of people feature often in Gursky's work. Here, the elevated vantage point and distance from his subject allows him to register the vast scale and intense activity of the trade floor.

▼ **CANDIDA HÖFER**
Kunsthalle Karlsruhe V, 1999
San Francisco Museum of Modern Art

A characteristic example of Höfer's focus on public or semi-public spaces and use of only existing light, which here becomes a subject in its own right.

OTHER WORKS

RINEKE DIJKSTRA
Montemor, Portugal, May 1, 1994, C, 1994,
from *Bullfighters,* 1994, 2000
San Francisco Museum of Modern Art

AXEL HÜTTE
Furka, Switzerland (Furka, Schweiz [I]), 1995
Fotomuseum Winterthur

THOMAS RUFF
Portrait (Stoya), 1986, from *Portraits,* 1986–91
Stedelijk Museum, Amsterdam

THOMAS STRUTH
San Zaccaria, Venice, 1995, from *Museum Photographs,*
1989–2002
Museum of Modern Art, New York

high vantage points offer a dense, dizzying experience in which the masses rather than individuals are the central subject. Like Luigi Ghirri before them, Olivo Barbieri, Walter Niedermayr and Massimo Vitali focus on man's interaction with the landscape, albeit seen from a distance where people are dwarfed by their surroundings.

Deadpan images often verge on the abstract: Höfer's images of the interior of cultural institutions emphasise structural symmetry and linearity. Her work, like many of Hütte's and Gursky's landscapes, recalls the geometric abstraction of Minimalist painting. It was this, as well as the large scale and the Bechers' establishing of the photograph as an art object, that helped Deadpan propel the reputation of the photographic medium to the level of painting and installation in auction houses and exhibition spaces during the 1990s.

 New Objectivity; Conceptualism; New Topographics; Postmodernism; Environmentalism & Globalisation

 Pictorialism; Social Realism; Subjectivism; Diarism; New Formalism

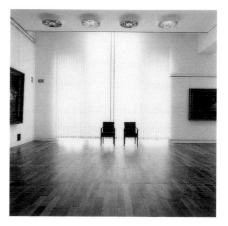

 Since the 1990s, the rapid growth of the global economy and heightened awareness of man's impact on nature has revitalised landscape photography, which now addresses mass consumption, global power and the delicate balance of social, political and economic forces.

EDWARD BURTYNSKY (1955–); **MITCH EPSTEIN** (1952–); **NADAV KANDER** (1961–); **SOPHIE RISTELHUEBER** (1949–); **SEBASTIÃO SALGADO** (1944–)

consumption; nature; objectivity; power; urbanisation

In 1968, the reproduction of the first complete satellite image of the earth on the cover of countercultural magazine *Whole Earth Catalog,* and the release of

Earthrise, taken by Apollo 8 astronauts, generated a new culture of global and environmental awareness. Photographers such as Robert Adams typified the new wave of images that responded to this by registering man's imprint on nature. Since the 1990s, landscape photography has again been reinvigorated by awareness of climate change and diminishing natural resources, as well as issues relating to globalisation, economic growth and the uneven distribution of labour and wealth.

Edward Burtynsky, Mitch Epstein and Richard Misrach have examined political and economic forces through the production and consumption of energy via fossil fuels, nuclear power and renewables. Working in the detached style of New Topographics

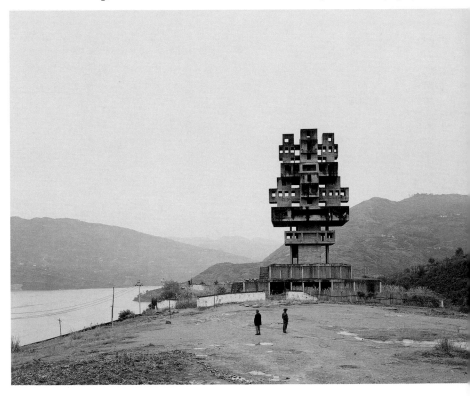

photography, they create large-scale colour landscapes that present energy production as impositions on the natural landscape.

Explicit critique of the human impact on nature is also seen in the work of Daniel Beltrá, David Maisel, and Susan Sayler and Edward Morris. Beltrá and Maisel both use aerial photography to create visually rich, near-abstract colour images of polluted seas and landscapes. Sayler and Morris's images of landscapes ravaged by drought, natural fires and melting icecaps were produced alongside research teams and conservation scientists, and are exhibited to promote understanding of climate change.

The effects of urbanisation, war, and economic and industrial growth on inhabited landscapes are the subject of work by Nadav Kander, Vera Lutter, Simon Norfolk, Sophie Ristelhueber, Thomas Struth and Michael Wolf. While Wolf and Lutter have produced large cityscapes that highlight the density of urban or industrial infrastructure, Ristelhueber has traced the destruction of nature and civilisations as a result of political conflict in Beirut, Iraq and Kuwait. In their respective series on China, Kander and Struth have reflected on the ways in which human life coexists amid the physical developments that result from the rapid growth of the country's economy.

Photographers such as Sammy Baloji, Nyaba Leon Ouedraogo and Sebastião Salgado take a more humanist approach. The subjects of Salgado's epic images, for instance, range from sublime landscapes of the last 'untouched' corners of the globe to portrayals of the strength and resilience of the human population.

NADAV KANDER
Fengjie III (Monument to Progress and Prosperity), Chongqing Municipality, 2007,
from *Yangtze – The Long River,* 2006–7
Museum of Contemporary Photography, Chicago

Kander captures what appears to be a hastily erected monument, the wide-angle shot allowing the viewer to take in how incongruous it seems in its surroundings. Like the Yangtze itself, in this series it symbolises the accelerated expansion and rapid change of a country experiencing massive economic growth.

OTHER WORKS

SAMMY BALOJI
Raccord #1, Cité de Kawama, from *Kolwezi,* 2011
Minneapolis Institute of Art, Minnesota

EDWARD BURTYNSKY
Nickel Tailings #34, Sudbury, Ontario, 1996, printed 1998, from *Tailings,* 1995–96
National Gallery of Canada, Ontario

MITCH EPSTEIN
Amos Coal Power Plant, Raymond, West Virginia, 2004, from *American Power,* 2003–8
San Francisco Museum of Modern Art

SOPHIE RISTELHUEBER
Fait, 1992
National Gallery of Canada, Ontario

SEBASTIÃO SALGADO
Serra Pelada, Brazil, 1986, from *Workers: An Archaeology of the Industrial Age,* 1986–92
International Center of Photography, New York

 Travel, Expedition & Tourism; New Topographics; Düsseldorf Deadpan; Activism

 The Nude; Still Life; Postwar Fashion; New Formalism

Activist photography is used to foreground human rights issues and support social movements. The Internet has transformed the way photography is used to communicate and mobilise civic action.

SHEBA CHHAACHI (1958–); **DANNY LYON** (1942–); **SUSAN MEISELAS** (1948–); **ZANELE MUHOLI** (1972–); **GUY TILLIM** (1962–)

advocacy; call to action; social injustice; social movement; uprising

In the late 19th century, John Thomson, in London, and Jacob Riis, in New York, each made photographs of the living and working conditions endured by the urban poor that were successfully used to improve these situations. Photography has been used as an agent for change ever since: shaped by social documentary and photojournalism, which flourished from the 1930s, and invigorated by the strident approach that characterised this genre in the postwar era, by photographers like Danny Lyon, a campaigner for the US Civil Rights movement.

Today, activist photography might be made independently or on commission, circulated in marketing campaigns or by protest movements, displayed in art galleries or on the street. Although not all photographs that communicate social injustice are made with activist intent, the majority of images that act as a call to action fall under the categories of documentary or photojournalism.

The politics of making images that advocate for others is a major point of concern within activist photography. Some of the most important voices in this regard were members of South Africa's Afrapix agency (1982–91), including Santu

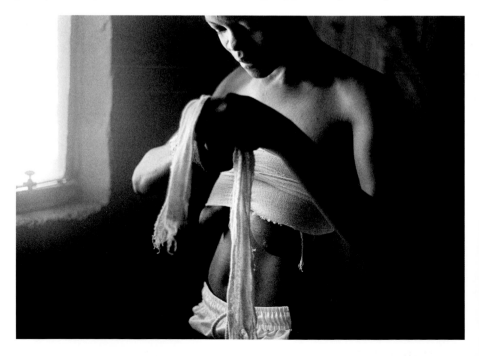

Mofokeng, Cedric Nunn and Guy Tillim. Working in the late-apartheid era, they promoted photography's ability to bring about change.

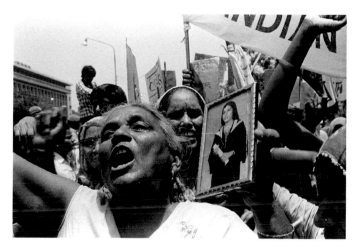

Sheba Chhachhi has similarly addressed what she has called 'the representation of politics and the politics of representation'. To portray the feminist movement in India, she not only documented protests, but invited the women involved to sit for portraits over which they had full control. Self-described 'visual activist' Zanele Muholi also employs similar strategies to grant agency to the members of South Africa's black LGBT communities.

Photography's ability to effect change has been transformed by the Internet age. At Magnum Photos, Susan Meiselas, herself a renowned activist photographer, has launched the 'Photography, Expanded' initiative to encourage photographers to use online platforms to disseminate images and galvanise audiences. In terms of impact, citizen journalism now plays a significant role, too, as seen in the Arab Spring uprisings in 2011, which represented a watershed moment in the use of social media to mobilise protest movements.

Social Realism; War Reportage, Photojournalism; Art Documentary; Post-Internet

Survey; Motionism; Still Life; Surrealism; New Formalism

↑ **SHEBA CHHACHHI**
Sathyarani – Anti Dowry Demonstration, Delhi, 1980, printed 2014, from *Seven Lives and a Dream,* 1980–91
Tate, UK

Chhachhi was an active part of the feminist movement in India. The portraits and shots of protests that form this 11-year series not only bore witness to the action, but were used to support the cause.

←

ZANELE MUHOLI
ID Crisis, from *Only Half the Picture,* 2003–6
Tate, UK

Muholi's sensitive depiction of a woman in the act of binding her breasts represents more than an intimate portrayal of one individual: it gives visibility to an under-represented community.

OTHER WORKS

DANNY LYON
Demonstrators Try to Enter an 'All-White' Swimming Pool, Cairo, IL, c 1962–64
Art Institute of Chicago

SUSAN MEISELAS
The Life of an Image: 'Molotov Man', 1979–2009, 2014
National Gallery of Art, Washington DC

GUY TILLIM
Protesters Calling for a Boycott of the Elections, Central Kinshasa, July 2006, from *Congo Democratic,* 2006
Tate, UK

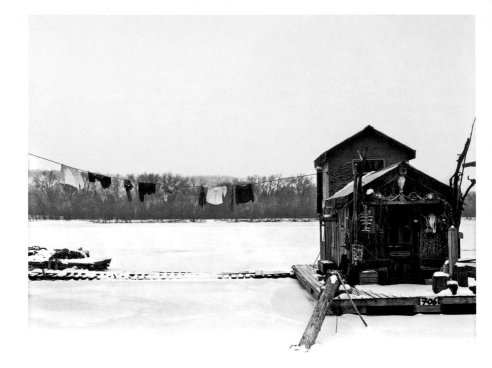

 Progressing from the notion of the photograph as an impartial witness, photographers take a conceptual approach to real scenarios, treating the relationship between art and documentary as a sliding scale, not a distinction.

 RINKO KAWAUCHI (1972–); BORIS MIKHAILOV (1938–); TARYN SIMON (1975–); ALEC SOTH (1969–); AKRAM ZAATARI (1966–)

conceptual; ephemera; installation; narrative; subjectivity

In his 1967 exhibition 'New Documents', curator John Szarkowsi introduced a new generation of photographers who, distinct from those associated with Social Realism, 'redirected the technique and aesthetic of documentary photography to more personal ends'. Today, the documentary mode has been reimagined by photographers who play with chronology, narrative and forms of presentation. Their approach suggests a hesitancy to accept the photograph as factual document, or evidence, and a tacit agreement with the viewer that the subject is presented from a conceptual standpoint.

Boris Mikhailov's *Red* (1968–75) is an example of a work that conveys social or political issues through a conceptual conceit. The loose grid of 84 photographs depict everyday life in the Ukraine; the subject matter is disparate, but each features the colour red, which unites the images while alluding to the ideology of the time. Disregard for linear narrative is also central to Rinko Kawauchi's practice, though in a

completely different style. She documents life in fragments; tender, ethereal images that offer glimpses of seemingly unrelated details, textures or fleeting gestures.

In the US, photographers including Alec Soth, Vanessa Winship and Christian Patterson are expanding upon the country's documentary tradition in projects that offer a deeply subjective view of people and place. For his photobook *Niagra* (2013), Soth explored the idea that the Falls attracts romance and heartbreak, and interspersed shots of motel rooms and portraits of honeymooning couples with photographs of found love letters. The inclusion of ephemera is characteristic of this genre. In contrast, Doug Rickard presents an alternative view of the US by mining Google Street View to source images of economically troubled, largely abandoned places.

The photographic archive and the installation each play an important role in Expanded Documentary. Akram Zaatari works with the archive of images in the Arab Image Foundation to foreground work that communicates untold stories about Middle Eastern culture and history. His installation *Hashem El Madani: Studio Practices* (2006) offers a view of Lebanon in the 1950s and 1960s through the collected work of a portrait photographer. Taryn Simon's practice is highly investigative, involving the use of photography and text to examine systems and structures that are hidden from view, or have escaped public consciousness. In *A Living Man Declared Dead and Other Chapters* (2008–11) she traced bloodlines and their related stories, displaying her findings as panels of portraits, written narratives and 'footnotes' to the project.

← **ALEC SOTH**
Charles, Vasa, Minnesota, 2002 (see p.120)
Peter's Houseboat, Winona, Minnesota,
both from *Sleeping by the Mississippi,* 1999–2004
Minneapolis Institute of Art, Minnesota

Soth's photobook *Sleeping by the Mississippi* (2004), in which these images were sequenced, resists clear narrative: it is a deliberately fragmented, dreamlike, and personal insight into America's 'third coast' as captured by the photographer over the course of several road trips.

OTHER WORKS

RINKO KAWAUCHI
Untitled, from *Illuminance,* 2007–11
Tokyo Photographic Art Museum

BORIS MIKHAILOV
Red, 1968–75, printed c 1999 2000
Tate, UK

TARYN SIMON
Chapter I, from *A Living Man Declared Dead and Other Chapters,* 2008–11
Museum of Modern Art, New York

AKRAM ZAATARI
Hashem El Madani: Studio Practices, 2006
Thyssen Bornemisza Art Contemporary, Vienna

Street & Society; Conceptualism; Art Documentary; Diarism; Fictional Narrativism

Survey; Futurism; Dadaism; The Family of Man; Advertising & Fashion; New Formalism

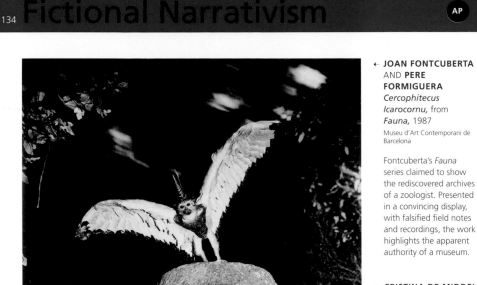

← **JOAN FONTCUBERTA** AND **PERE FORMIGUERA**
Cercophitecus Icarocornu, from *Fauna,* 1987
Museu d'Art Contemporani de Barcelona

Fontcuberta's *Fauna* series claimed to show the rediscovered archives of a zoologist. Presented in a convincing display, with falsified field notes and recordings, the work highlights the apparent authority of a museum.

↘ **CRISTINA DE MIDDEL**
Umeko, from *The Afronauts* (photobook), 2012
International Center of Photography, New York

In her narrative about the 1960s Zambian space mission, de Middel used an imagined cast of characters and fantastical costumes to reflect the spirit of imagination at the endeavour's heart.

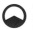 The use of staging, appropriation or image manipulation to tell a story that is real, imagined or a combination of both. In blurring the line between fact and fiction, photographers draw attention to the medium's complex relationship with truth.

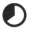 CRISTINA DE MIDDEL (1975–); JOAN FONTCUBERTA (1955–); KILUANJI KIA HENDA (1979–); ALEXANDRA LETHBRIDGE (1987–); MAX PINCKERS (1988–)

conceptual; convincing; evidence; image manipulation; staging

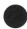 The photograph's position as 'evidence' is complicated and much contested. But its capacity for storytelling is certain. Many have explored this in projects that fuse the real and imagined to create rich visual narratives.

Some have explored how a true story can be communicated through re-enacting and staging, as well as through straightforward documentary. For Cristina de Middel, a former photojournalist, playing with fiction opens up new ways of engaging with important stories. In her photobook *The Afronauts* (2012) she staged images to represent Zambia's 1960s space programme, which was little documented at the time, and supported these with sketches and

pseudo-archival material to build a compelling narrative. Max Pinckers likewise takes real scenarios as his starting point: he anchored his 2013 series about an activist organisation in India with documentary photographs, real portraits and newspaper clippings, and elaborated on these with staged mises en scène and symbolic still lifes.

In other cases, fictional narratives highlight the authority that the photograph wields, and our will to believe what we see. Joan Fontcuberta has staged elaborate photographic hoaxes that mimic the look of fact-based formats, including reportage or scientific records. Kiluanji Kia Henda is interested in what he has called the photograph's capacity for 'sensationalism, omission or disorientation'. In *Icarus 13* (2007) he made a sequence of images shot in unrecognisable sites and presented them as 'documents' of an Angolan scientific mission to the sun as a fable about post-independence ambition. In contrast, Alexandra Lethbridge does not seek to query photography's veracity, but its capacity to spark the imagination. In projects including *The Meteorite Hunter* (2014) she blends archival, found, in-camera

and manipulated photographs in a playful manner so that the question of what is real or not becomes irrelevant.

The hybridising of fact and fiction has also bled into the work of photographers working from a documentary standpoint. Erica McDonald's *The Laundry Sherpas of Brooklyn* (2012–13) is an example of how the reframing of otherwise straightforward photographs, through the use of an imaginative title, for instance, can introduce a fictive element without deviating too far from the real scenario they depict – in this case street photographs of people headed to the launderette.

OTHER WORKS

KILUANJI KIA HENDA
Rusty Mirage (The City Skyline), 2013
Tate, UK

MAX PINCKERS
Will They Sing Like Raindrops or Leave Me Thirsty? (photobook), 2014
Museum of Modern Art, New York

ALEXANDRA LETHBRIDGE
The Meteorite Hunter (photobook), 2014
Museum of Modern Art, New York

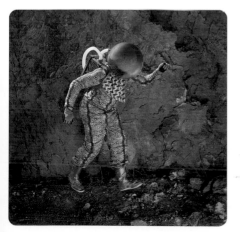

 Conceptualism; Postmodernism; Art Documentary; Staged Tableaux; Expanded Documentary

The Social Document; New Objectivity; Group f.64; War Reportage; New Formalism

The rise of surveillance and the changed nature of conflict have prompted new photographic application. Often creating their images by hijacking the technologies they are investigating, photographers reveal what hidden systems look like and how they permeate our lives.

EDMUND CLARK (1963–); **RAPHAËL DALLAPORTA** (1980–); **MISHKA HENNER** (1976–); **TREVOR PAGLEN** (1974–); **DONOVAN WYLIE** (1971–)

data; counter-terrorism; intelligence gathering; investigation; satellite

Post 9/11, the mechanisms behind conflict and counter-terrorism activity, and concerns about how surveillance technologies are an accepted part of life, have become a major subject in photography. Some photographic series concentrate on hidden sites: Edmund Clark, for instance, has documented camp complexes, naval bases and detainees' homes in Guantanamo Bay, and terrorist control centres to which he was granted access. Others reveal what is in plain sight, but taken for granted, as in Donovan Wylie's photographs of military watchtowers in England, Ireland and the Arctic, which illustrate how structures of national defence imprint themselves upon the landscape. Both employ the deadpan style associated with the New Topographics photographers.

Trevor Paglen seeks to represent the facets of mass surveillance and data collection that do not have an obvious or tangible form. In 2014, he located and photographed the buildings that housed

the top-five US intelligence agencies, and made his images freely available online. The buildings may look like any other civic institutions, but by bringing the images into the public domain he seeks to create what he has called a 'visual and cultural vocabulary' around surveillance, making it seem less of an abstract concept.

Collaboration – with scientists, human rights activists or journalists, among others – is a major characteristic of this genre. So too is investigation. Paradoxically, many photographers make use of the very surveillance technology on which they are commenting in order to create their work. Paglen has used commercial satellite technology to track classified US drones, while Mishka Henner has used Google Street View to help locate the overt and covert sites that are the focus of his series *Fifty One US Military Outposts* (2014).

These technologies can yield beautiful results. In Henner's *Dutch Landscapes* (2011) he captures the colourful shapes that the Dutch government use to censor sites on Google's satellite imagery, while Paglen's images from space possess an abstract quality sometimes referred to as an 'astronomical sublime'. For Raphaël Dallaporta, surveillance technology offered a means of making alternative representations of a country at war: in *Ruins* (2011) he used a pacifist drone to create striking aerial studies of landscapes in Afghanistan that represent important archaeological sites.

 EDMUND CLARK
Camp One: Exercise Cage from *Guantanamo: If the Light Goes Out,* 2009
Imperial War Museum, London

Shot straight-on, and devoid of people or action, Clark's image concentrates attention on the structure of one of the places that detainees must spend countless hours of their time. The mesh ceiling that takes up a third of the horizontal plane emphasises that this is a place of oppression.

↑ **TREVOR PAGLEN**
STSS-1 and Two Unidentified Spacecraft over Carson City (Space Tracking and Surveillance System, USA 205), 2010, from *The Other Night Sky,* 2007–11
Smithsonian American Art Museum, Washington DC

Paglen used data produced by amateur satellite observers to map secret American satellites and space debris in the earth's orbit, which he then shot using telescopes and digital and large-format cameras.

OTHER WORKS

RAPHAËL DALLAPORTA
Ruin, Season 1, from *Ruins,* 2011
Musée Nicéphore Niépce, Chalon-sur-Saône, France

MISHKA HENNER
Nato Storage Annex, Coevorden, Drenthe, from *Dutch Landscapes,* 2011
Centre Pompidou, Paris

DONOVAN WYLIE
OP 1a. Forward Operating Base, Masum Ghar, Kandahar Province, Afghanistan, 2010, printed 2015, from *Outposts,* 2010
National Gallery of Canada

 Survey; War Reportage; New Topographics; Post-Internet

The Nude; Still Life; Postwar Colour; Advertising & Fashion; New Formalism

A term coined in the early 2010s to describe a new generation making photography about photography. They use constructed sculptures, digital manipulation, or in-camera techniques to draw attention to the rudiments of the process, the physical nature of the photograph, and the labour involved in its construction.

WALEAD BESHTY (1976–); LUCAS BLALOCK (1978–); LIZ DESCHENES (1966–); JESSICA EATON (1977–); DANIEL GORDON (1980–)

abstraction; colour; constructed; process; still life

A wave of articles and exhibitions in the early 2010s, including 'New Photography' at the Museum of Modern Art, New York (2013), 'Under Construction' at Foam photography museum, Amsterdam (2014), and artist Chris Wiley's essay 'Depth of Focus' in *Frieze* (2011) acknowledged the growing tendency for young photographers to make work that takes photography itself as its subject.

This approach has come to be known as New Formalism, but has also been described as 'constructed' and 'concrete' photography; the latter a reference to Concrete Art. New Formalism can also be traced back to the early darkroom techniques of László Moholy-Nagy and others associated with the New Vision, via Conceptual artists like John Hilliard and James Welling, whose work foregrounds process, technique and perception.

Focus on the chemistry of traditional darkroom processes is a major strand of New Formalism. Walead Beshty and Liz Deschenes make camera-less works by exposing photographic paper or applying photographic chemicals to metal, respectively, to create abstracted fields of colour. Eileen Quinlan's process has involved the use of intentionally damaged film to cause colours to develop in unexpected ways, creating bold kaleidoscopic effects.

Others associated with this movement are interested in drawing attention to the constructed, physical nature of the photograph. Lucas Blalock uses Photoshop to wildly manipulate and rearrange his photographs of still lifes and tableaux vivants; the results suggest a computer glitch. In contrast, Hannah Whitaker's work features bold geometric patterns that appear to be digitally generated, but result from the artist piercing holes in her film, or photographing through cut-out paper. Daniel Gordon culls portraits from the Internet, which he prints and reassembles into painterly 3D collages that, when photographed, look as though they could have been made entirely in-computer.

While these works are gestural, bearing the mark of the artist's hand, Jessica Eaton uses sculpture to slightly different ends. She photographs monochromatic 3D cubes through colour filters, so that colour is 'added' in-camera. They look like digitally rendered optical illusions, though they are in essence object studies.

This use of the still life is a major characteristic of New Formalism. The return to studio-based practice, after decades when documentary-based practices dominated, suggests a young generation's confidence with the idea of photography as fine art, and the concept that the photograph does not have to represent, or 'be about', anything other than itself.

→ **WALEAD BESHTY**
Six Magnet, Three Color Curl (CMY: Irvine, California, September 6th 2009, Fuji Crystal Archive Type C), 2009
Museum of Contemporary Photography, Chicago

This work is a type of photogram, made without a camera, but by rolling sheets of photographic paper and exposing them to different coloured light: cyan, magenta and yellow.

OTHER WORKS

LUCAS BLALOCK
Right Shoe, 2013
Museum of Modern Art, New York

LIZ DESCHENES
Tilt/Swing #4B, from *Tilt/Swing,* 2009
Walker Art Center, Minneapolis

JESSICA EATON
cfaal 279, 2012, from *cfaal,* 2010–15
Museum of Fine Arts, St Petersburg, Florida

DANIEL GORDON
Red Headed Woman, 2008, from *Portrait Studio,* 2008–9
Museum of Modern Art, New York

 Still Life; Dadaism; Conceptualism; Postmodernism; Post-Internet

 Photojournalism; The Family of Man; Diarism; Düsseldorf Deadpan

Post-Internet refers to art concerned with the conditions of the digital age. Major subjects within this are the role the photograph plays in 'networked' culture, and the ways the Internet has affected our understanding of what photography is.

DIS COLLECTIVE (FOUNDED 2010); CONSTANT DULLAART (1979–); ANOUK KRUITHOF (1981–); KATE STECIW (1978–); PENELOPE UMBRICO (1957–)

appropriation; communities; data; networks; social media

The digital age has transformed how art is made and circulated. The avalanche of new technologies has created a new toolkit with which artists can work, while the question of how these technologies have impacted life, online and off, is fertile subject matter for exploration.

Given that more than one billion images are uploaded to the net each day, photography plays a major role in Post-Internet art. Artists address the new 'life' an image adopts when it is posted online: How is it reproduced and re-contextualised? What are the implications of it, and the data it contains, becoming the property of social media platforms? They look at the ways in which the mass of images impacts on us culturally and psychologically, and how the Internet has altered our perception of photography as an artistic medium.

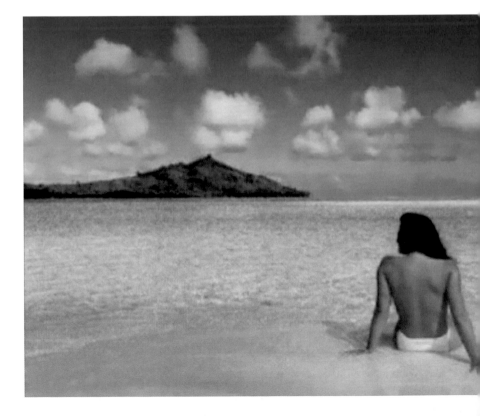

Post-Internet artists have, for example, been prompted to assert the distinction between the 'image' that exists online, as something ephemeral, and the photograph, as a physical object with a clear relationship to labour and craftsmanship. As a result, this has expanded the idea that photographic works have to exist in flat, two-dimensional forms and given rise to the prominence of photography-based sculptural works, as seen in the practices of artists such as Artie Vierkant or Anouk Kruithof.

Many Post-Internet works reflect an anxiety about the volume of images freely available online. Penelope Umbrico's photographic installations, made from Internet-sourced images, highlight the use of online photo communities and the volume of image content they generate. Erica Scourti has investigated how one can maintain individuality amid the glut of personal snapshots posted online, using tools like Google's 'Search by Image' function as part of her process.

Sometimes the use of this technology is a mode of critique. Just as Postmodernism saw the appropriation of mass-media imagery as a means of questioning their influence, Post-Internet artists adopt the aesthetic of digital media to expose their prevalence in contemporary visual culture. Stock images, corporate branding, emojis, GIFs and memes; impersonations of Tumblr, Instagram, and Facebook pages, can all feature. Kate Steciw, Constant Dullaart and the DIS Collective, for example, have all appropriated – or in DIS's case, created stock imagery in their work. They draw attention to its omnipresence in everyday life and also explore how such imagery can take on a new cultural and economic value when it is re-presented as fine art.

← **CONSTANT DULLAART**
Jennifer in Paradise, from *Jennifer in Paradise,*
2013–

This is the demonstration image used in the first edition of Photoshop, taken by the programme's co-creator John Knoll in 1988. Dullaart's series is homage to the image and its cultural significance. He rebuilt a high-resolution version of the file in Photoshop, then used its filter tools to distort it in various different ways.

OTHER WORKS

DIS COLLECTIVE
See http://disimages.com

ANOUK KRUITHOF
Pixel Stress (photobook), 2013
International Center of Photography, New York

PENELOPE UMBRICO
5,377,183 Suns from Flickr (Partial) 4/28/09, 2009
San Francisco Museum of Modern Art

 Futurism; Self-Portrait, Performance & Identity; Conflict & Surveillance; New Formalism

 Subjectivism; The Candid Portrait; Postwar Fashion; Art Documentary; Düsseldorf Deadpan

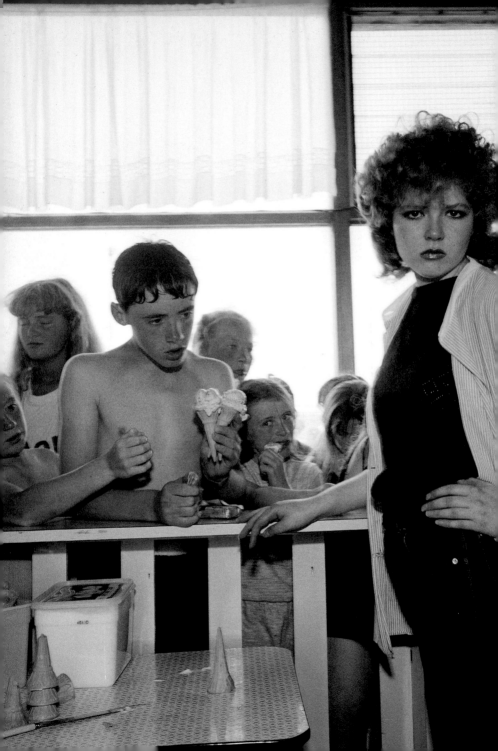

REFERENCE
SECTION

List of Photographers

A

ABBOTT, Berenice (1898–1991)
Industrialism

ADAMS, Ansel (1902–84)
Group f.64

ADAMS, Eddie (1933–2004)
War Reportage

ADAMS, Robert (1937–)
New Topographics;
Environmentalism & Globalisation

ADAMSON, Robert (1821–48)
The Social Document

AHO, Claire (1925–2015)
Postwar Fashion

ÁLVAREZ BRAVO, Lola
(1907–93)
Mexican Modernism

ÁLVAREZ BRAVO, Manuel
(1902–2002)
Mexican Modernism

ANDRIEU, Jules (1838–84)
Early Conflict

ANDUJAR, Claudia (1931–)
Art Documentary

ANSCHÜTZ, Ottomar (1846–
1907)
Motionism

APPERT, Eugène (1814–67)
Early Conflict

ARAKI, Nobuyoshi (1940–)
Diarism

ARBUS, Diane (1923–71)
The Candid Portrait

ARCHER, Frederick Scott
(1813–57)
Negative-Positivism

ARNATT, Keith (1930–2008)
Conceptualism

ARNOLD, Eve (1912–2012)
Photojournalism; Celebrity &
Paparazzism

ATGET, Eugène (1857–1927)
Early Street

ATKINS, Anna (1799–1871)
The First Photograph

AUSTEN, Alice (1866–1952)
Early Street

AVEDON, Richard (1923–2004)
Postwar Fashion

B

BAILEY, David (1938–)
Postwar Fashion

BALDESSARI, John (1931–)
Conceptualism

BALOJI, Sammy (1978–)
Environmentalism & Globalisation

BALTERMANTS, Dmitri (1912–90)
War Reportage

BALTZ, Lewis (1945–2014)
New Topographics

BARBIERI, Olivo (1954–)
Düsseldorf Deadpan

BARNARD, George (1819–1902)
Early Conflict

BASSMAN, Lillian (1917–2012)
Postwar Fashion

BAYARD, Hippolyte (1801–87)
Negative-Positivism

BEAMAN, EO (1837–76)
Survey

BEARD, Richard (1801–85)
Daguerreotypy; The Social
Document

BEATO, Felice (1832–1909)
Travel, Expedition & Tourism; Early
Conflict

BEATON, Cecil (1904–80)
Fashion & Society

BECHER, Bernd and Hilla
(1931–2007/1934–2015)
New Topographics; Düsseldorf
Deadpan

BELLMER, Hans (1902–75)
Surrealism

BELTRÁ, Daniel (1964–)
Environmentalism & Globalisation

BESHTY, Walead (1976–)
New Formalism

BIERMANN, Aenne (1898–1933)
New Objectivity

BILLINGHAM, Richard (1970–)
Diarism

BISCHOF, Werner (1916–54)
Photojournalism

BLALOCK, Lucas (1978–)
New Formalism

BLANQUART-EVRARD,
Louis-Désiré (1802–72)
Negative-Positivism; Travel,
Expedition & Tourism

BLOSSFELDT, Karl (1865–1932)
New Objectivity

BLUME, Anna and Bernhard
(1937– / 1937–2011)
Self-Portrait, Performance
& Identity

BLUMENFELD, Erwin (1897–
1969)
Fashion & Society; Postwar Colour

BOIFFARD, Jacques-André
(1902–61)
Surrealism

BOLTANSKI, Christian (1944–)
Conceptualism

BOUGHTON, Alice (1866–1943)
The Nude

BOURDIN, Guy (1928–91)
Postwar Fashion; Advertising &
Fashion

BOURKE-WHITE, Margaret
(1904–71)
Industrialism: War Reportage;
Photojournalism

BRADY, Mathew (1823–96)
Early Conflict

BRAGAGLIA, Anton Giulio
(1890–1960)
Motionism; Futurism

BRAGAGLIA, Arturo (1893–1962)
Motionism; Futurism

BRANDT, Bill (1904–83)
Early Street; The Nude;
Photojournalism; Art Documentary

BRANZI, Piergiorgio (1928–)
Street & Society

BRAQUEHAIS, Bruno (1823–75)
Early Conflict

BRASSAÏ (Gyula Halász)
(1899–1984)
Early Street; Surrealism

BRAUN, Adolphe (1812–77)
Travel, Expedition & Tourism; Still Life

BRIGMAN, Anne (1869–1950)
Pictorialism; The Nude

BURGIN, Victor (1941–)
Conceptualism

BURKE, John (c 1843–1900)
Early Conflict

BURROWS, Larry (1926–71)
War Reportage

BURTYNSKY, Edward (1955–)
Environmentalism & Globalisation

C

CAHUN, Claude (1894–1954)
Self-Portrait, Performance & Identity

CALLAHAN, Harry (1912–99)
Postwar Colour

CAMERON, Julia Margaret
(1815–79)
Pictorialism

CAMISA, Alfredo (1927–2007)
Subjectivism; Street & Society

CAPA, Cornell (1918–2008)
Photojournalism

CAPA, Robert (1913–54)
War Reportage

CARJAT, Étienne (1828–1906)
The Studio Portrait

CARTIER-BRESSON, Henri
(1908–2004)
Early Street; Mexican Modernism; Photojournalism; The Family of Man; Street & Society

CASTAGNERI, Mario (1892–1940)
Futurism

CHHACHHI, Sheba (1958–)
Activism

CLARK, Edmund (1963–)
Conflict & Surveillance

CLARK, Larry (1943–)
Art Documentary; Diarism

CLAUDET, Antoine (1797–1867)
Daguerreotypy; The Studio Portrait

COBURN, Alvin Langdon
(1882–1966)
Pictorialism

COLE, Ernest (1940–90)
Photojournalism

COOK, George S (1819–1902)
Early Conflict

COPPOLA, Horacio (1906–2012)
Still Life; Bauhaus and the New Vision

CORNELIUS, Robert (1809–93)
Daguerreotypy; The Studio Portrait

COWDEROY, Benjamin
(1812–1904)
Negative-Positivism

CREWDSON, Gregory (1962–)
Staged Tableaux

CUNNINGHAM, Imogen
(1883–1976)
The Nude; Group f.64

D

DAGUERRE, Louis-Jacques-Mandé
(1787–1851)
The First Photograph; Daguerreotypy; Negative-Positivism

DAHL-WOLFE, Louise
(1895–1989)
Fashion & Society

DALLAPORTA, Raphaël (1980–)
Conflict & Surveillance

DAVIDSON, Bruce (1933–)
Street & Society

DAVISON, George (1854–1930)
Pictorialism

DAVY, Humphry (1778–1829)
The First Photograph

DAY, Corinne (1962–2010)
Diarism

DAY, F Holland (1864–1933)
Pictorialism

DEAL, Joe (1947–2010)
New Topographics

DECARAVA, Roy (1919–2009)
The Family of Man

DEEN DAYAL, Lala (Raja)
(1844–1905)
The Studio Portrait

DELLENBAUGH, Frederick S
(1853–1935)
Still Life

DEMACHY, Robert (1859–1936)
Pictorialism; The Nude

DE MEYER, Adolph (1868–1946)
Fashion & Society; Still Life

DE MIDDEL, Cristina (1975–)
Fictional Narrativism

DEPERO, Fortunato (1892–1960)
Futurism

DESCHENES, Liz (1966–)
New Formalism

DIJKSTRA, Rineke (1959–)
Düsseldorf Deadpan

DISDÉRI, André-Adolphe-Eugène
(1819–89)
The Studio Portrait

DIS Collective (founded 2010)
Post-Internet

DIVOLA, John (1949–)
Conceptualism

DOISNEAU, Robert (1912–94)
Street & Society

DONOVAN, Terence (1936–96)
Postwar Fashion

DRTIKOL, František (1883–1961)
Pictorialism; The Nude

DU CAMP, Maxime (1822–94)
Travel, Expedition & Tourism

DUFFY, Brian (1933–2010)
Postwar Fashion

DULLAART, Constant (1979–)
Post-Internet

DUNCAN, David Douglas (1916–)
War Reportage

DURIEU, Eugène (1800–74)
The Nude

E

EAKINS, Thomas (1844–1916)
Motionism

EATON, Jessica (1977–)
New Formalism

EDGERTON, Harold (1903–90)
Motionism

EDWARDS, John Paul (1884–1968)
Group f.64

EGGLESTON, William (1939–)
Postwar Colour; Diarism

EISENSTAEDT, Alfred (1898–1995)
Photojournalism; The Family of Man

EMERSON, Peter Henry (1856–1936)
Pictorialism

EPSTEIN, Mitch (1952–)
Environmentalism & Globalisation

ÉRRAZURIZ, Paz (1944–)
Art Documentary

ERWITT, Elliott (1928–)
The Family of Man

ESSAYDI, Lalla (1956–)
Self-Portrait, Performance & Identity

EVANS, Frederick H (1853–1943)
Pictorialism

EVANS, Walker (1903–75)
Social Realism; The Candid Portrait; Street & Society

F

FARKAS, Thomaz (1924–2011)
Subjectivism

FENTON, Roger (1819–69)
Early Conflict; Still Life

FERRIER, Claude-Marie (1811–89)
Travel, Expedition & Tourism

FIEGER, Erwin (1928–2013)
Postwar Colour

FIZEAU, Hippolyte (1819–96)
Daguerreotypy

FONTCUBERTA, Joan (1955–)
Fictional Narrativism

FOSSO, Samuel (1962–)
Self-Portrait, Performance & Identity

FOX, Anna (1961–)
Satirism

FRANK, Robert (1924–)
Street & Society; Art Documentary

FREUND, Gisèle (1908–2000)
Postwar Colour

FRIEDLANDER, Lee (1934–)
Street & Society; Self-Portrait, Performance & Identity

FRITH, Francis (1822–98)
Travel, Expedition & Tourism

FUNKE, Jaromír (1896–1945)
New Objectivity

G

GALELLA, Ron (1931–)
Celebrity & Paparazzism

GARDNER, Alexander (1821–82)
Early Conflict

GEPPETTI, Marcello (1933–98)
Celebrity & Paparazzism

GILDEN, Bruce (1946–)
The Candid Portrait

GODDARD, John Frederick (1795–1866)
Daguerreotypy

GOLDBLATT, David (1930–)
Art Documentary

GOLDIN, Nan (1953–)
Diarism

GOHLKE, Frank (1942–)
New Topographics

GORDON, Daniel (1980–)
New Formalism

GRÄFF, Werner (1901–78)
Bauhaus & the New Vision

GRAHAM, Dan (1942–)
New Topographics

GRAHAM, Paul (1956–)
Satirism

GURSKY, Andreas (1955–)
Düsseldorf Deadpan

H

HAAS, Ernst (1921–86)
Postwar Colour

HAJEK-HALKE, Heinz (1898–1983)
The Nude

HALSMAN, Philippe (1906–79)
Photojournalism; Celebrity & Paparazzism

HANFSTAENGL, Franz (1804–77)
The Studio Portrait

HARE, David (1917–92)
Surrealism

HARRIS, Lyle Ashton (1965–)
Self-Portrait, Performance & Identity

HAUSMANN, Raoul (1886–1971)
Dadaism

HAWES, Josiah Johnson (1808–1901)
The Studio Portrait

HEARTFIELD, John (1891–1968)
Dadaism

HEINECKEN, Robert (1931–2006)
Postmodernism

HENDA, Kiluanji Kia (1979–)
Fictional Narrativism

HENNEMAN, Nicolaas (1813–98)
Negative-Positivism

HENNER, Mishka (1976–)
Conflict & Surveillance

HENRI, Florence (1893–1982)
Still Life

HERSCHEL, John (1792–1871)
The First Photograph; Negative-Positivism

HERZOG, Fred (1930–)
Postwar Colour

HILL, David Octavius (1802–70)
The Social Document

HILLERS, John K (1843–1925)
Survey

HILLIARD, John (1945–)
Conceptualism; New Formalism

HINE, Lewis (1874–1940)
The Social Document

HÖCH, Hannah (1889–1978)
Dadaism

HÖFER, Candida (1944–)
Düsseldorf Deadpan

HOGG, Jabez (1817–1909)
Daguerrotypy

HOLDER, Preston (1907–80)
Group f.64

HORNA, Kati (1912–2000)
Surrealism; Mexican Modernism

HORST, Horst P (1906–99)
Fashion & Society

HOSOE, Eikoh (1933–)
Street & Society; Diarism

HOYNINGEN-HUENE, George
(1900–1968)
The Nude

HUNTER, Alexis (1948–2014)
Conceptualism

HÜTTE, Axel (1951–)
Düsseldorf Deadpan

I

IGNATOVICH, Boris (1899–1976)
Constructivism

ISENRING, Johann Baptist
(1796–1860)
Daguerreotypy

ISHIUCHI, Miyako (1947–)
Street & Society

ITURBIDE, Graciela (1942–)
Art Documentary

IWAMIYA, Takeji (1920–89)
Subjectivism

J

JACKSON, William Henry
(1843–1942)
Survey

JANAH, Sunil (1918–2012)
Photojournalism

JONES, Sarah (1959–)
Staged Tableaux

JONES GRIFFITHS, Philip
(1936–2008)
War Reportage

K

KANAGA, Consuelo (1894–1978)
Group f.64; The Family of Man

KANDER, Nadav (1961–)
Environmentalism & Globalisation

KÄSEBIER, Gertrude (1852–1934)
Pictorialism

KAWADA, Kikuji (1933–)
Street & Society

KAWAUCHI, Rinko (1972–)
Expanded Documentary

KEETMAN, Peter (1916–2005)
Subjectivism

KEPES, György (1906–2001)
Bauhaus & the New Vision

KEPPLER, Victor (1904–87)
Postwar Colour

KERTÉSZ, André (1894–1985)
Early Street; The Nude; Street &
Society

KILLIP, Chris (1946–)
Art Documentary

KINSZKI, Imre (1901–45)
New Objectivity

KLEIN, William (1928–)
Street & Society; Postwar Fashion;
Art Documentary

KLUTSIS, Gustav (1895–1938)
Constructivism

KNIGHT, Nick (1958–)
Advertising & Fashion

KONTTINEN, Sirkka-Liisa (1948–)
Art Documentary

KOPPITZ, Rudolf (1884–1936)
The Nude

KOUDELKA, Josef (1938–)
Art Documentary

KRUITHOF, Anouk (1981–)
Post-Internet

KRULL, Germaine (1897–1985)
The Nude; Industrialism

KÜHN, Heinrich (1866 1944)
Pictorialism; Still Life

KUROKAWA, Suizan (1882–
1944)
Pictorialism

L

LANGE, Dorothea (1895–1965)
Group f.64; Social Realism; The
Family of Man

LANGLOIS, Jean-Charles
(1789–1870)
Early Conflict

LARTIGUE, Jacques-Henri
(1894–1986)
Early Street

LAUTERWASSER, Siegfried
(1913–2000)
Subjectivism

LAVENSON, Alma (1897–1989)
Group f.64

LE GRAY, Gustave (1820–84)
Negative-Positivism; Early Conflict;
Pictorialism

LEIBOVITZ, Annie (1949–)
Advertising & Fashion

LEITER, Saul (1923–2013)
Postwar Colour

LEREBOURS, Noël Marie Paymal
(1807–73)
Travel, Expedition & Tourism

LETHBRIDGE, Alexandra (1987–)
Fictional Narrativism

LEVINE, Sherrie (1947–)
Postmodernism

LEVITT, Helen (1913–2009)
Street & Society

LISSITZKY, El (1890–1941)
Constructivism

LIST, Herbert (1903–75)
The Nude

LUMIÈRE, Auguste (1862–1954)
Motionism

LUMIÈRE, Louis (1864–1948)
Motionism

LUTTER, Vera (1960–)
Environmentalism & Globalisation

LUTTERODT, George (active from 1876)
The Studio Portrait

LYNES, George Platt (1907–55)
The Nude

LYON, Danny (1942–)
Street & Society; Art Documentary;
Activism

M

MAAR, Dora (1907–97)
Surrealism

MAGUBANE, Peter (1932–)
Photojournalism

MAISEL, David (1961–)
Environmentalism & Globalisation

MANDEL, Mike (1950–)
Conceptualism

MAN RAY (Emmanuel Radnitzky)
(1890–1976)
The Nude; Fashion & Society;
Dadaism; Surrealism

MAPPLETHORPE, Robert
(1946–89)
Self-Portrait, Performance & Identity

MAREY, Étienne-Jules (1830–1904)
Motionism

MARK, Mary Ellen (1940–2015)
The Candid Portrait; Art
Documentary

MARTIN, Paul (1864–1944)
Early Street

MARVILLE, Charles (1813–79)
Early Street

MASOERO, Filippo (1894–1969)
Futurism

MATSUMOTO, Eiichi (1915–2004)
War Reportage

MAYALL, John JE (1813–1901)
The Studio Portrait

MCCOSH, John (1805–85)
Early Conflict

MCCULLIN, Don (1935–)
War Reportage

MCDONALD, Erica (1975–)
Fictional Narrativism

MCGINLEY, Ryan (1977–)
Diarism

MEISELAS, Susan (1948–)
Activism

MENDIETA, Ana (1948–85)
Conceptualism

MEYEROWITZ, Joel (1938–)
Postwar Colour

MICHALS, Duane (1932–)
Street & Society

MIKHAILOV, Boris (1938–)
Self-Portrait, Performance &
Identity; Expanded Documentary

MILI, Gjon (1904–84)
Motionism

MILLER, Lee (1907–77)
Surrealism; War Reportage

MISRACH, Richard (1949–)
Environmentalism & Globalisation

MODEL, Lisette (1901–83)
The Candid Portrait

MODOTTI, Tina (1896–1942)
Mexican Modernism

MOFOKENG, Santu (1956–)
Activism

MOHOLY, Lucia (1894–1989)
Bauhaus & the New Vision

MOHOLY-NAGY, László
(1895–1946)
Bauhaus & the New Vision

MOORE, David (1961–)
Satirism

MORIMURA, Yasumasa (1951–)
Postmodernism

MORIYAMA, Daido (1938–)
Street & Society; Diarism

MORRIS, Edward (1971–)
Environmentalism & Globalisation

MOULINS, Félix-Jacques (1802–75)
The Nude

MUHOLI, Zanele (1972–)
Activism

MUNARI, Bruno (1907–88)
Futurism

MUNKÁCSI, Martin (1896–1963)
Fashion & Society

MURAY, Nickolas (1892–1965)
Still Life

MUYBRIDGE, Eadweard
(1830–1904)
Motionism

N

NADAR (Gaspard-Félix
Tournachon) (1820–1910)
The Studio Portrait

NAKAHIRA, Takuma (1938–)
Diarism

NÈGRE, Charles (1820–80)
Early Street

NESHAT, Shirin (1957–)
Self-Portrait, Performance & Identity

NEVILLE, Mark (1966–)
Satirism

NEWMAN, Arnold (1918–2006)
Celebrity & Paparazzism

NEWTON, Helmut (1920–2004)
Postwar Fashion

NICÉPHORE NIÉPCE, Joseph
(1765–1833)
The First Photograph;
Daguerreotypy; Still Life

NIEDERMAYR, Walter (1952–)
Düsseldorf Deadpan

NIXON, Nicholas (1947–)
New Topographics

NIZZOLI, Marcello (1897–1969)
Futurism

NORFOLK, Simon (1963–)
Environmentalism & Globalisation

NOSKOWIAK, Sonya (1900–75)
Group f.64

NUNN, Cedric (1957–)
Activism

O

ORKIN, Ruth (1921–85)
Postwar Colour

O'SULLIVAN, Timothy H
(1840–82)
Survey; Early Conflict

OUEDRAOGO, Nyaba Leon
(1978–)
Environmentalism & Globalisation

OUTERBRIDGE, Paul (1896–1958)
Still Life

P

PAGLEN, Trevor (1974–)
Conflict & Surveillance

PALADINI, Vinicio (1902–71)
Futurism

PANNAGGI, Ivo (1901–81)
Futurism

PARKINSON, Norman (1913–90)
Postwar Fashion

PARKS, Gordon (1912–2006)
Social Realism

PARR, Martin (1952–)
Art Documentary; Satirism

PATTERSON, Christian (1972–)
Expanded Documentary

PENN, Irving (1917–2009)
Postwar Fashion

PETERHANS, Walter (1897–1960)
Still Life; Bauhaus & the New Vision

PETERSEN, Anders (1944–)
Art Documentary

PIERSON, Pierre-Louis (1822–1913)
The Studio Portrait

PINCKERS, Max (1988–)
Fictional Narrativism

PIPER, Adrian (1948–)
Self-Portrait, Performance & Identity

PONTING, Herbert (1870–1935)
Travel, Expedition & Tourism

PRINCE, Richard (1949–)
Postmodernism

Q

QINGSONG, Wang (1966–)
Staged Tableaux

QUIGLEY, Edward (1898–1977)
Industrialism

QUINLAN, Eileen (1972–)
New Formalism

R

RANGEL, Ricardo (1924–2009)
Art Documentary

RAY-JONES, Tony (1941–72)
Art Documentary

REAS, Paul (1955–)
Satirism

REISEWITZ, Wolfgang
(1917–2012)
Subjectivism

REJLANDER, Oscar G (1813–75)
The Social Document; Pictorialism;
The Nude

RENGER-PATZSCH, Albert
(1897–1966)
New Objectivity; Industrialism

RIBOUD, Marc (1923–2016)
Photojournalism

RICKARD, Doug (1968–)
Expanded Documentary

RIIS, Jacob (1849–1914)
The Social Document

RISTELHUEBER, Sophie (1949–)
Environmentalism & Globalisation

ROBERTSON, James (1813–88)
Early Conflict

ROBINSON, Henry Peach
(1830–1901)
Pictorialism

RODCHENKO, Alexander
(1891–1956)
Constructivism

RODGER, George (1908–95)
War Reportage; Photojournalism

ROH, Franz (1890–1965)
Bauhaus & the New Vision

RONIS, Willy (1910–2009)
Street & Society

ROSENTHAL, Joe (1911–2006)
War Reportage

ROSLER, Martha (1943–)
Conceptualism; Postmodernism

ROTHSTEIN, Arthur (1915–85)
Social Realism

RUFF, Thomas (1958–)
Düsseldorf Deadpan

RUSCHA, Ed (1937–)
Conceptualism; New Topographics

S

SALGADO, Sebastião (1944–)
Environmentalism & Globalisation

SALOMON, Erich (1886–1944)
Photojournalism

SANDER, August (1876–1964)
The Social Document; New
Objectivity

SANKO, Galina (1904–81)
War Reportage

SAYLER, Susan (1969–)
Environmentalism & Globalisation

SCHAD, Christian (1894–1982)
Dadaism

SCHLABS, Bronisław (1920–2009)
Subjectivism

SCHNEIDERS, Toni (1920–2006)
Subjectivism

SCHOTT, John (1944–)
New Topographics

SCOURTI, Erica (1980–)
Post-Internet

SECCHIAROLI, Tazio (1925–98)
Celebrity & Paparazzism

SEKULA, Allan (1951–2013)
Postmodernism

SEYMOUR, David 'Chim'
(1911–56)
War Reportage

SHEELER, Charles (1883–1965)
Industrialism

SHERMAN, Cindy (1954–)
Postmodernism; Self-Portrait,
Performance & Identity

SHORE, Stephen (1947–)
Postwar Colour; New Topographics;
Diarism

SILVY, Camille (1834–1910)
The Studio Portrait; Pictorialism

SIMON, Taryn (1975–)
Expanded Documentary

SISKIND, Aaron (1903–1991)
Subjectivism

SKOGLUND, Sandy (1946–)
Staged Tableaux

SMITH, W Eugene (1918–78)
War Reportage

SMITH, Graham (1947–)
Art Documentary

SOMMER, Frederick (1905–99)
Still Life

SORCI, Elio (1932–2013)
Celebrity & Paparazzism

SOTH, Alec (1969–)
Expanded Documentary

SPENCE, Jo (1934–92)
Self-Portrait, Performance & Identity

STACKPOLE, Peter (1913–97)
Group f.64

STARKEY, Hannah (1971–)
Staged Tableaux

STECIW, Kate (1978–)
Post-Internet

STEICHEN, Edward (1879–1973)
Pictorialism; Fashion & Society; Still
Life; The Family of Man

STEINER, Ralph (1899–1986)
Still Life; Industrialism

STEINERT, Otto (1915–78)
Subjectivism

STERN, Grete (1904–99)
Surrealism

STERNFELD, Joel (1944–)
Postwar Colour

STIEGLITZ, Alfred (1864–1946)
Pictorialism; Still Life

STRAND, Paul (1890–1976)
Early Street; Still Life; Industrialism;
Group f.64; The Candid Portrait

STRUTH, Thomas (1954–)
Düsseldorf Deadpan;
Environmentalism & Globalisation

SULTAN, Larry (1946–2009)
Conceptualism

SWIFT, Henry (1891–1962)
Group f.64

SZATHMARI, Carol (1812–87)
Early Conflict

T

TABARD, Maurice (1897–1984)
The Nude; Surrealism

TAKANASHI, Yutaka (1935–)
Street & Society

TALBOT, William Henry Fox
(1800–77)
The First Photograph; Negative-
Positivism

TARO, Gerda (1910–37)
War Reportage

TATO (Guglielmo Sansoni)
(1896–1974)
Futurism

TELLER, Juergen (1964–)
Advertising & Fashion

TESTINO, Mario (1954–)
Advertising & Fashion

THOMSON, John (1837–1921)
Travel, Expedition & Tourism; The
Social Document

TILLIM, Guy (1962–)
Activism

TILLMANS, Wolfgang (1968–)
Diarism

TOMATSU, Shomei (1930–2012)
Street & Society

TOSCANI, Oliviero (1942–)
Advertising & Fashion

TOURNACHON, Adrien
(1825–1903)
The Studio Portrait

TOURTIN, Emile (active 1873–99)
The Studio Portrait

TRCKA, Anton Josef (1893–1940)
Pictorialism

TRIPE, Linnaeus (1822–1902)
Travel, Expedition & Tourism

TSCHICHOLD, Jan (1902–74)
Bauhaus & the New Vision

TURBEVILLE, Deborah
(1932–2013)
Postwar Fashion

U

UBAC, Raoul (1910–85)
Surrealism

UMBRICO, Penelope (1957–)
Post-Internet

ÚT, Nick (Huynh Công) (1951–)
War Reportage

V

VAN DER ELSKEN, Ed (1925–90)
Diarism

VAN DYKE, Willard (1906–86)
Group f.64

VIERKANT, Artie (1986–)
Post-Internet

VITALI, Massimo (1944–)
Düsseldorf Deadpan

VYARAWALLA, Homai
(1913–2012)
Photojournalism

W

WALKER, Tim (1970–)
Advertising & Fashion

WALL, Jeff (1946–)
Staged Tableaux

WALLACE, Dougie ('Glasweegee')
(1974–)
Satirism

WARHOL, Andy (1928–87)
Celebrity & Paparazzism

WATKINS, Carleton E
(1829–1916)
Survey

WATKINS, Margaret (1884–1969)
Still Life

WATSON-SCHÜTZE, Eva
(1867–1935)
Pictorialism

WEARING, Gillian (1963–)
Self-Portrait, Performance & Identity

WEDGWOOD, Thomas
(1777–1805)
The First Photograph

WEEGEE (Arthur Fellig)
(1899–1968)
The Candid Portrait; Street &
Society; Celebrity & Paparazzism

WEEMS, Carrie Mae (1953–)
Staged Tableaux

WELLING, James (1951–)
New Formalism

WESSEL, Henry, Jr (1942–)
New Topographics

WESTON, Brett (1911–93)
Group f.64

WESTON, Edward (1886–1958)
The Nude; Still Life; Mexican
Modernism; Group f.64

WHIPPLE, John Adams (1822–91)
Daguerreotypy

WHITAKER, Hannah (1980–)
New Formalism

WHITE, Clarence H (1871–1925)
Pictorialism; Still Life

WHITE, Minor (1908–76)
Still Life; Subjectivism

WILKE, Hannah (1940–93)
Conceptualism; Self-Portrait,
Performance & Identity

WILLIAMS, Christopher (1956–)
Conceptualism

WILLIAMS, Thomas Richard
(1824–71)
Still Life

WINDSTOSSER, Ludwig
(1921–83)
Subjectivism

WINOGRAND, Garry (1928–84)
Street & Society

WINSHIP, Vanessa (1960–)
Expanded Documentary

WOLCOTT, Marion Post (1910–90)
Social Realism

WOLF, Michael (1954–)
Environmentalism & Globalisation

WOODMAN, Francesca
(1958–81)
Self-Portrait, Performance & Identity

WORTHINGTON, Arthur Mason
(1852–1916)
Motionism

WURM, Erwin (1954–)
Self-Portrait, Performance & Identity

WULZ, Wanda (1903–84)
Futurism

WYLIE, Donovan (1971–)
Conflict & Surveillance

Y

YAMAHATA, Yosuke (1917–66)
War Reportage; The Family of Man

YAMAWAKI, Iwao (1898–1987)
Still Life; Bauhaus & the New Vision

Z

ZAATARI, Akram (1966–)
Expanded Documentary

ZELMA, Gyorgy (1906–84)
Constructivism

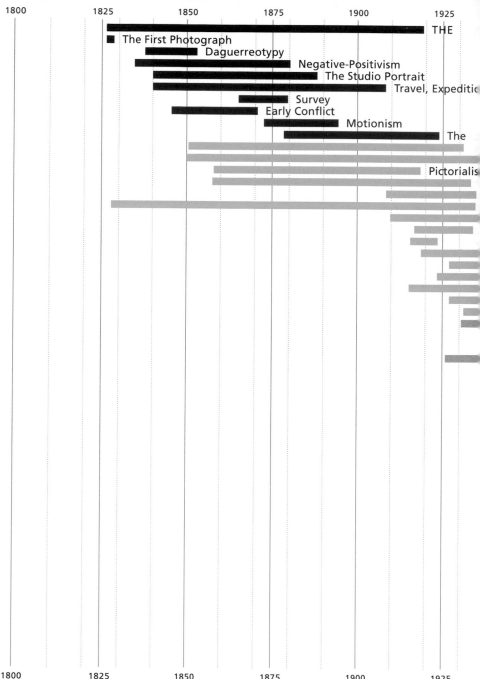

The First Photograph
Daguerreotypy
Negative-Positivism
The Studio Portrait
Travel, Expeditio
Survey
Early Conflict
Motionism
THE
The
Pictorialis

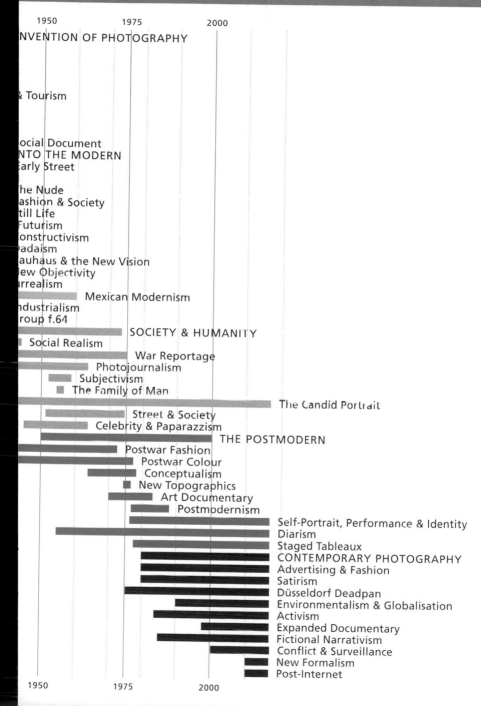

1950 1975 2000

NVENTION OF PHOTOGRAPHY

& Tourism

ocial Document
NTO THE MODERN
Early Street

he Nude
ashion & Society
till Life
Futurism
onstructivism
adaism
auhaus & the New Vision
lew Objectivity
irrealism

Mexican Modernism
ndustrialism
roup f.64

SOCIETY & HUMANITY

Social Realism

War Reportage
Photojournalism
Subjectivism
The Family of Man

The Candid Portrait

Street & Society
Celebrity & Paparazzism

THE POSTMODERN

Postwar Fashion
Postwar Colour
Conceptualism
New Topographics
Art Documentary
Postmodernism

Self-Portrait, Performance & Identity
Diarism
Staged Tableaux
CONTEMPORARY PHOTOGRAPHY
Advertising & Fashion
Satirism
Düsseldorf Deadpan
Environmentalism & Globalisation
Activism
Expanded Documentary
Fictional Narrativism
Conflict & Surveillance
New Formalism
Post-Internet

1950 1975 2000

ABSTRACTION
The use of in-camera or darkroom techniques to focus on particular characteristics and exclude others, to the point that the image is no longer representational; or, creating non-representational shapes and forms without a camera, for example through the use of light.

APERTURE
The hole within a camera lens through which light passes to reach the sensor. The size of the aperture is calibrated in 'f-stops': the higher the stop, the smaller the aperture, and the greater depth of field.

APPROPRIATION
Art that adopts imagery, ideas or materials from pre-existing sources, including other artworks. This can involve the modification of the chosen works, but from the late 1970s original material began to be presented largely unmediated by American artists like Richard Prince and Sherrie Levine.

BROMOIL PROCESS
(See *Oil-Pigment Process)*

BRÛLAGE
A distortion technique invented by Surrealist photographers Raoul Ubac and David Hare whereby the negative is subject to intense heat, causing the film emulsion to melt and warp. The results are difficult to control, and in prints made from these negatives, the subject appears to be twisted and deformed.

CALOTYPE
The first process for creating paper negatives, also known as the Talbotype after inventor William Henry Fox Talbot, who patented it in 1841. A piece of writing paper was coated with chemical solutions before being placed in the camera to expose a latent image. This was then developed in the darkroom to leave a deep brown negative image. Positive prints could then be made from these calotype negatives (see *Salt Print).*

CAMERA OBSCURA
A darkened room, or a box, with a hole through which light from an outside source passes, projecting an inverted version of the outside view onto the opposite surface. Discovered in the 11th century and improved with the use of mirrors from the 16th century on, to project the image with the correct orientation. Used as a drawing aid for artists, the camera obscura was a direct precursor to the photographic camera.

CANDID
A photograph that is direct, honest and frank, usually used in this context to describe an informal photograph taken without the subject having prepared for the shot, or even without their knowledge that it is being taken.

CARTES DE VISITE
Portraits printed on 4 x 2 ½ inch (10 x 6 cm) paper, the size of the formal calling card, patented by André-Adolphe-Eugène Disdéri in 1854. The craze for cartes des visite, at its peak in the 1860s, saw people collect cards of celebrities and aristocracy – which they could purchase at stationers – as well as family and friends.

CHROMOGENIC PRINT
A colour print made from a colour negative, transparency or digital file, using chromogenic colour processes and materials, which were first introduced to the market in the mid-1930s. Kodak Type-C paper was a specific brand of chromogenic paper, which has led to the colloquial use of the terms 'C-Type' and 'C-Print' to refer to chromogenic colour prints.

CHRONOPHOTOGRAPHY
A method for analysing motion by taking a series of still pictures at regular intervals through the action's duration. The term was coined by Étienne Jules Marey in 1870, but the process established by Eadward Muybridge in 1877, who used a trigger system to record the movement of a horse in a continuous series of images. A precursor to cinematography.

COLLODION PROCESS
(See *Wet Collodion Process)*

COMBINATION PRINTING
A creative technique and early form of photomontage refined in the 1850s and 1860s by photographers including Oscar G Rejlander and Henry Peach Robinson. Multiple negatives are carefully arranged together and exposed onto a single sheet of paper to create one, seamless image.

CONCERNED PHOTOGRAPHY
Coined by photographer Cornell Capa in 1966 to describe a type of photojournalism that demonstrates 'a concern for mankind'. Concerned photography not only records social and political issues, but educates the viewer and even incites change.

CONTACT PRINT
A photograph made by placing the negative directly in contact with the sensitised paper or other substrate, such as glass, before exposing them to a light source. The resultant image is the same size as the negative.

CUBISM

An artistic movement created by Pablo Picasso and Georges Braque which developed in Paris between 1909 and 1914, characterised by the use of a wide range of different viewpoints within one picture or sculpture. The Cubists' use of non-linear perspectives, and collage techniques they sometimes used to achieve this, were a major influence on Modernist photography and movements including Futurism and Constructivism.

CYANOTYPE (See Photogram)

DAGUERREOTYPE

A unique and highly detailed positive image on a polished, silver-coated copper plate, made by the method announced by Louis Jacques-Mandé Daguerre in 1839. Daguerreotypy was the first commercially viable photographic process, and responsible for popularising photography. Superseded by negative-positive processes in the 1850s.

DEPTH OF FIELD

The sharpness of the image in front of and behind the point on which the lens is focused. This is controlled by the aperture: when the lens is open wide, only the focal point is sharp, whereas a smaller opening will give a greater depth of field.

DOUBLE EXPOSURE

(See Multiple Exposure)

DYE TRANSFER

Process for hand-making colour prints, reintroduced by Kodak in 1946. Three negatives are made from a colour positive or negative by photographing it through red, green and blue filters. The dyes from these are transferred onto one sheet of paper, resulting in exceptionally rich, saturated colours. The process is complex, but allows the printer a great deal of control, and the results are highly stable.

EXPOSURE

The intensity and total amount of time in which light hits a light-sensitive material (such as sensitised paper) or component (a camera sensor). In modern cameras exposure is controlled through aperture, the opening in the camera shutter.

FORESHORTENING

Capturing the subject from an angle so that one dimension is relatively shortened and appears to recede into the distance, creating the illusion of three dimensions. This mimics the spatial depth perceived by the human eye.

GELATIN SILVER PRINT

The gelatin silver process was introduced in the 1870s and since then has been the primary means of making black-and-white photographs by hand. Light-sensitive silver salts are suspended in gelatin that coats a sheet of paper; the image is separated from the paper by a thin baryta layer, resulting in a smooth and even surface.

KODACHROME

Colour reversal (transparency) film launched as 16 mm movie film in 1935 and in other formats, including 35 mm for still cameras, in 1936. The first mass-market colour film, Kodachrome superseded the early colour process Autochrome and was widely used by amateurs and professionals until it was discontinued in 2010.

LATENT IMAGE

An invisible image registered by light falling on photographic film or photosensitive paper. The image is then developed, or made visible, through the use of chemical processes. The discovery of the latent image (by Louis-Jacques-Mandé Daguerre and William Henry Fox Talbot, separately) reduced exposure times from minutes to seconds.

MULTIPLE EXPOSURE

Exposing the same frame of film two or more times, resulting in superimposed images. Can result accidentally by failure to wind the camera film on far enough, but also used for artistic effect.

NATURALISM

An aesthetic approach outlined by Peter Henry Emerson in his handbook Naturalistic Photography (1889). Based on capturing the world as it is, without the use of contrived settings and costumes, and mimicking how the eye sees: less sharp than a camera lens. Emerson's ideas helped lay the foundations for Pictorialism (see chapter 11).

OIL-PIGMENT PROCESS

A process introduced in 1904, whereby coloured pigment is brushed onto the relief of a gelatin silver print to create soft, painterly effects. Bromoil, introduced in 1907, is a variation of the oil-pigment process; both were popular with Pictorialist photographers.

PHOTO-COLLAGE

(See Photomontage)

PHOTOBOOK

Book in which the vast majority of the content is photographs. Since the early 20th century photobooks have been one of the key channels through which photographers share their work, as they allow them creative control over the format and layout, can be made inexpensively, and are easy to circulate.

PHOTO-ESSAY

A story told through a series of photographs, which may or may not be accompanied by captions. Popularised in picture magazines that dominated in the 1930s such as Life, Look and Vu.

PHOTOGRAM

Cameraless photograph made by placing objects on sensitised paper and exposing the paper to natural or artificial light. Where light hits the paper, it darkens; where protected by the object, it remains lighter, depending on the object's degree of opacity. William Henry Fox Talbot, who discovered the method, called it 'photogenic drawing'; other photographers have coined different names for their variation of the process. Cyanotype, used to make blueprints, is a variation of the photogram made with a Prussian blue dye.

PHOTOMECHANICAL

Any process where photographs are used to make a plate from which reproductions are then printed. Woodburytype, patented in 1866, was the first photomechanical process; in the early 1870s half-tone printing became the dominant means of reproducing images in high-print-run publications like newspapers and magazines.

PHOTOMONTAGE

An image made by assembling different images together either by layering negatives or cutting and pasting pre-existing images, which can be from the same or different sources. The cut-and-paste method is also referred to as photo-collage.

PHOTOTELEGRAPHY

The transmission of pictures through telegraph or telephone wires. The first photograph was transmitted via this method in 1921; the Associated Press launched its system Wirephoto in 1935, and with the advent of portable equipment in the 1930s, the method was widely used by photojournalists. Not to be confused with telephoto, a type of camera lens.

PURE PHOTOGRAPHY

(See *Straight Photography*)

RAYOGRAPH

(See *Photogram*)

RETOUCHING

Removing or disguising blemishes on the print or negative, or the subject of the photograph, and altering tonality, through the careful use of knifes, chemicals or pigments. Images can also be retouched digitally, something that has become synonymous with Adobe Photoshop.

SALT PRINT

Made by using paper sensitised to the light by coating with a solution of table salt and gelatin that is then left to dry before being brushed with a silver nitrate solution. Salt prints tend to be matt and reddish-brown in hue; the image appears to be soaked into the paper. The process was used almost exclusively for printing from calotype negatives until albumen and wet collodion negative processes were introduced in 1850 and 1851.

SCHADOGRAPH

(See *Photogram*)

SERIAL

Artworks that consist of a series of uniform objects or prints, which are usually presented as being equal in value, as well as form and content. Connected with mechanical reproduction and closely associated with Conceptualism and Minimalism.

SHUTTER SPEED

Determines the length of time a camera shutter is open (exposure time). When capturing motion, fast shutter speeds will freeze the action. Long shutter speeds, also known as long exposure, will create the appearance of blur: this is used to capture action in low or fleeting light.

SOLARISATION

Originally meaning the reversal of image tones as a result of extreme and accidental over-exposure of the negative or plate in a camera. Now used to describe the intentional use of over-exposure in the darkroom to partially reverse the tones and create a halo-like outline around the image – strictly speaking, this is called the Sabattier effect. In 1930, Man Ray was one of the first to use this technique for artistic effect.

STEREO CARD

Also known as a stereograph. Two identical images arranged side-by-side on one plate or card. When viewed through the stereoscope, a special optical device, the eye reads them as a single image, with depth. The craze for stereoscopes swept Europe and the US during the 1850s and 1860s; they were a hugely popular form of home entertainment.

STRAIGHT PHOTOGRAPHY

Also known as 'Pure Photography'. Photography that is unsentimental and not manipulated. This came to prominence from the late 1910s among practitioners who wanted to champion the camera's ability to record the world with precision. New Objectivity and Group f.64 were based on Straight Photography (see chapters 19 and 23).

WET COLLODION PROCESS

Frederick Scott Archer invented the wet collodion negative in 1851. A glass plate is coated with a light-sensitive iodide solution mixed in collodion, and exposed in the camera while still wet before being developed. This replaced Daguerreotypy and Calotypy on account of the high-resolution images it yielded, and was widely used in photomechanical processes, but superseded by the gelatin silver process from the 1880s.

List of Collections

AUSTRIA

Thyssen-Bornemisza Art
Contemporary, Vienna
Expanded Documentary

Verbund Art Collection, Vienna
Self-Portrait, Performance & Identity

BRAZIL

Inhotim Contemporary Art
Centre, Brumadinho
Art Documentary

CANADA

National Gallery of Canada,
Ontario
Environmentalism & Globalisation

FRANCE

Bibliothèque Nationale de France,
Paris
The Studio Portrait

Centre Pompidou, Paris
Early Street; The Nude; Surrealism;
Conflict & Surveillance

Musée d'Orsay, Paris
The Studio Portrait

Musée Nicéphore Niépce,
Chalon-sur-Saône
Conflict & Surveillance

Société Française de
Photographie, Paris
Daguerreotypy; Negative-Positivism

GERMANY

Akademie der Künste, Berlin
Dadaism

Bayerisches Nationalmuseum,
Munich
Daguerreotypy

Universität der Künste Berlin
New Objectivity

Museum Folkwang, Essen
Subjectivism

Museum für Kunst und Gewerbe,
Hamburg
Dadaism

SK Stiftung Kultur, Cologne
New Objectivity

HUNGARY

Hungarian Museum of
Photography, Kecskemét
Fashion & Society

INDIA

Indira Gandhi National Centre for
the Arts, New Delhi
The Studio Portrait

ITALY

Museo Nazionale Alinari Della
Fotografia, Florence
Futurism; Street & Society

Museo di Arte Moderna e
Contemporanea di Trento e
Roverto
Futurism

JAPAN

Kobe Fashion Museum
Advertising & Fashion

Tokyo Photographic Art Museum
Subjectivism; Diarism; Expanded
Documentary

THE NETHERLANDS

Stedelijk Museum, Amsterdam
Diarism; Düsseldorf Deadpan

POLAND

Museum of Modern Art, Warsaw
Subjectivism

RUSSIA

Pushkin State Museum of Fine
Arts, Moscow
Constructivism

State Tretyakov Gallery, Moscow
Constructivism

SPAIN

Museu d'Art Contemporani
de Barcelona
Fictional Narrativism

SWEDEN

Moderna Museet, Stockholm
Photojournalism; Art Documentary

SWITZERLAND

Fotomuseum Winterthur
Düsseldorf Deadpan

UK

Arts Council England Collection
Satirism

British Council Collection
Satirism

Imperial War Museum, London
Early Conflict; Conflict & Surveillance

Museum of London
Satirism

National Army Museum, London
Early Conflict

National Galleries of Scotland,
Edinburgh
The Social Document;
Photojournalism; Self-Portrait,
Performance & Identity

National Portrait Gallery, London
The Studio Portrait; Postwar Fashion;
Advertising & Fashion

Scott Polar Research Institute
Museum, University of Cambridge
Travel, Expedition & Tourism

Tate
Bauhaus & the New Vision; War
Reportage; The Candid Portrait;
Street & Society; Conceptualism;
New Topographics; Self-Portrait,
Performance & Identity; Diarism;
Staged Tableaux; Düsseldorf
Deadpan; Activism; Expanded
Documentary; Fictional Narrativism

Victoria and Albert Museum,
London
The First Photograph; Daguerreotypy;
Early Conflict; Motionism; The Social
Document; Early Street; Pictorialism;
The Nude; Fashion & Society; Still
Life; War Reportage; Photojournalism;
Postwar Fashion; Art Documentary;
Diarism; Staged Tableaux; Advertising
& Fashion; Conflict & Surveillance

Wellcome Library, London
Travel, Expedition & Tourism

US

Amon Carter Museum of American Art, Fort Worth, Texas
Staged Tableaux

Art Institute of Chicago
The Nude; Postwar Fashion; Postmodernism; Activism

Boston Public Library, Massachusetts
Motionism

Brooklyn Museum, New York
Group f.64; Art Documentary; Diarism

Center for Creative Photography, Tucson, Arizona
The Nude; Mexican Modernism; Industrialism; Group f.64; Street & Society

George Eastman Museum, Rochester, New York
Survey; Early Conflict; Motionism; The Social Document; Pictorialism; Surrealism; New Topographics

Harry Ransom Center, University of Texas at Austin
The First Photograph; The Family of Man

Harvard College Observatory, Cambridge, Massachusetts
Daguerreotypy

International Center of Photography, New York
Fashion & Society; War Reportage; The Family of Man; The Candid Portrait; Celebrity & Paparazzism; Staged Tableaux; Environmentalism & Globalisation; Fictional Narrativism; Post-Internet

J. Paul Getty Museum, Los Angeles
The First Photograph; Daguerreotypy; Travel, Expedition & Tourism; Survey; Early Conflict; Pictorialism; The Nude; Still Life; New Objectivity; Mexican Modernism; Industrialism; Social Realism; The Candid Portrait; Street & Society; Conceptualism

Library of Congress, Washington DC
Daguerreotypy; The Studio Portrait; Early Conflict

The Library Company of Philadelphia
Motionism

Los Angeles County Museum of Art
Pictorialism

Massachusetts Institute of Technology, Cambridge
Motionism

The Metropolitan Museum of Art, New York
The First Photograph; Negative-Positivism; The Studio Portrait; Early Street; Pictorialism; The Nude; Fashion & Society; Still Life; Futurism; Constructivism; Dadaism; Bauhaus & the New Vision; Photojournalism; Subjectivism; The Candid Portrait; Street & Society; Postmodernism; Self-Portrait, Performance & Identity

Minneapolis Institute of Art
Survey; Environmetalism & Globalisation; Expanded Documentary

Museum of Contemporary Photography, Chicago
Postwar Colour; Environmentalism & Globalisation; New Formalism

Museum of Fine Arts, Boston
Mexican Modernism; Industrialism

Museum of Fine Arts, Houston
The Nude

Museum of Fine Arts, St Petersburg, Florida
New Formalism

Museum of Modern Art, New York
The Social Document; Still Life; Dadaism; Bauhaus & the New Vision; New Objectivity; Surrealism; Mexican Modernism; Social Realism; War Reportage; Photojournalism; Subjectivism; The Candid Portrait; Street & Society; Celebrity & Paparazzism; Postwar Fashion; Postwar Colour; Art Documentary; Postmodernism; Diarism; Satirism; Düsseldorf Deadpan; Expanded Documentary; Fictional Narrativism; New Formalism

National Gallery of Art, Washington DC
The Nude; Social Realism; Street & Society; Activism

National Museum of American History, Washington DC
Industrialism

National Portrait Gallery, Washington DC
Celebrity & Paparazzism

Peabody Essex Museum, Salem, Massachusetts
Travel, Expedition & Tourism

Princeton University Art Museum, New Jersey
The Social Document; Subjectivism

San Francisco Museum of Modern Art
Constructivism; Surrealism; Group f.64; Celebrity & Paparazzism; Postwar Colour; Postmodernism; Diarism; Düsseldorf Deadpan; Environmentalism & Globalisation; Post-Internet

Smithsonian American Art Museum, Washington DC
Social Realism; Conflict & Surveillance

Solomon R. Guggenheim Museum, New York
Self-Portrait, Performance & Identity; Staged Tableaux

Spencer Museum of Art, Lawrence, Kansas
Constructivism

Walker Art Center, Minneapolis
Staged Tableaux; New Formalism

Whitney Museum of American Art, New York
Postwar Colour; Conceptualism

Yale University Library, New Haven, Connecticut
Photojournalism

AN IQON BOOK
This book was designed
and produced by
Iqon Editions Limited
Ovest House
58 West Street
Brighton BN1 2RA

Publisher, concept and direction:
David Breuer

Designer: Isambard Thomas

Editor and Picture Researcher:
Caroline Ellerby

Bloomsbury Visual Arts
An imprint of Bloomsbury
Publishing Plc
50 Bedford Square London
WC1B 3DP UK

1385 Broadway New York
NY 10018 USA

www.bloomsbury.com

BLOOMSBURY and the Diana logo
are trademarks of Bloomsbury
Publishing Plc

First published in 2017 by
Bloomsbury Visual Arts

British Library Cataloguing-in-Pub-
lication Data
A catalogue record for this book is
available from the British Library.

ISBN: 978-1-4742-7759-4

Printed and bound in China

To find out more about our
authors and books visit www.
bloomsbury.com. Here you will
find extracts, author interviews,
details of forthcoming events and
the option to sign up for our
newsletters.

Celia White is the author
of Chapters 4, 7, 8, 10, 20, 25,
26, 34, 38, 40, 43, 44
Celia is Collection Research Editor
at Tate and writes about
contemporary and modern art and
photography for publications
including *The Burlington
Magazine* and *Studio
International*.

Cover Illustration details
(left to right, from top)
Charles Sheeler, *Crissed-Crossed
Conveyors – Ford Plant*, 1927 (p 68);
Sandy Skoglund, *Revenge of the
Goldfish*, 1981 (pp 118–19); Cristina de
Middel, *Umeko*, from *The Afronauts*
(photobook), 2012 (p 135); Martin Parr,
GB. England. New Brighton, from *The
Last Resort*, 1983–85 (pp 124 and 142);
William Klein, *Gun 1, New York*, 1954,
from *Life is Good and Good for You in
New York*, 1954–55; Walead Beshty, *Six
Magnet, Three Color Curl (CMY: Irvine,
California, September 6th 2009, Fuji
Crystal Archive Type C)*, 2009 (p 139);
Dorothea Lange, *Migrant Mother,
Nipomo, California*, 1936 (p 75); Trevor
Paglen, *STSS-1 and Two Unidentified
Spacecraft over Carson City (Space
Tracking and Surveillance System, USA
205)*, from *The Other Night Sky*, 2010
(p 137); Oscar G Rejlander, *Ariadne*,
1857 (p 42); Eadweard Muybridge, Plate
626 of volume 9 ('Annie G Galloping'),
from *Animal Locomotion*, 1887 (p 31);
Robert Capa, *Death of a Loyalist
Militiaman, Cordoba Front*, early
September 1936 (pp 78–79); Herbert
Ponting, *Grotto in a Berg. Terra Nova in
the Distance. Taylor and Wright (Interior)*,
5 *January 1911* (pp 2 and 25); Cecil
Beaton, *Miss Nancy Beaton as a Shooting
Star*, 1928 (p 47); William Eggleston,
Untitled, Memphis, 1970 (p 99); Nick
Knight, *Susie Smoking, for Yohji
Yamamoto Autumn/Winter 1988–89*

Endpapers
Andreas Gursky, *Chicago Board of
Trade II*, 1999 (pp 126–27);

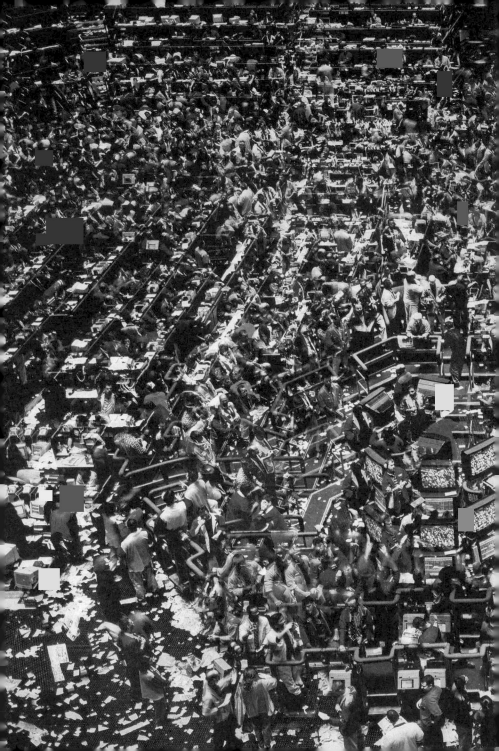